Botticelli

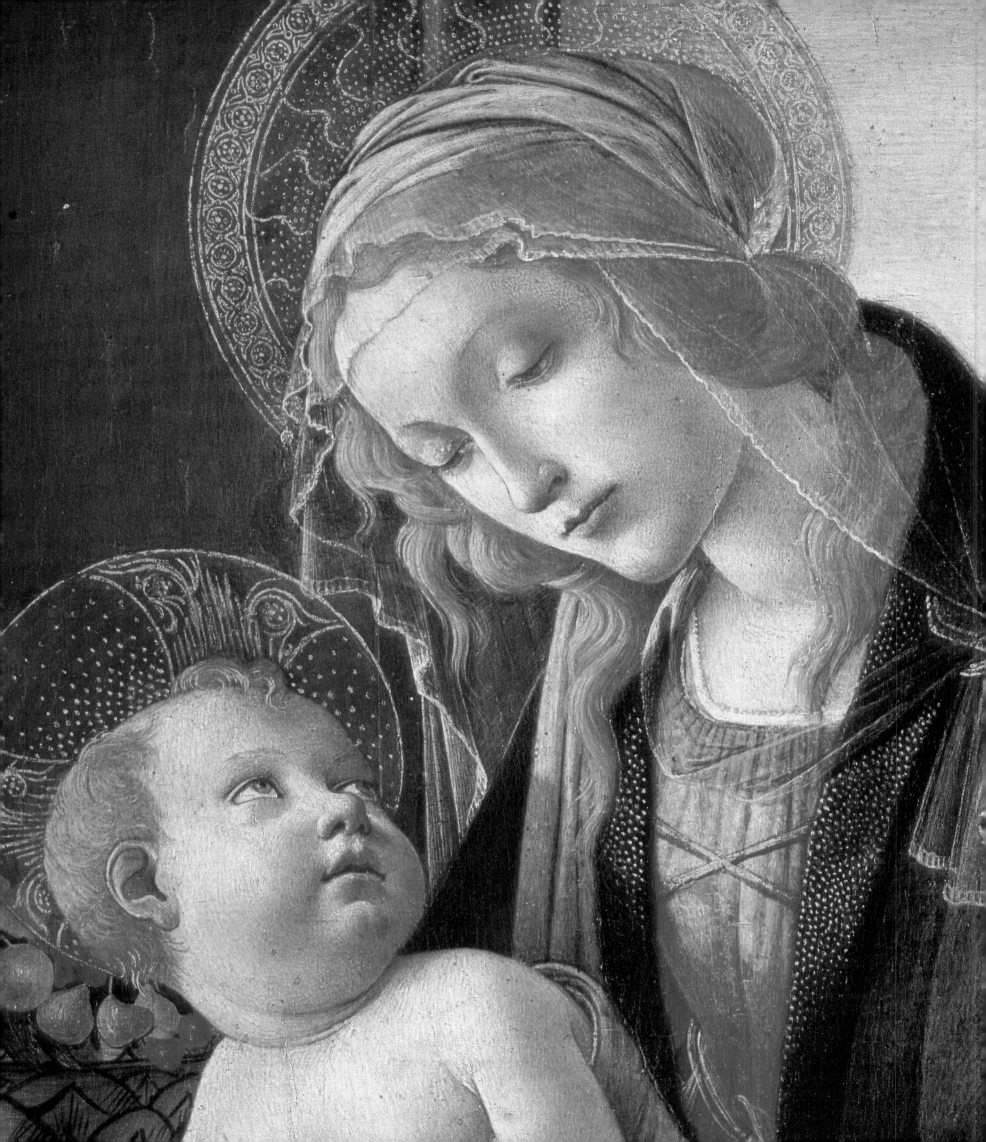

Alexandra Grömling
Tilman Lingesleben

Alessandro
Botticelli

1444/45–1510

KÖNEMANN

1 (frontispiece)
Madonna del Libro (detail ill. 38), ca. 1480
Panel, 58 x 39.5 cm
Museo Poldi Pezzoli, Milan

© 1998 Könemann Verlagsgesellschaft mbH
Bonner Str. 126, D-50968 Köln

Art Director: Peter Feierabend
Project Manager and Editor: Sally Bald
Assistant: Susanne Hergarden
German Editor: Ute E. Hammer
Assistant: Jeannette Fentroß
Translation from the German: Fiona Hulse
Contributing editor: Susan James
Production Manager: Detlev Schaper
Layout: Claudia Faber
Typesetting: Greiner & Reichel, Cologne
Reproductions: CLG Fotolito, Verona
Printing and Binding: Neue Stalling, Oldenburg
Printed in Germany

ISBN 3-8290-0240-8

Contents

BACKGROUND AND TRAINING

A tax return made by Mariano di Vanni Filipepi shows that his fourth son, Alessandro, was 13 years old in 1457. At that time the Florentine year began on 25 March, and this means that Sandro, as he was called by his contemporaries, must have been born between March 1444 and March 1445 by the modern calendar. The Filipepi family, which apart from his mother Smeralda also included two sisters and three brothers, lived on the modest income earned by their father, who had worked in the Ognissanti district of Florence as a tanner since 1433. It was a district of the city moulded by the important Florentine clothworking trades. Sandro's nickname derived from the one given to his eldest brother Giovanni, who because of his corpulence was called 'Il Botticello', or little barrel. From 1458 Giovanni is recorded as having worked as a broker. Filipepi's rise in social position appears to have been matched by an improvement in his financial circumstances. In 1464 the family was in a position to buy a house in what is now the Via della Porcellana, not far from the Ognissanti church. Here, apart from a few interruptions, Botticelli lived and worked until his death in 1510.

In the immediate neighborhood lived the influential Vespucci merchant family, which produced the seafarer Amerigo (1454–1512), after whom the American continent was later to be named. The artist Botticelli painted for this family on several occasions. One of his undisputed masterpieces, the fresco with *St. Augustine* (ill. 43) in the Ognissanti church, was commissioned by them.

Giorgio Vasari (1511–1574), the important biographer of the lives of the artists, whose "Vita di Botticelli" (1550/1564) is still the most extensive source of information about Botticelli, though one that needs to be read critically, reports that Sandro was at first apprenticed as a goldsmith before being placed, probably at the beginning of the 1460s, with Fra Filippo Lippi in order to study painting. At the time it was not unusual to make such changes in training. Andrea del Verrocchio (1435–1488) and Antonio del Pollaiuolo (ca. 1432–1498) were both Florentine painters and sculptors who started their artistic career as goldsmiths. These artists practised the important techniques associated with this craft, such as engraving, enamelling and chasing, and their work showed a precise capturing of contours and sensitive use of decorative gold ornamentation. Both of these features are present throughout Botticelli's work and may be a direct result of his early experiences as a goldsmith.

Following the death of Fra Angelico (ca. 1396–1455), Botticelli's teacher, the Carmelite monk Fra Filippo Lippi, was probably the most successful painter in Florence. He was, however, well-known for being a quarrelsome and eccentric person; he was taken to court for falsification of documents and had to answer to the charge of flouting the terms of his contracts by allowing students to work on his paintings. The peak of his potentially scandalous life was his love for the beautiful nun Lucrezia Buti. Their son Filippino (1457–1504) also became a painter and following his father's death worked in Botticelli's workshop. From 1452 onwards, Filippo Lippi worked mainly in the town of Prato, near Florence, where he painted the main chapel in the cathedral with scenes from the lives of St. Stephen and John the Baptist. After completion of the picture cycle in 1467, he was called to Spoleto in order to decorate its choir chapel with frescoes. There is no indication that Botticelli followed his master to Spoleto. At this point he appears to have already finished his apprenticeship and to have stayed in Florence.

2 Unknown artist
The View with the Chain (after the copper engraving by Francesco Rosselli), ca. 1486
Copper engraving
Museo di Firenze com'era, Florence

This veduta of Florence is one of the first views in the modern sense of the city on the banks of the Arno. At the center of the city is the cathedral of Santa Maria del Fiore with its large dome and the campanile, and to the right of it the Palazzo della Signoria, the seat of government. At the bottom left one can see the church of Santa Maria Novella, near which Botticelli lived and worked, with the exception of a few journeys, right up until his death.

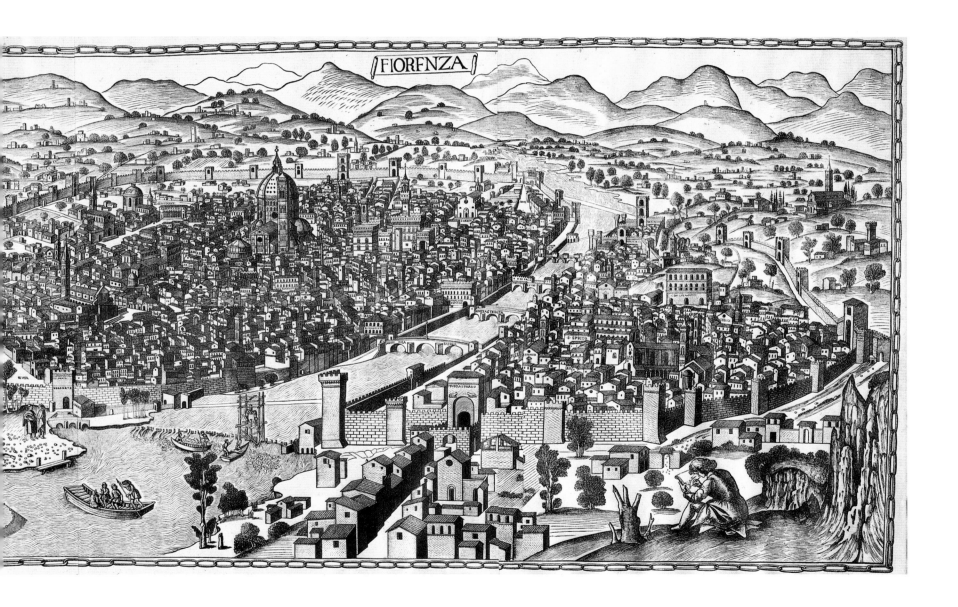

The Early Work

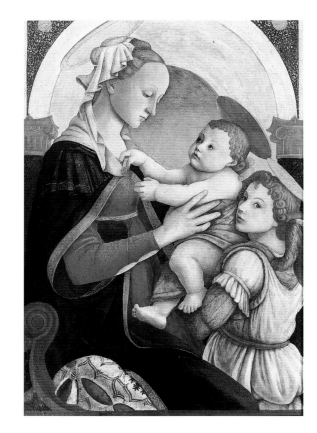

3 *Madonna and Child with an Angel*, ca. 1466
Panel, 87 x 60 cm
Galerie dello Spedale degli Innocenti, Florence

It is possible that this somewhat awkward painting of the
Madonna was produced while Botticelli was still working
in the workshop of his teacher, Filippo Lippi. The initial
inspiration for the painting came from the latter's famous
Madonna in the Uffizi (ill. 4). Botticelli replaced the
landscape with an arched architecture which frames the
heads of the mother and child and emphasizes the two
main figures as the center of the devotional scene.

4 (opposite) Filippo Lippi
Madonna Adoring the Child and Two Angels, ca.1465
Panel, 95 x 62 cm
Galleria degli Uffizi, Florence

Lippi's picture of the Madonna is a balanced combination
of a delightful grace and solemn devotion. The Madonna
is skilfully placed in front of a stone frame with a
breathtaking view out onto a landscape, and is adoring
the child who is held by two angels. The painting made
a lasting impression on Botticelli and inspired him to
produce a number of variations.

Nowadays Botticelli's early works are recognized to be
predominantly small and medium format panel
paintings of the Madonna, the composition of which
usually bears some relation to famous pictures by his
teacher. For example, his so-called *Madonna Guidi* in
the Louvre in Paris was probably created under the
evident influence of Lippi's *Madonna and Child before
a Landscape*, and even his *Madonna and Child with an
Angel* (ill. 3) can be directly attributed to the
composition of a superb Lippi painting (ill. 4). A
preliminary sketch for this panel painting is kept in the
Uffizi, and it is possible that Botticelli used it as a guide
while still in his master's workshop. He did, however,
change the theme and, instead of the worshipping Mary,
shows her receiving her child from an angel. If this work
still seems rather stiff, paintings such as the *Madonna
della Loggia* (ill. 5) or the one from the Florentine
Accademia (ill. 6) make it possible to see the gestures
and expressions of mother and child becoming more
lifelike and intimate. In this and a series of similar
paintings, the young artist was trying out the repertoire
of motifs associated with this theme. He varied the
placing and number of figures in the picture and their
visual contact with the observer as well as the
backgrounds and details. His manner of painting
steadily became more refined and permitted him to
produce skilful transparent effects such as the veils
around Mary's head. These were the first tentative
attempts to produce something other than the formal
language he had learnt, and already contain clear
indications of the artist's own developing style. These
domestic devotional pictures were the perfect
framework for such a development, as from the middle
of the century there was increasing demand for them in
Florence.

Botticelli's earliest biblical history painting, an
Adoration of the Magi (ill. 7), has a similar experimental
character. Its long format is unusual, too low to be used
on an altar and too large to be used as a panel on a
cassone, a wooden household chest. It is conceivable
that the painting was let into the sort of wooden
panelling that one often finds in Florentine palaces. The
composition of the picture suggests that it was mounted
at eye level, and it is Botticelli's earliest attempt still in
existence at a more complex perspective construction.
The picture is divided into a main area and two side
sections by foreshortened walls and pillars, and the
events unfold, like a frieze, from left to right. Obeying
the pressures of the low panel, Botticelli started with a
crowded entourage of horses, squires and courtiers, and
led the procession in two groups around the rocks and
ruins. At its head the tumult of figures opens out and
the scene is dominated by colorfully accentuated robed
figures, the kings' immediate household. The youngest
of them is pausing reverently and the middle one is
respectfully removing his crown; the eldest is already
kneeling before Mary in order to kiss her child's feet. To
one side of this scene, Joseph is leaning against a pillar
in front of the stable in which there would have been
plenty of room for the familiar ox and ass. Rather

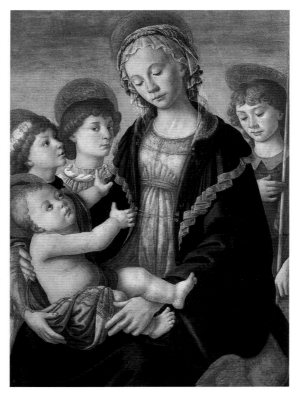

5 (far left) *Madonna della Loggia*, ca.1467
Panel, 72 x 50 cm
Galleria degli Uffizi, Florence

The theme of the Madonna and Child embracing, which was extremely widespread in the sculpture and painting of the Quattrocento, is derived from a Byzantine pictorial type. What is new here is the motif of the loggia, which still makes a rather flat impression behind the figures, although the even fall of the light is attempting to integrate it properly into the scene.

6 (left) *Madonna and Child, Two Angels and the Young St. John the Baptist*, ca. 1467
Panel, 85 x 62 cm
Galleria dell' Accademia, Florence

Supported by an angel, Mary is holding her child on her knees. Her eyes are inaccessibly lowered. The group is flanked by another angel and the young Baptist, who is added to the composition in a somewhat helpless manner to the right behind Mary. The translucent veil and the gold braid trimming of Mary's cloak are signs of Botticelli's love of ornamentation.

abruptly, two shepherds are hurrying up from the right.

Lippi is still clearly a model where the composition of the picture is concerned. Certain motifs can even be traced back directly to his *Adoration* in the Washington National Gallery. Botticelli, however, depicts some beautiful figures, frequently arranged in pairs, which somehow do not create a harmonious unity. Attractions such as the dwarf on the edge of the royal household or the Madonna's delicate profile are valuable set pieces, as is the view out between the cliffs onto the landscape, which the young artist borrowed from a painting by Jan van Eyck. Botticelli's acquaintance with the pictorial forms of the Dutch artists probably also dates back to his time in Lippi's workshop.

In August 1470 Botticelli was paid by the Florentine *Tribunale di Mercanzia* (a court where economic crimes were judged) to produce an over life-size painting of the enthroned Virtue of *Fortitude* (ill. 15); it was finally put up in the courtroom above the judges' chairs, next to six further paintings of the Virtues produced by the Pollaiuolo brothers. It is the first painting by Botticelli for which sources exist that definitely attribute the work to him, and it forms a stylistic turning point between his earliest works, which were more reliant on his master, and his independent early work. The considerable sculptural quality of this figure marks a huge step forward from the gentle elegance of the formal language employed in Lippi's workshop. There is no simple explanation for the phenomenon, as there are no sources to say what steps Botticelli took after the conclusion of his apprenticeship in order to establish himself as a painter in Florence. It is certain that he had dealings with the workshops of Andrea del Verocchio and the brothers

Antonio and Piero del Pollaiuolo, as these had introduced to contemporary Florentine painting a powerful method of depicting figures based on sculptural values. The dry, rather restless style of the Pollaiuolo workshop did, however, clearly differ from the tangible Botticelli paintings of this period, and it is difficult to assess Verrocchio's artistic work. None of his early paintings can definitely be attributed to him. It is, however, known that his workshop was a vital attraction for the young generation of painters and produced students as important as Domenico Ghirlandaio, Leonardo and Pietro Perugino. There is, however, no proof that Botticelli was, as has occasionally been supposed, directly employed by one or the other workshop. What the commission to produce the *Fortitude* does show is that by 1470 Botticelli was in direct competition with the two most important painters of the period. Piero del Pollaiuolo had received the commission to paint the seven Virtues for the Tribunale in 1469, but by spring of the following year had not yet delivered all the paintings. As a result, new tenders were invited for the remaining Virtues. Apart from Pollaiuolo, Verrocchio also applied with a figure, but without success. Botticelli, in contrast, was commissioned to produce two of the Virtues, but for some unknown reason he only produced the *Fortitude*.

A remarkable artistic image is also revealed by two small paintings depicting scenes from the story of Judith (ills. 8, 9) which were probably produced towards the end of the 1460s. While the heads of Judith and the maid, and the gentle colors and unruly garments, relate back to Lippi's paintings, the blue-robed heroine could, in contrast, be a sister of the *Fortitude*. The only signs indicating that these works were produced before that

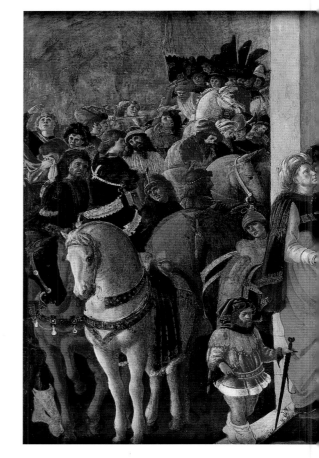

major commission of 1470 are the less sharp drawing and softer modelling.

Judith's story is related in a book of the Old Testament. She left her besieged native city of Bethulia and entered the Assyrian camp, apparently as a turncoat. Bewitched by her beauty, their captain Holofernes invited Judith into his tent. After a banquet, she used the drunken man's own sword to cut his head off, and brought it back to her people; they were then able to put the leaderless Assyrian army to flight. In republican Florence, Judith was a symbol of freedom and, like David who vanquished Goliath, was a prototype of the weak who triumph over the strong in a just cause. The Florentine sculptor Donatello (1386–1466) created famous bronze figures on both themes.

Botticelli's Judith is no longer a political symbol. In *Judith's Return to Bethulia*, she is not gazing ahead, enjoying the freedom gained through her victory over the tyrant, but is facing backwards and wrapped in thought. In her right hand she holds the bloody instrument of death and in her left she balances the olive branch, the symbol of peace, and as she walks she seems to be searching for inner equilibrium. Her maid is hurrying after her, holding the head of Holofernes,

wrapped in a cloth, over her head and carrying the empty wine flasks, while in the background, over the contested city of Bethulia in the wide landscape, dawn is breaking.

The *Discovery of the Body of Holofernes* (ill. 9) is also characterized by this psychological capacity for understanding. The outraged Assyrians are crowded around their beheaded leader, each with his own expression of grief, horror and dismay. Bending over the bed, the impressively foreshortened figure of a warrior is carefully lifting the sheet. This effective gesture confronts the observer directly with the gruesome sight of the bleeding, headless neck. The body on the bed, which stretches right across the width of the picture, makes a rather relaxed impression. It is suggestive of a tranquil sleeping youth rather than of a battle to the death. It is the first surviving nude by Botticelli, and is a reference to his early study of the classical period in general, just as his soldiers, grouped one behind the other, remind us of the construction of classical reliefs in particular.

Some panel paintings of the Madonna remain from the years around 1470, and they are striking expressions of Botticelli's further stylistic development. The two full

7 *Adoration of the Magi*, ca.1466–1468
Panel, 50 x 136 cm
The National Gallery, London

The Three Kings' magnificent retinue has reached the stable in Bethlehem. The eldest king is kneeling humbly in front of the child. The panel painting's unusual dimensions created difficulties for the young painter. When compared to the crowded group of figures on the left, the right side seems strangely empty.

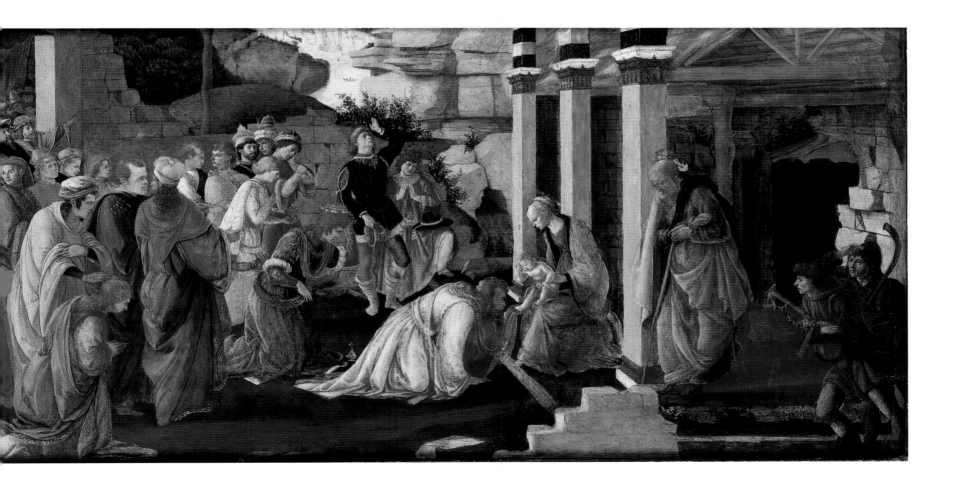

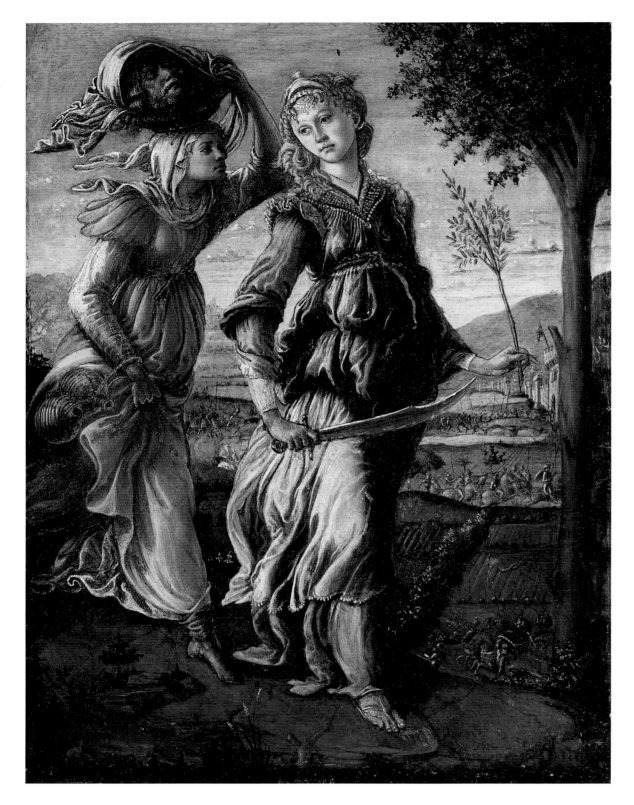

8 (left) *Judith's Return to Bethulia*, ca. 1469–1470
Panel, 31 x 24 cm
Galleria degli Uffizi, Florence

The Old Testament heroine appears thoughtful, not triumphant. Botticelli's counterpart to the picture of Judith returning home with the cut off head of Holofernes is, most unusually, the extremely rare depiction of the parallel story, the discovery of Holofernes' body. The two panel paintings, which are both painted as finely as miniatures, would presumably have been extremely valuable pieces of art that would have been carefully stored away and occasionally brought out and put on view.

9 (opposite) *Discovery of the Body of Holofernes*, ca. 1469–1470
Panel, 31 x 25 cm
Galleria degli Uffizi, Florence

The soldiers are standing in dismay around the bed on which the headless body of their commander Holofernes is lying. They had expected to find him in Judith's arms, who, however, is already hurrying home. There is only a brief description of the scene in the Bible, and it clearly stimulated Botticelli's imagination. When compared to the other painting, however, the youthful well-formed body presents us with a contradiction: in that painting, the cut off head of Holofernes has the features of an older bearded man.

figure pictures of the Madonna in the Uffizi (ills. 10, 11) are only a little smaller than the panel of the *Fortitude* (ill. 15), and are also broadly comparable in the nature of the commission, to produce a monumental seated figure that filled the entire picture. The figures are uniformly lit from the right, and not just the lack of pictorial space suggests that the *Madonna in Glory* (ill. 10) was the earlier work. Her flesh colors are rather softer, and her robes are flatter and less three-dimensional in appearance. The more powerful and rather more naturalistic physical presence of the two later figures is also a characteristic of two further pictures of the Madonna which are now kept in Naples (ill. 12) and Boston (ill. 13). They show Mary in a three quarter view as a seated half length figure with the child sitting on her lap. They also make it clear how the young Botticelli was able to transform Lippi's formal language into a more voluminous style of figure with its own elegance. In addition, Mary is now placed within clearly defined pictorial spaces which provide an opportunity

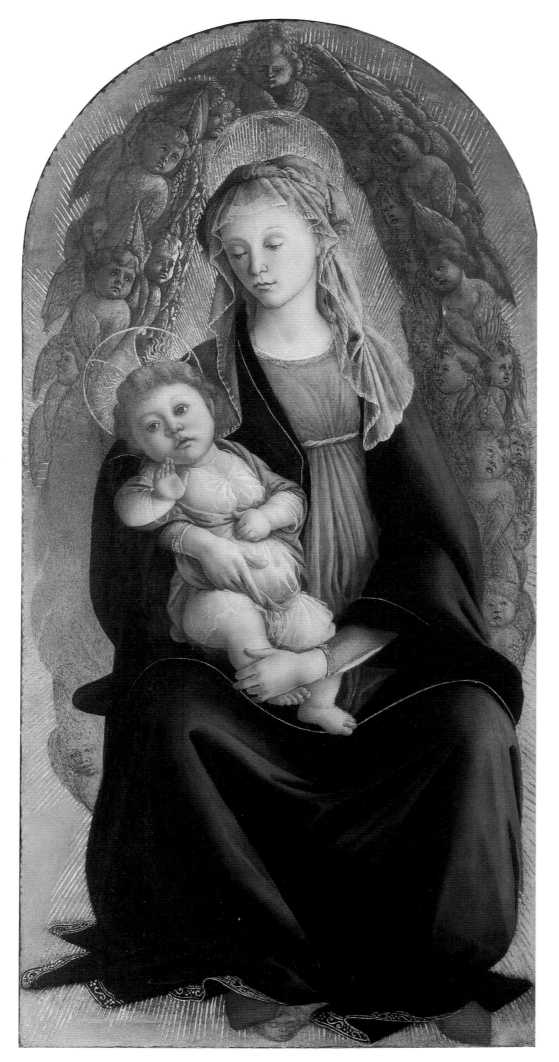

10 *Madonna in Glory*, ca.1469–1470
Panel, 120 x 65 cm
Galleria degli Uffizi, Florence

Mary is enthroned on clouds in a glory of seraphim. The
Christ Child, with the cruciform nimbus, is looking
towards the observer and raising his hand in blessing.
Botticelli has succeeded in expressing the tensions in this
theme with sensitivity: the mother, who is fully aware of
the Passion her son will suffer, is holding him protectively
in her arms.

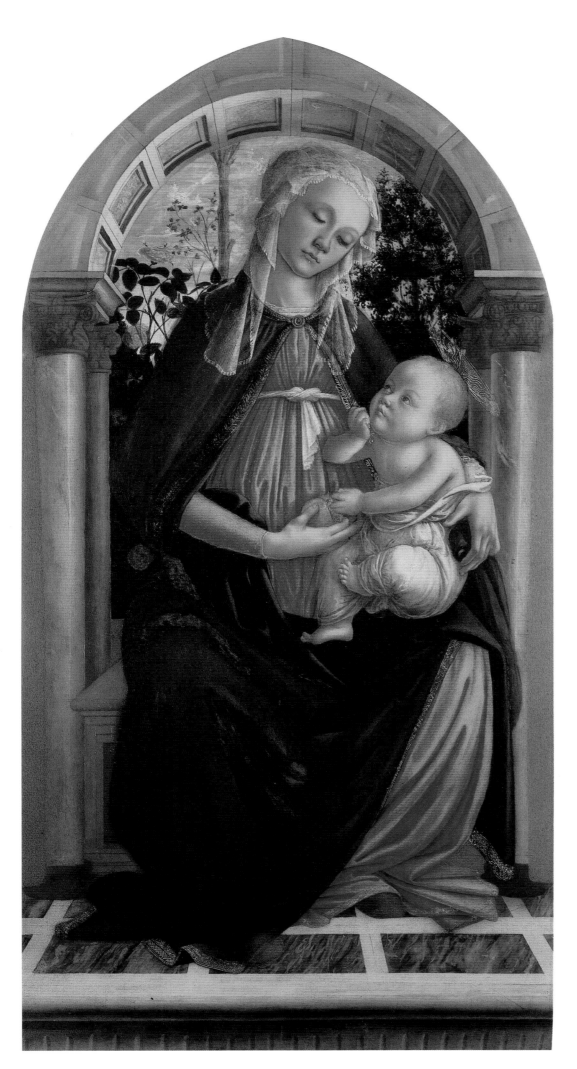

11 *Madonna of the Rosegarden*, ca. 1470
Panel, 124 x 65 cm
Galleria degli Uffizi, Florence

Arising strictly from the format of the picture, the arch
structure frames the group of mother and child sitting on
a stone bench. There is a powerful three-dimensional
quality to the figures. Behind the Madonna we can look
out onto a garden. A rose bush is clearly visible there, a
symbol of her beauty and purity.

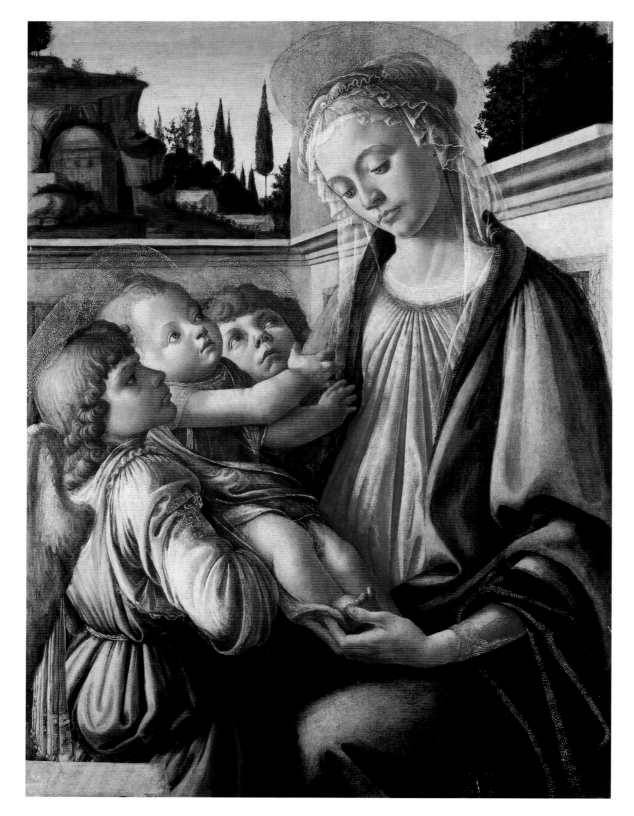

for rich iconographical allusions of a type that were
foreign to the earlier works. Behind the corners of the
walls, which are a reference to the *Hortus Conclusus*, a
symbol of Mary's virginity, landscapes extend which
already show hints of a use of aerial perspective. The
towers should be understood as hidden attributes of
Mary; they are a reference back to the Song of Songs in
the Old Testament, and embody Mary's purity.
Symbolical references to the Passion of Christ, such as
the pomegranate that the child is holding in the
Madonna of the Rosegarden (ill. 11) or the lavish bowl of
grapes and ears of grain in the *Madonna of the Eucharist*
(ill. 13), complete a type of Madonna characterized by
a gentle melancholy, a clear contrast with the more
charming variants in Lippi's work.

Judging from the few sources that survive, 1470 was
the year when Botticelli, who by now was 25, made his
decisive breakthrough. While his father, in a tax return

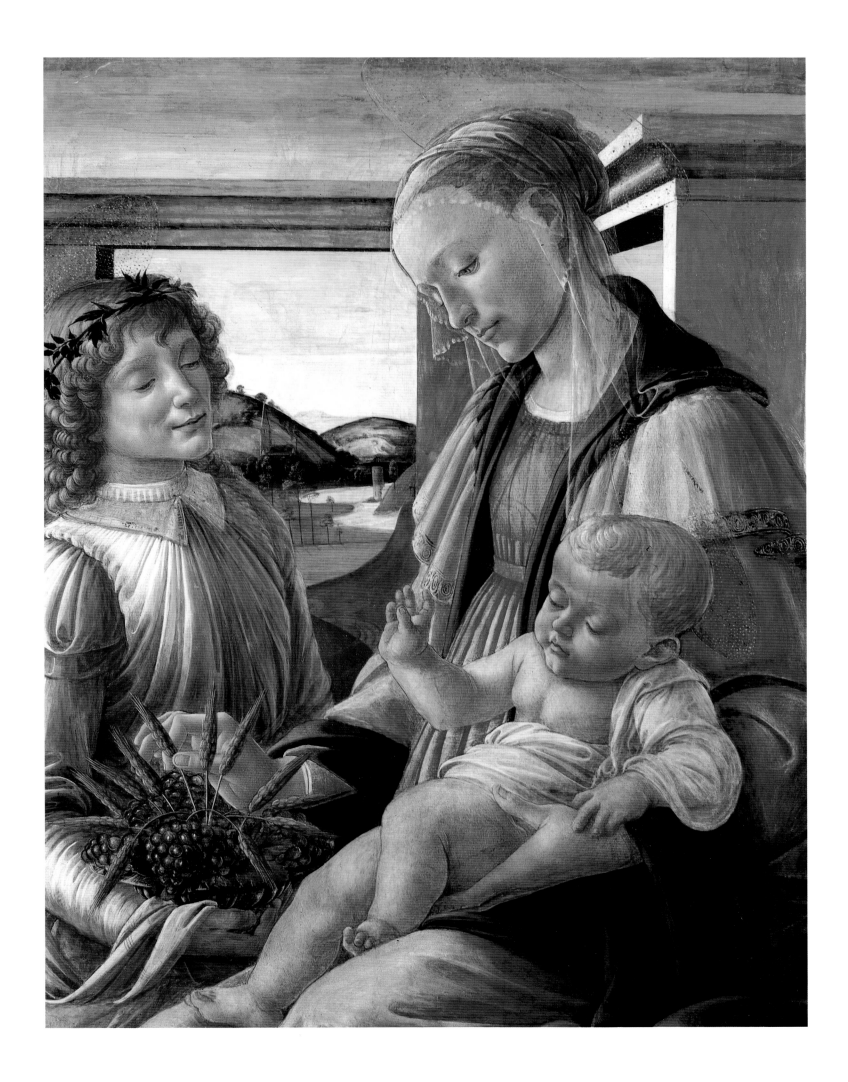

14 Piero del Pollaiuolo
Temperance, 1470
Panel, 167 x 87 cm
Galleria degli Uffizi, Florence

Pollaiuolo set his *Temperance* right back in the pictorial space, probably in order to demonstrate the perspective qualities of his painting. This also provided enough space for his figure to make an expansive gesture with which she gives an effective display of her attributes. The symbol of her temperance is the wide arc of water that she is pouring into a bowl containing wine.

15 *Fortitude*, ca. 1470
Panel, 167 x 87 cm
Galleria degli Uffizi, Florence

The staff of command and breastplate identify this figure as a personification of fortitude. It is the first painting that sources can definitely prove to be Botticelli's work, and part of a cycle of seven paintings of the Virtues, commissioned by the Florentine Tribunale to be hung behind the judges' chairs. The other six Virtues were painted by the Pollaiuolo brothers.

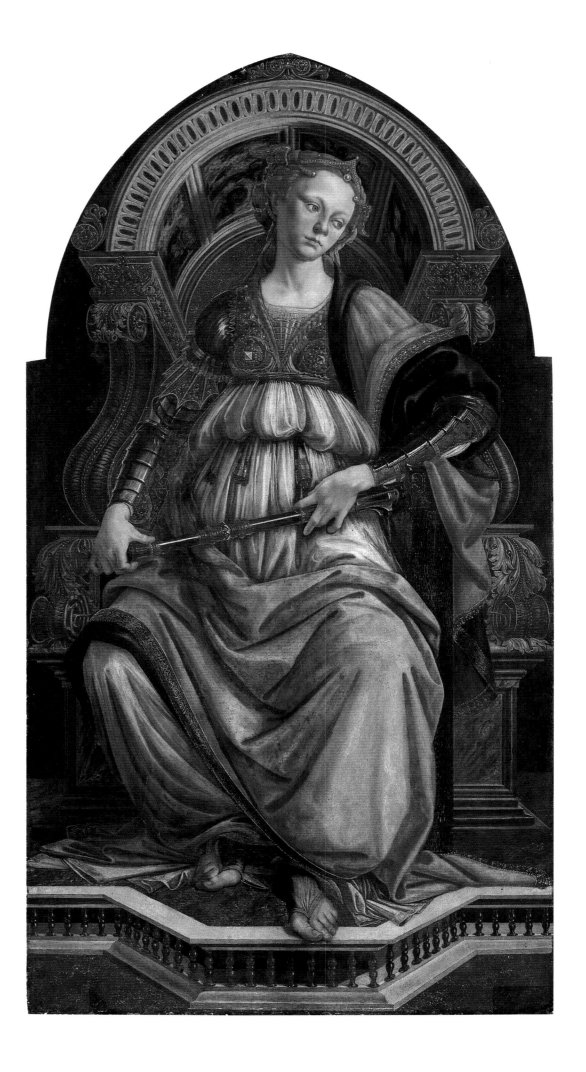

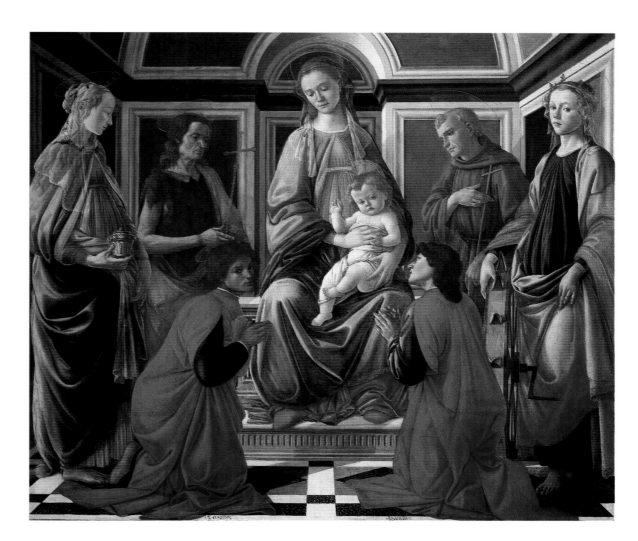

16 *Madonna and Child with Six Saints*, ca. 1470
Panel, 170 x 194 cm
Galleria degli Uffizi, Florence

This type of altar painting is called a *Sacra Conversazione*, and it shows the enthroned Madonna surrounded by saints. To the left are Mary Magdalene with the ointment jar and St. John the Baptist wearing furs, and to the right are St. Francis of Assisi in the Franciscans' habit and Catherine of Alexandria with her wheel. The two kneeling saints, Cosmas and Damian, were patron saints of both the Medicis and doctors and pharmacists.

dating from 1469, still listed him as a member of his household, Benedetto Dei, a contemporary chronicler, mentions that Botticelli directed his own new and ambitious workshop from 1470 onwards. By then, Botticelli must have gained a good reputation in Florence in order to have been mentioned by Dei. Good connections with influential citizens, who were in a position to make decisions about the award of important public and ecclesiastical commissions, were a fundamental prerequisite for establishing oneself as an independent master. The sources relating to the above mentioned major series of Virtues for the Florentine Tribunale make it clear that by 1470 Botticelli was already being sponsored by one of the most powerful personalities in Florence. Tommaso Soderini (1403–1485), one of the consuls of the Tribunale, had mentioned him to the members of the commission. Soderini was one of the most loyal supporters of the Medicis. Having risen to power as a trusted advisor of Cosimo de' Medici (1389–1464), he also supported the governments of the later Medici rulers, Piero (1416–1469) and Lorenzo (1449–1492).

The iconographical program of the series of Virtues had almost certainly been defined in advance by the members of the commission. There were six judges' seats in the courtroom, and the seven paintings of the Virtues were to be arranged above them. The three theological

Virtues of *Fides*, *Spes* and *Caritas* (Faith, Hope and Charity) were probably contrasted with three of the four ancient cardinal virtues, Temperantia, Prudentia and Fortitudo (Temperance, Prudence and Fortitude). Justitia (Justice) would have been located in a prominent position, as the courtroom was a place for dispensing justice and arbitrating economic disputes. All seven paintings still exist and can now be seen, hanging together, in the Uffizi.

Botticelli made good use of the opportunities presented by this commission, as is shown by a comparison of his *Fortitude* (ill. 15) and *Temperance* (ill. 14), one of the six other Virtues painted by the Pollaiuolo brothers. The gestures and figure of Pollaiuolo's *Temperance* are stiff in comparison to the very lifelike presence of Botticelli's *Fortitude*. Backed by the richly ornamented architecture of the throne, she fills almost the entire panel. Her red cloak is elegantly draped over her thigh and shoulder, and its imposing folds emphasize her monumental figure. Over her silver-gray garment she is wearing a breastplate and bracers; these are some of her attributes, together with the staff of command and the column within the throne niche against which she is gently leaning her arm. However, the ability to defend herself is only one side of her personality being expressed. Above the confident *contrapposto* of her body, Fortitude is thoughtfully

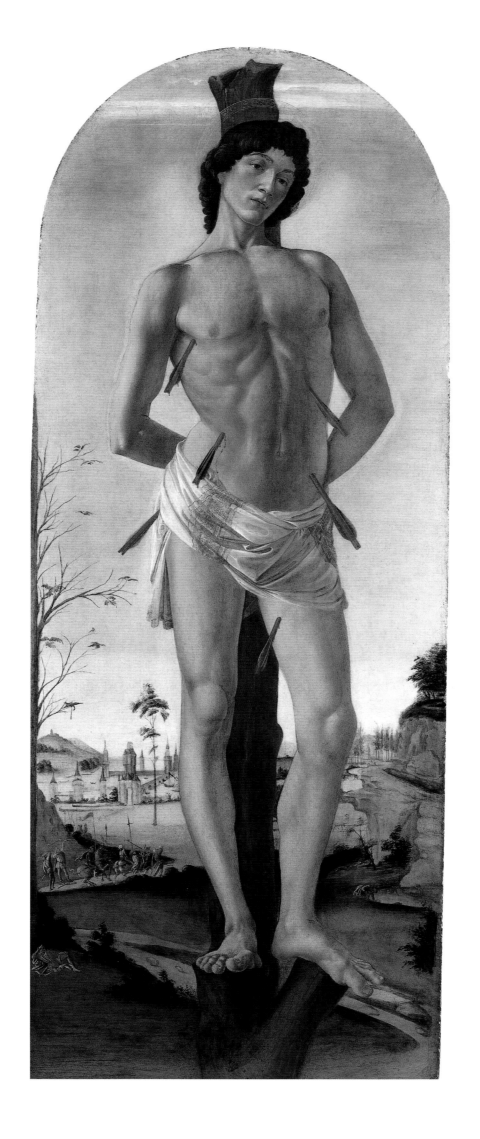

17 (opposite) *St. Sebastian*, 1474
Panel, 195 x 75 cm
Staatliche Museen Preußischer Kulturbesitz,
Gemäldegalerie, Berlin

The saint is serenely enduring the six arrows that have
been shot into him. Clothed only in a loincloth, he is
standing on the stumps of a tree that has been cut to the
shape of a stake and which rises suddenly in the center of
the picture, in front of the landscape and sky. The torture
is past, Sebastian's tormentors have already moved on and
are hunting for herons. The scene showing the torturers
leaving is a very rare theme for depiction.

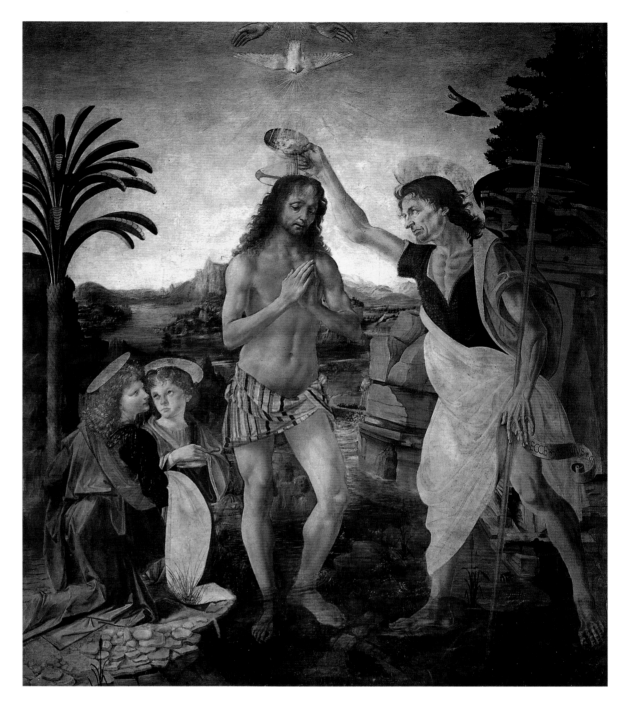

18 (right) Andrea del Verrocchio and Leonardo da Vinci
Baptism of Christ, early 1470s and early 1480s
Panel, 177 x 151 cm
Galleria degli Uffizi, Florence

In about 1470, Botticelli spent time studying Verrochio's
very sculptural way of depicting figures. The picture of
the Baptism was a commission given to Verrocchio, and
he painted St. John and Christ. The angel on the left is
considered to be the work of Leonardo, while there is
debate amongst researchers as to the correct attribution
of the other angel. One suggestion is that Botticelli
produced this figure, but this does however seem unlikely.

turning her head, crowned with a diadem, and subtly
demonstrates that the power of Fortitude also derives
from contemplative sources.

In the meantime, Botticelli had also learned to arrange
a larger number of almost life-size figures in a space
constructed according to the laws of perspective. This is
demonstrated by his first altarpiece still in existence, the
Madonna and Child with Six Saints (ill. 16). It is a
symmetrical composition in which each of the standing
saints is allotted a section of the marble panelled space.
There is still enough space for the kneeling figures of
saints Cosmas and Damian. Their features are very
much akin to portraits, but it is not possible to identify
any of them.

Due to overpainting at a later date, it is difficult to
judge this panel. For instance, even with the naked eye

it is obvious that Mary's dress was originally more
broadly cut. The figure of St. Catherine does, however,
bear comparison with the style of the *Fortitude*, making
it likely that the painting dates from around 1470.

From 1472 onwards, Botticelli can be proven to have
made payments to the Compagnia di San Luca, a lay
brotherhood, rich in tradition, comprising a union of
artists under the name of their patron saint, St. Luke.
The union was very important socially and
organizationally for the profession, probably also
because painters in Florence belonged to the guild of
doctors and apothecaries, which according to the
remaining proofs of payment Botticelli did not join
until towards the end of his life. In 1472 Botticelli must
already have been in charge of a busy workshop. The
records of the Guild of St. Luke show that, at the time,

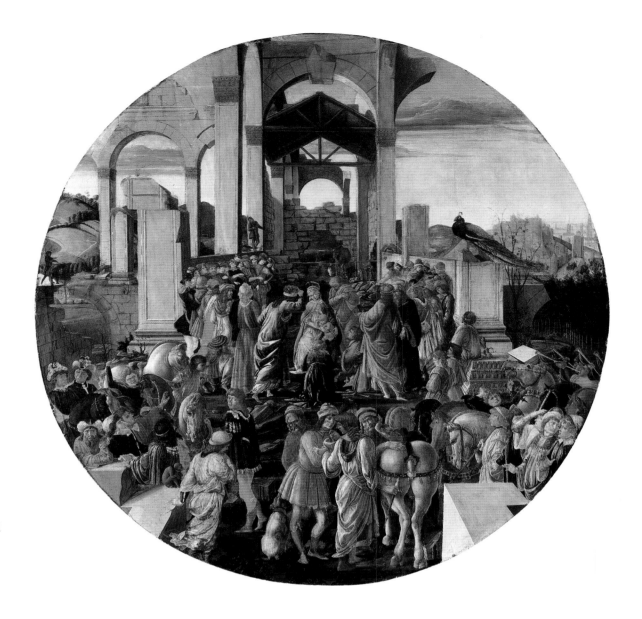

19 *Adoration of the Magi*, ca.1470–1474
Panel, ø 131.5 cm
The National Gallery, London

There is such a wealth of figures in this composition that
the overall effect can seem quite confusing, but in the
center is the child sitting on Mary's lap. The scene is a
ruined, pseudoclassical temple building. It was considered
to be the symbol of the destruction of the heathen world
by Christ's arrival, for according to mediaeval legend an
ancient temple of peace collapsed in Rome when Christ
was born.

Filippino Lippi worked under Botticelli's guidance. A
further workshop assistant was put on record in 1473 in
legal documents.

In January 1474, according to an anonymous source
written before Vasari's *Lives*, a panel painting of *St.
Sebastian* (ill. 17) by Botticelli was mounted on a pillar
in the Florentine church of Santa Maria Maggiore.
Nothing is said about the composition of the work or
who commissioned it, but the theme and the location
where it was erected suggest that it is the narrow, high
rectangular painting in the Berlin state museums.

Since the early Middle Ages, Sebastian had been one
of the most important saints associated with the Plague.
As is related in the *Legenda Aurea*, put together by
Jacobus de Voragine in the 13th century, he died the
death of a martyr during the Emperor Diocletian's reign,
for he, the commander of the imperial bodyguard, had
converted to Christianity and persuaded other Romans
to follow suit. Before he was finally beaten to death by
the Emperor's thugs, he had miraculously managed to
survive a first attempt at executing him: archers had tied
him to a tree and shot arrows at him. As a help in times
of plague, St. Sebastian was part of the same tradition

as Apollo, the classical god of healing. His instruments
of martyrdom also relate to a classical idea that the gods
used pestilential arrows to shoot at mankind. The
epidemics of the Black Death between 1350 and 1450
had reduced the number of inhabitants of Florence by
at least half. At the same time, the worship of this saint
increased greatly.

The reconstructed hanging position means that
Botticelli's painting would have been ordered not as an
altarpiece but as a votive image, possibly in gratitude for
surviving an attack of the Plague. This explains the way
the saint fills the entire frame. In the manner
characteristic of Botticelli, he is leaning his head
thoughtfully to one side and is seeking to make visual
contact with the observer; the work is composed to be
seen from below, possibly when kneeling in worship.

St. Sebastian is the first monumental nude in
Botticelli's work. His well-proportioned, powerful
figure exudes tranquillity and composure, expressed in
the harmonic balanced structure of his body. The well-
balanced *contrapposto*, and the structure of the muscles
and bones which can be made out under his skin, are
evidence of Botticelli's sophisticated studies of anatomy.

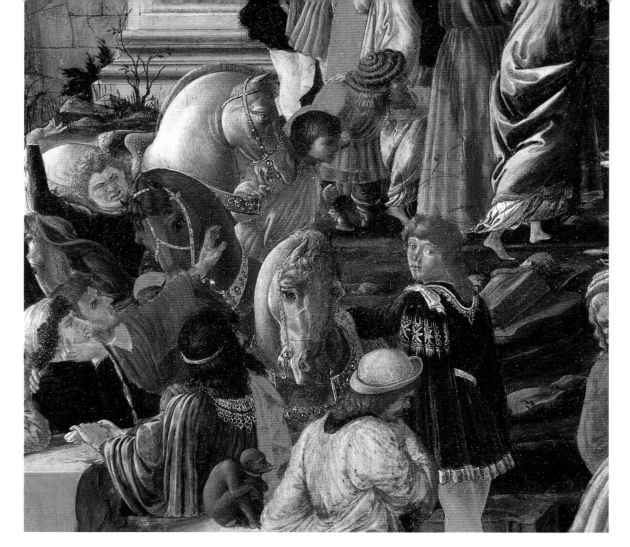

20 *Adoration of the Magi* (detail ill. 19), ca. 1470–1474

Some of the figures are looking towards the observer; examples include the old man leaning on a massive square hewn stone on the left, and the young man next to the horse. Others, such as the man pointing to the back, are leading the observer's eyes towards the center of the scene.

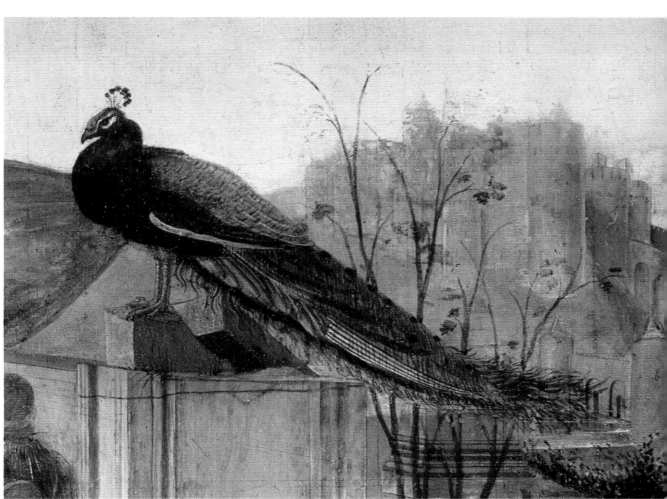

21 *Adoration of the Magi* (detail ill.19), ca. 1470–1474

The magnificent peacock that is clearly visible in the scene is a symbol of the resurrection of Christ, for the bird's flesh was considered to be imperishable.

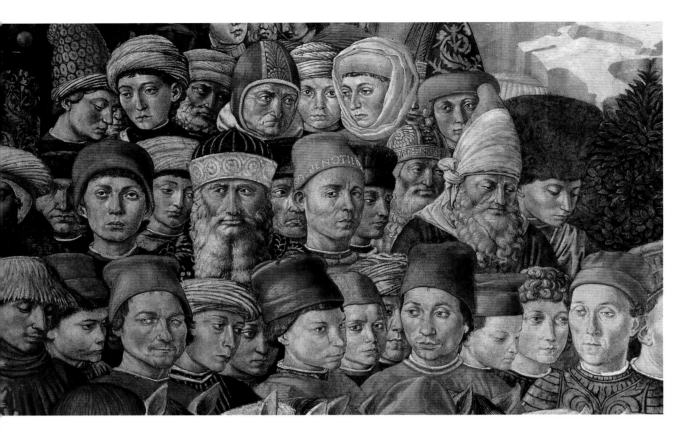

22 Benozzo Gozzoli
The Procession of King Caspar (detail ill. 23), ca. 1459

Led by Cosimo and Piero de' Medici, various respectable Florentines are portrayed in the youngest king's retinue. Further back, Gozzoli has left us a self-portrait, signed on the red cap.

X-rays show how much Botticelli worked on the standing position and proportions of the figure; the main areas where he made corrections to his original design are the shoulders, arms and legs.

Given the competition between workshops for important ecclesiastical, public and private commissions, a nude as beautiful as the *St. Sebastian* will have had a considerable effect on Florence's artistic circles. Contemporary efforts to produce anatomically precise male bodies, made in the studios of Verrocchio and the Pollaiuolo brothers, were probably competing projects. Verrocchio's *Baptism of Christ* (ill. 18) was begun in the early 1470s. In 1475, the Pollaiuolo brothers made their appearance with the altar to St. Sebastian, commissioned by the Pucci family, for the church of Santissima Annunziata, which is now in the London National Gallery.

Vasari's Life of Botticelli suggests that he also worked for the Pucci family, who had risen to power and influence under the Medicis, and produced a circular picture for them whose theme was the *Adoration of the Magi* (ill. 19).

From the mid 15th to early 16th centuries, *tondos* were popular decorative objects. They were frequently used to ornament the public rooms in private palaces, or the meeting places used by wealthy brotherhoods and guilds. Botticelli made a remarkable innovation in the use of this circular format, for it was not previously known in the tradition of the theme of the Adoration. In accordance with tradition, Mary is holding the child on her lap, but is now seated in a frontal position in the center of the composition. The kings are kneeling before her, their backs to the observer, and can therefore no

longer be interpreted, as was customary, merely as personifications of the three ages of man. The events take place within a cleverly planned perspective construction. The vanishing point is in the break in the wall above Mary's head. The basic lines of composition focus on the Adoration group, which however is still dominated by the magnificent variety of forms.

By using diverse motifs of people and animals, distributed in a great variety of positions, poses and gestures throughout the picture, Botticelli was following the advice of contemporary art theory. As Leone Battista Alberti wrote in his treatise "On Painting", published in 1435, "The first thing that gives pleasure in a 'historia' is a plentiful variety". This *varietà* (variety) of depiction and *ornato* (decoration) of the scene are criteria which the artist so took to heart when structuring his panel that he, in the process, to some degree lost sight of the unity of the composition. As a result, the impression given by the *tondo* is of a demonstration of his artistic skill, and this effect tends to outweigh its function as a devotional picture.

The Adoration of the Magi was one of the most popular themes in paintings of the Florentine Quattrocento. There are still five paintings on the theme in existence by Botticelli alone, and sources tell of another fresco which was destroyed in the 16th century. Patron saints of travellers and merchants, the Three Kings were of great importance to a city which lived on trade and banking. The term "Magi", used for the Three Kings in the Latin Vulgate Bible and several European languages, was used as the name for the *Compagnia dei Magi*, a brotherhood based in the monastery of San Marco whose members included the most influential

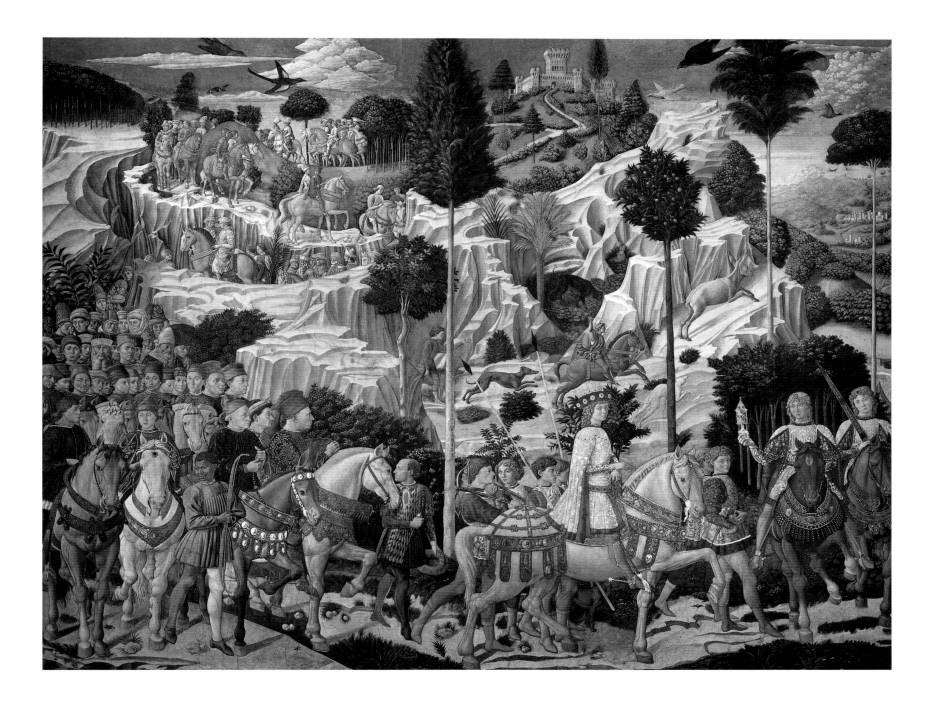

23 Benozzo Gozzoli
The Procession of King Caspar, part of the cycle of frescoes
on *The Procession of the Magi* in the Capella dei Magi,
ca. 1459
Fresco
Palazzo Medici-Riccardi, Florence

The *Procession of the Magi* was the work with which
Gozzoli was commissioned to decorate the chapel in
the Medici palace. The room was not merely a place for
private worship, but also served public and political
purposes, such as audiences. The pictorial decorations
reflected the splendor of the processions in honor of the
three oriental kings, which took place at that time in
Florence.

citizens of the city. Their activities were fundamentally
determined by the ruling Medicis and their supporters.
At irregular intervals, the feast day of the Three Kings
was marked with splendid processions, a magnificent
display which was also used by the rulers to present
themselves. There are accounts that Cosimo de' Medici
marched through the streets of Florence wearing the
robes of one of the Kings. The high degree of
identification of the ruling family with the Three Kings
is also confirmed by a letter of 1468 addressed to
Lorenzo the Magnificent, in which Florence is described
as the "Repubblica dei Magi". It is therefore not
particularly surprising that contemporary paintings of
the Three Kings and their magnificent retinues also
included the society of the time, such as Gozzoli's
frescoes showing the *Procession of the Magi* (ill. 23).

Botticelli's most famous *Adoration of the Magi* (ill. 24),
like Gozzoli's frescoes, contains some portraits of

important Florentines, and its artistic quality and
masterly composition mean that it forms one of the high
points of the artist's early work.

Old descriptions tell us that the painting was
originally in an opulent marble frame and decorated the
altar of a small mortuary chapel in the church of Santa
Maria Novella, donated by the Florentine businessman
Guaspare del Lama. Del Lama was a social climber who
had acquired considerable wealth by means of dubious
money dealings, and like the Medicis belonged to the
guild of moneychangers. In 1472 he took on an
important position in the brotherhood of St. Peter the
Martyr. A prerequisite for this office was the acquisition
of a tomb in the church of Santa Maria Novella. Before
he was finally buried there in 1481, he rapidly sank in
social standing. In 1476 his guild convicted him of
financial fraud and stopped one of his most important
sources of income. It is therefore assumed that the

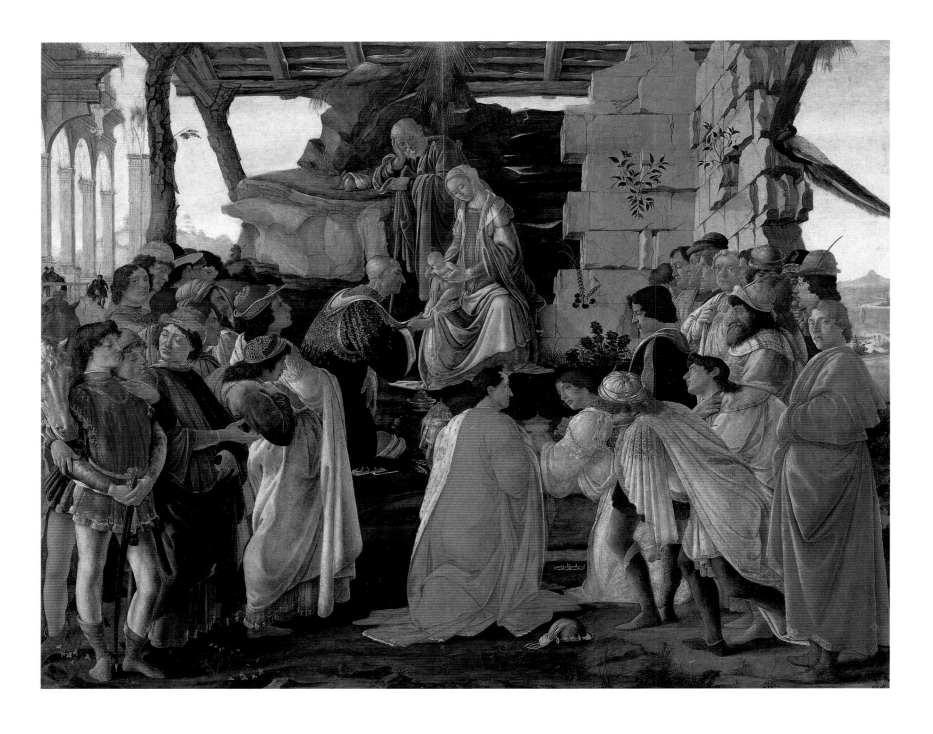

24 *Adoration of the Magi*, ca. 1475
Panel, 111 x 134 cm
Galleria degli Uffizi, Florence

The retinue of the three kings is spread out in two solemn groups on the steadily rising ground, and in the middle distance, raised above them, are the Holy Family and the kings kneeling before them. There is an unusual degree of magnificence in this painting, as a result of the depiction of valuable materials, partly gold, and fashionable headwear. The center king, dressed in a red, ermine lined cloak, emphasizes the central, colorful axis of the symmetrically composed group of figures.

decoration of his mortuary chapel, including Botticelli's altar painting, had been completed by this date. The choice of theme of the picture can be explained by the Christian name of the man who commissioned the work, as he was named after King Guaspare (Caspar), the youngest of the Three Kings.

The composition further develops the achievements of the *Adoration tondo* (ill. 19), but is concentrated on the central scene in front of the stable, so that the face of almost every figure can be made out. Vasari, who was still able to see the painting in its original location in the 16th century, wrote that the three Kings' heads were portraits of the Medicis, and by doing so provoked a debate about the identification of the individual figures that continues to this day.

A comparison with definitely identified portraits of the age, however, only succeeds in identifying the elder

king as Cosimo de' Medici and the middle king as his son Piero the Gouty. As both of them were already dead when the painting was produced, it is likely that the third king was also painted in remembrance of a dead member of the Medici family, possibly Giovanni, Cosimo's second son. All further attempts at identification of the numerous heads with portrait-like features remain mere speculation, though it is likely that further Medicis, still living, were portrayed, as well as the man who commissioned the work. Del Lama may well be present amongst the Kings' companions on the right, behind his patron saint, and is possibly the elderly gentleman wearing a blue robe who is gazing towards the observer. It is surely the case that del Lama's intention, in commissioning this altarpiece, was to take his place, as a loyal supporter of the Medicis, amongst the highest-ranking members of his society. It perhaps

even represents an attempt on his part to flatter Florence's ruling family, as his money dealings relied on their continuing goodwill.

It is extremely doubtful whether Botticelli, as has frequently been assumed, depicted himself on this panel painting. A common suggestion is that he is the man standing on the right edge, wearing a yellow garment, who is confidently gazing towards the observer. It is true that artists' self-portraits are not unknown in history paintings of this period; Gozzoli even went to far as to sign the hat worn by his singular portrait head (ill. 22) in the frescoes of the Medici Chapel (ill. 23), but in that instance he was standing in the back rows of the retinue. In contrast, there is no definite portrait of Botticelli in existence, and it is questionable whether, even given his status as a valued craftsman, he would have been allowed to appear in so prominent a position in such an illustrious circle.

Botticelli will also have gained considerable fame during these years as a painter of individual portraits, as otherwise del Lama would hardly have come to him with his request for an altarpiece in which the artist was to produce such a polished and varied display of partly standardized, but also partly individually characterized heads. With some exceptions (ill. 31), the remaining early portraits by Botticelli show their subjects in a three quarter view, a new ambitious form of portrait which did not become widespread in Florence until about 1470. At first, the Italian Early Renaissance was dominated by a strict profile portrait on a neutral background, in the tradition of medallion art. By the middle of the century, sculptured portrait busts had become positively fashionable in Florence. In the 15th century, a wealthy class of merchants and the rise of Humanism had made it possible for ordinary citizens to do what had so long been reserved for important noble or spiritual leaders; to express their desire for personal fame and individual remembrance by owning a portrait of themselves.

In Flanders, pioneering artists such as Jan van Eyck and Rogier van der Weyden had already been producing portraits in three quarter view during the first half of the century; at first these were painted on a neutral background, but the next generation of artists also painted them against the background of a room or landscape. It is possible that Botticelli was brought face to face with the new developments north of the Alps while still working in the workshop of his master, Filippo Lippi. Extensive trade links between Italy and Flanders had also worked to the advantage of the exchange of pieces of art and artistic ideas. But in the case of portrait paintings, these interactions can only be comprehended to a limited extent. For example, in a double portrait which is now in the New York Metropolitan Museum, even Lippi decided to link the customary Italian profile portrait with an interior and view through a window onto a landscape.

Botticelli's early portraits are characterized by a great joy in experimenting with the new forms of portrait painting. In the case of the proud *Young Man* (ill. 26) wearing a red jerkin and fashionable dark purple head-dress, the artist painted his half length portrait diagonally against a blue sky. His head is turned to one side, so that his face can be seen in a three quarter view. The fact that we see this young man slightly from below gives him a somewhat condescending air.

The portrait of the mysterious *Man with the Medal of Cosimo the Elder* (ill. 27) is another instance of Botticelli's good use of the greater opportunities for expression provided by the three quarter view. It is a half length portrait in front of an extensive light landscape with a river, and the man's head projects above the horizon. The light, which falls on the subject from the left, clearly shapes his striking features, and there are stronger shadows on the side of his face closer to the observer. This lends a sense of distance to his insistent gaze. The poor drawing of his hands makes the experimental nature of this portrait more than clear. It is one of the earliest Italian portraits to make the hands a part of the portrait's theme. The commemorative medal of Cosimo, who died in 1464, dates from about 1465–1470 and has given rise to an entire series of suggestions concerning the identity of the man depicted. So far it has not been possible to give a definitive answer to the question whether this is a close relative or supporter of the Medicis, or perhaps the man who created the medal.

His *Portrait of a Lady* (ill. 28) is also characterized by a vivid play of light and shadow; this is the work in which Botticelli took up his master's attempts to produce portraits in an interior space. While it is artfully constructed around the half length figure, the section of the room nonetheless appears to be curiously restricted.

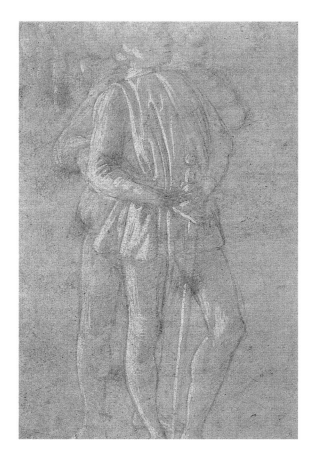

25 Botticelli or Filippino Lippi
Study of two standing figures, ca. 1475
Metal point on primed paper, white highlights,
16.5 x 10 cm
Musée des Beaux Arts, Cabinet des dessins (Inv. no. pl. 77), Lille

This study is one of the few remaining drawings directly related to a painting by Botticelli. The artist, who to judge by the style may have been Botticelli's student Filippino Lippi, was testing the posture and stance of the two young men who can be seen at the front left in the *Adoration of the Magi* (ill. 24). There are differences in the head and hand positions of the figure at the rear, so that it is likely that this work was produced as part of the preparations for that group of figures.

 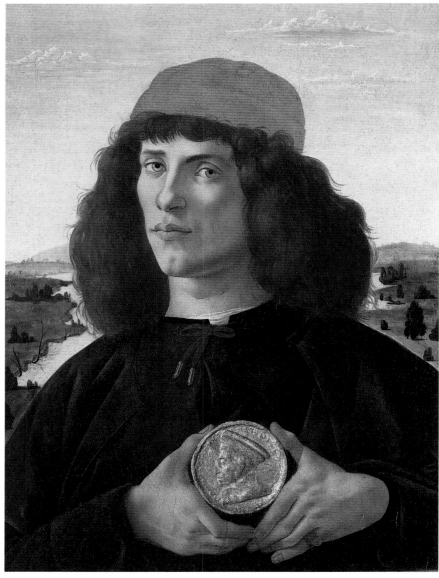

26 (above left) *Portrait of a Young Man*, ca. 1470–1473
Panel, 51 x 33.7 cm
Palazzo Pitti, Galleria Palatina, Florence

Botticelli painted this portrait in a three quarter view like a silhouette against a pale blue sky. The young man, who is looking very slightly down towards the observer, is wearing a red jerkin and the characteristic headgear of the Florentine Quattrocento, the mazzocchio. The hat band which is casually draped across his shoulder provides an artistic frame for the young man's face.

27 (above right) *Portrait of a Man with the Medal of Cosimo the Elder*, ca. 1474–1475
Panel, 57.5 x 44 cm
Galleria degli Uffizi, Florence

The picture of this unidentified young man is one of the most unusual portraits of the Early Renaissance. The man is gazing at the observer and holding up a medal bearing the profile of the head of Cosimo de' Medici, who died in 1464. Botticelli set the medal into the painting as a gilded plaster cast.

The woman is touching the window frame with her right hand, and it appears that she has just stepped to the open window in order to be seen by the observer. This gives the portrait an air of great immediacy. The lady's appearance is also one of restrained elegance. Over her costly dark red dress she is wearing a white, see-through outer garment which changes the strong color into a discreet salmon pink. Like the delicately modelled carnations, it agrees harmoniously with the shades of brown and gray which dominate her surroundings.

The portrait of Giuliano de' Medici (1453–1478; ills. 29, 30), the younger brother of Lorenzo the Magnificent, is turned to the right and there are no less than three known versions of it. Their significance continues to be a subject for debate just as much as the question whether Botticelli carried out the paintings entirely on his own. The origins of the paintings can only be traced back as far as the 19th century; there is,

however, a source in the early 16th century which mentions a portrait of Giuliano by Botticelli, and the depicted man has been definitely identified thanks to contemporary portrait busts and medallions (ill. 33). Giuliano had been killed on 26 April 1478, while mass was being celebrated in Florence Cathedral, during the course of an attack made by the Pazzi family, who were the Medicis' rivals for power and banking business. This is why researchers used to assume that the oddly lowered gaze, most unusual in portrait painting, was the result of the work being based on a death mask of Giuliano.

When the slightly different version of the portrait (ill. 29), now in the National Gallery of Art in Washington, came to light in 1942, it raised a new aspect for discussion, as it shows Giuliano standing behind a window, to the left of which a turtle dove is sitting on a dried out, leafless twig. According to ancient tradition, the dove does not take a new mate when its old mate

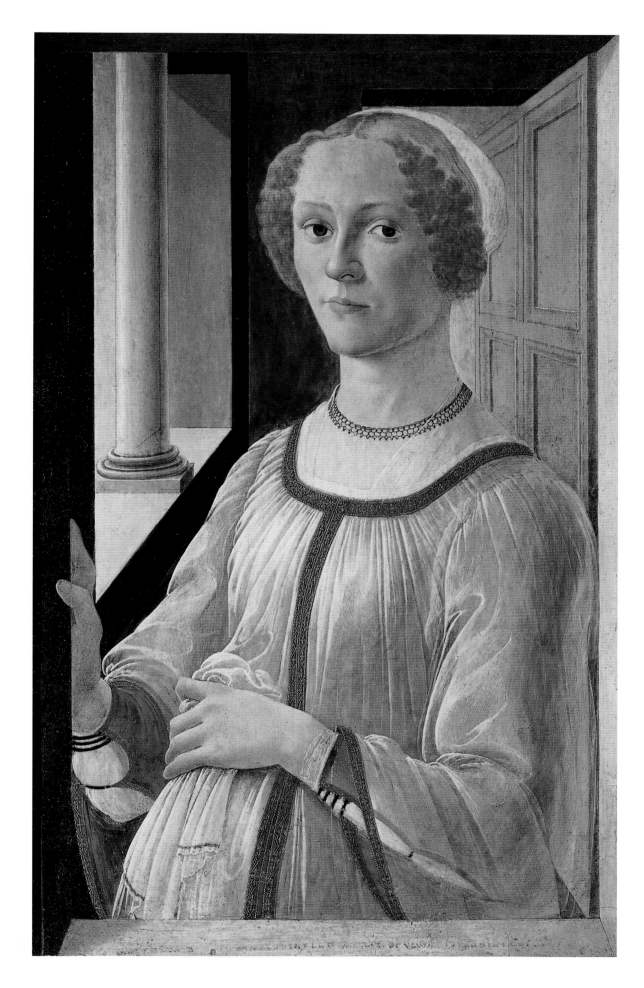

28 *Portrait of a Lady* (Smeralda Brandini?),
ca. 1470–1475
Panel, 65.7 x 41 cm
Victoria and Albert Museum, London

If the inscription on the window jamb, possibly dating
from the 16th century, is to be believed, this is a portrait
of Smeralda Brandini, who was a member of a respected
Florentine family. A sign of her rank and respectable
status is the handkerchief which she is holding in the
hand placed across her body.

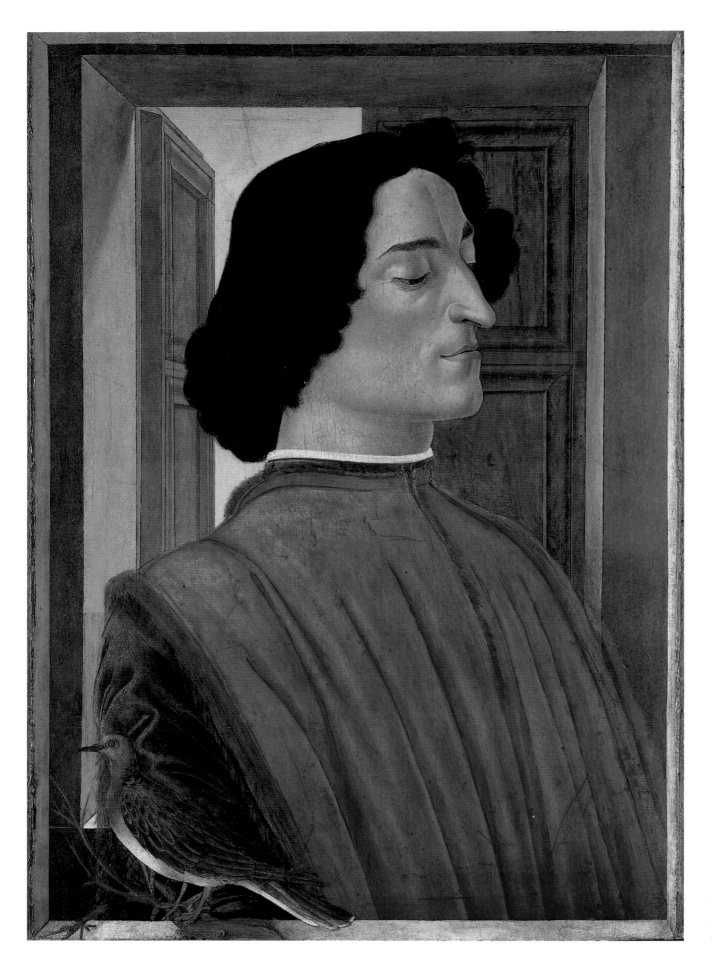

29 *Portrait of Giuliano de' Medici*,
ca.1476–1477
Panel, 75.6 x 52.6 cm
National Gallery of Art, Washington D. C.

Botticelli placed this portrait in a most skilful
relationship with the framing forms. In the
background, one window shutter is open,
allowing us to see the blue sky, and the other is
behind the subject's bowed head. The dove by
the window jamb is a symbol of loyalty, and for
this reason it is thought that Giuliano
commissioned this portrait following the death
of his courtly love, Simonetta.

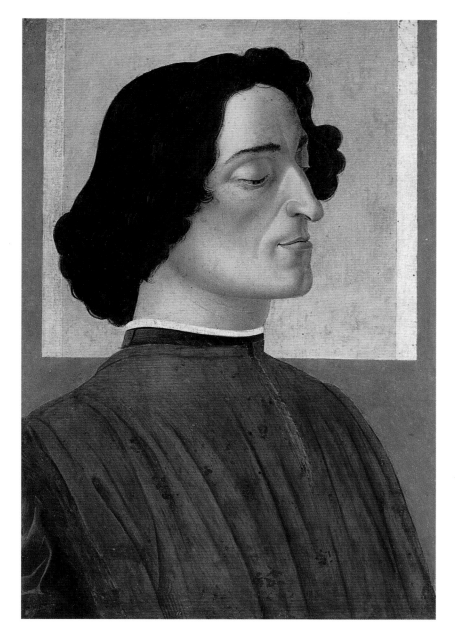

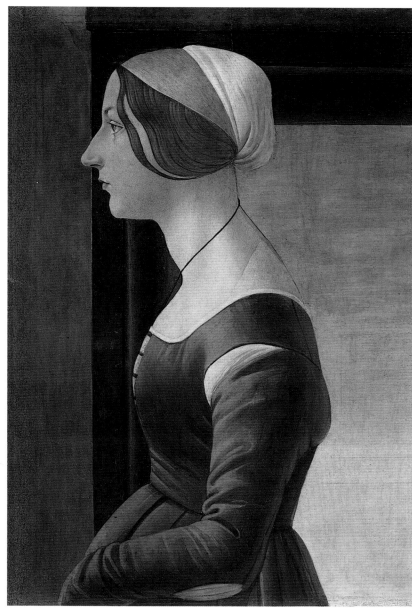

30 (above left) *Portrait of Giuliano de' Medici*, ca. 1478
Panel, 54 x 36 cm
Accademia Carrara, Bergamo

Three similar portraits of Giuliano still exist. In contrast to the version in Washington (ill. 29), the portraits that are now in Bergamo and Berlin were probably not created until after Giuliano's assassination during the Pazzi conspiracy in 1478, when copies would have been ordered by friends and relatives as commemorative portraits.

31 (above right) *Portrait of a Woman*, ca. 1475
Panel, 61 x 40 cm
Palazzo Pitti, Galleria Palatina, Florence

The lock of hair coming loose from her bun gives a more spontaneous feeling to this severe profile portrait. The half length figure is slightly to the left of the center of the picture. Behind her is a dark window frame and it contrasts with the gentle flow of her contours. The attribution of the work to Botticelli is disputed.

dies, and prefers to spend its time mourning on leafless branches. As a result, it was a symbol of eternal loyalty to Botticelli's contemporaries. In 1476, Giuliano's knightly love Simonetta, on whose behalf he had taken the field in 1475 during a great tournament on the square in front of the church of Santa Croce, had died of consumption. As a result, Giuliano may well, as Ronald Lightbown has recently suggested, have commissioned the portrait himself in memory of his eternal mourning for Simonetta. The two other portraits of Giuliano, which are stylistically somewhat weaker, would therefore have been produced following this model, probably with the aid of workshop assistants, and may well have been ordered as posthumous commemorative portraits after Giuliano was assassinated.

The tournament was held in 1475 to celebrate a

defence alliance negotiated by Lorenzo de' Medici between Florence, Milan and Venice. Eye witnesses commented on the magnificent display with which the city was covering itself in glory. Giuliano eventually emerged as victor from the tournament field, which he had entered with a lavishly decorated retinue. His silver helmet was made in Verrocchio's workshop. The standard carried in front of him, which allegorically expressed his loving respect for Simonetta, who was married to a Vespucci, was painted by Botticelli. It was later mounted onto wood in memory of Giuliano's victory and used to decorate a room in the Palazzo Medici, but is now known only by description. This is the first mythological work which Botticelli can be proven to have produced, and at the same time it is his first known commission for a member of the Medici family.

32 (below left) Bertoldo di Giovanni
Medal Commemorating the Pazzi Conspiracy, front: *head of Lorenzo de' Medici*, ca. 1478
Bronze, ø 64 mm
Museo Nazionale del Bargello, Florence

On 26 April 1478, an assassination was carried out in Florence's cathedral with the tacit agreement of the Pope. During mass, members of the Pazzi family and their close friends attacked the two Medici brothers. Guiliano was stabbed to death, and Lorenzo was forced to flee into the sacristy. The rebellion failed and the plotters, including an archbishop, were hanged. There followed a two-year war with the Pope, but Lorenzo eventually brought it to an end using his political skills.

33 (below right) Bertoldo di Giovanni
Medal Commemorating the Pazzi Conspiracy, rear: *head of Giuliano de' Medici*, ca. 1478
Bronze, Ø 64 mm
Museo Nazionale del Bargello, Florence

On both sides of the medal, each of the portrait heads is depicted in a monumental size above the octagonal choir in which mass is being celebrated. Outside, one can see Giuliano's assassination and Lorenzo's battle against his attackers. In both cases, the proven sites of the attack – in one case the north, and in the other case the south side of the choir – are precisely depicted.

In the 15th century, Florence was an important European trade and cultural center, and its activities were significantly shaped by the Medici family.

Cosimo de' Medici (1389–1464), later known as Cosimo the Elder, inherited a flourishing banking business from his father, and by expanding it he became one of the wealthiest men of his age. As a banker, he cultivated good relations with the European ruling houses and the Papal court. In 1434 he was made gonfalonier of Florence and, during his thirty year period in office, was able to secure his family's leading position conclusively. Though the city state of Florence was still a republic in name, power was concentrated in the hands of a few families. Cosimo was able to place people he trusted in important public positions. At the same time, marriages created a network of mutually dependent families that was to serve to keep the Medicis in power until 1494.

Cosimo's son Piero (1416–1469), known as Piero the Gouty due to his ill health, died just five years after his father, and as a result his son Lorenzo (1449–1492), who was just twenty years old, became the political leader of the city in 1469. Lorenzo's period as ruler was characterized by political crises and the continual decline of the family banking business. At the beginning of the 1470s, the Roman branch of the bank lost the Pope, its most important customer, to the rival Pazzi family bank, and the latter also competed for power with Lorenzo in Florence (ills. 32, 33).

Nonetheless, Lorenzo's rule is considered to be the brilliant pinnacle of the Medici period. He followed in the tradition of his father and grandfather by being famous as a generous sponsor of the arts and sciences. In contrast to his predecessors, though, he personally commissioned few major works. Rather, he combined the virtues of statesman, scholar and poet to create a cultural climate in which the upper strata of Florentine society in general were inspired to become patrons. The result was a cultural flowering that even contemporaries were to term a Golden Age. Lorenzo was a great lover of luxury and staged public displays of magnificence in which the city was able to play a major part with glittering festivities; this earned him the nickname "the Magnificent".

Lorenzo's personal interests focused on poetry and humanist studies. He left quite an extensive body of work comprising religious poetry and poems of pleasantry and love. He frequently took part in meetings of a circle of scholars (ill. 35) that was brought into being by his grandfather, to which some of the most important Italian humanists of the age belonged. The doctor and philosopher Marsilio Ficino (1433–1499) was Lorenzo's teacher. In 1463 he was commissioned by Cosimo to translate Plato's entire works into Latin, an enormous undertaking that was completed by about 1477. He received a villa in Careggi which became the center for the scholars' circle. His student Giovanni Pico della Mirandola (1463–1494) also knew

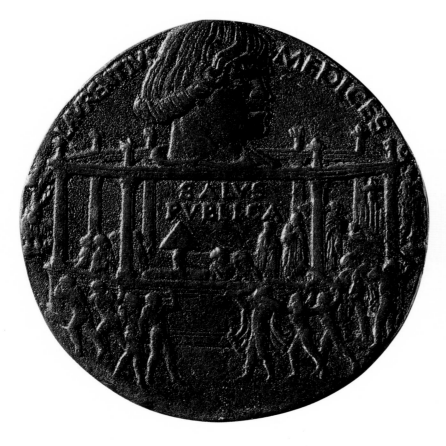

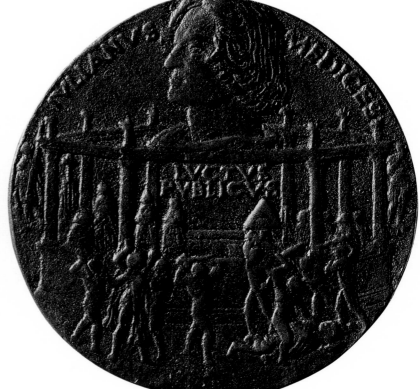

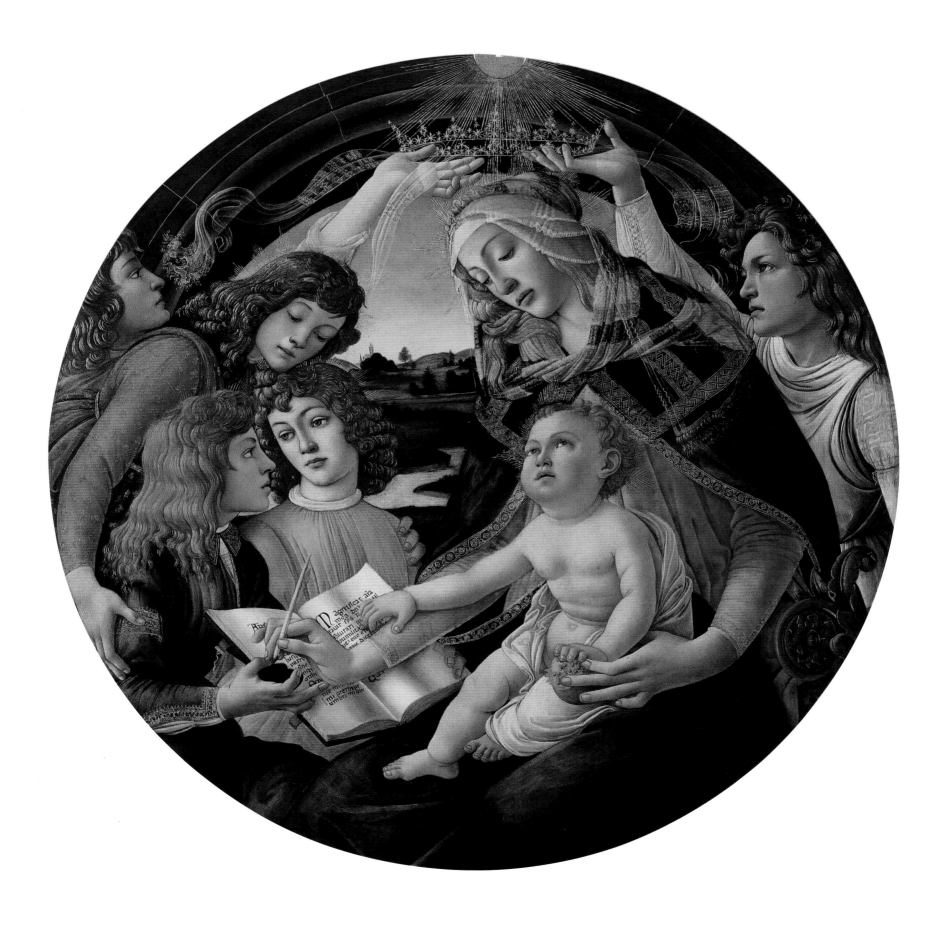

40 *Madonna of the Magnificat (Madone del Magnificat)*,
ca. 1480–1481
Panel, ø 118 cm
Galleria degli Uffizi, Florence

Christ appears to be Mary's inspiration as she writes
down the last lines of the Magnificat, her hymn in praise

of the Lord, which according to St. Luke's Gospel she already sang
during her meeting with Elizabeth. Two of the wingless angels are
crowning the Queen of Heaven. The crown she is wearing is a
delicate piece of goldsmith's work consisting of innumerable stars;
they are an allusion to the *stella matutina* (morning star), one of
the Mother of God's names in contemporary hymns devoted to
Mary.

THE PAINTER OF FRESCOES

41 *St. Augustine* (detail ill. 43), 1480

By using the Italian 24 hour clock, Botticelli was giving an important hint as to the picture's interpretation. Unlike our present clocks, it shows the hour before sunset, the time at which St. Jerome, who is depicted on the fresco's counterpart, died in a monastery in Bethlehem.

42 (following double page, left) Domenico Ghirlandaio *St. Jerome*, 1480
Fresco, 184 x 119 cm
Ognissanti, Florence

Ghirlandaio painted the counterpart to Botticelli's fresco of St. Augustine, and it is dated on the desk. Behind the shadow of the scissors and ruler, the date 1480 can be made out. St. Jerome is leaning his head on his hand and is looking up thoughtfully from his writing.

43 (following double page, right) *St. Augustine*, 1480
Fresco, 185 x 123 cm
Ognissanti, Florence

St. Augustine has been interrupted at his studies. He is deeply moved as he raises his eyes and, in an expansive gesture, lays his right hand to his chest: for he is seeing a vision of the death of St. Jerome. On the desk in his study is an armillary sphere, an astronomical device used to fix the positions of heavenly bodies. To the right, next to him, is a bishop's miter which is lavishly studded with pearls, a reference to the saint's office as a bishop of Hippo in Africa.

When the Duke of Milan, Lodovico il Moro, decided in about 1490 to decorate the Carthusian monastery of Pavia with frescoes, he consulted his Florentine agent for artistic advice. The latter told him about the four most famous painters working in Florence. He mentioned Botticelli, together with his student Filippino Lippi (1457–1504), Pietro Perugino (1445/48–1523), originally from Umbria, and Domenico Ghirlandaio (1449–1494), and in his judgment said it was open to question which of these carried off the palm. In his letter, he described Botticelli as follows: "an outstanding painter, both on panels and walls. He carries out his works with excellent judgment and well-judged proportions." This source confirms how famous an artist he was even beyond Tuscany, not only as a painter of panels but also of frescoes. Even if only one work dating from the 1470s (ill. 44) and four important frescoes commissioned in the first half of the 1480s now remain, we do know from documents, telling of paintings that have since been destroyed, that Botticelli was greatly in demand as a master of fresco paintings during the last three decades of the Quattrocento.

He would have learned the basic techniques associated with fresco painting while working for his teacher, Filippo Lippi. He is first mentioned working independently as a fresco painter in 1474, when he was called to Pisa in order to participate in the painting of the monumental funerary architecture of the Camposanto. For some unknown reason, Botticelli neither finished his trial piece depicting the *Assumption of the Virgin* in Pisa Cathedral, nor did he start work in the Camposanto. In Florence in 1478, he received what was probably the most important public commission the city government was in a position to award. Immediately after the revolt of the Pazzis against the Medicis had been put down, Botticelli was given the macabre task of painting the façade of the Florentine court buildings with pictures disgracing both those conspirators already hanged and those still on the run (cf. ill. 45). The pictures remained there until 1494, when they were destroyed once the Medici family lost power during the political crisis of the 1490s and fled Florence.

Botticelli worked for the Vespucci family up to the end of the 1490s, and it was for them, in 1480, that he painted *St. Augustine* (ill. 43) in the Ognissanti church; as early biographers of Botticelli unanimously agree, it was created in competition with Ghirlandaio's fresco of *St. Jerome* (ill. 42). Both paintings are based on a single concept. They were painted on either side of one of the doors leading into the monks' choir. For that reason, it is assumed that they were painted for the order of Humiliati, the monks attached to the Ognissanti church. It is probable that Botticelli's picture was a separate gift from the Vespucci family, as their coat of arms is emblazoned on the stone cornice above St. Augustine, but is not present in Ghirlandaio's painting of St. Jerome. Both frescoes were later taken down during the course of renovations, and now hang opposite each other in the nave of the church.

The theme of the studying saint was widespread in the humanist culture of the Renaissance. It was also particularly important for the Humiliati, as they lived according to the Rule of St. Benedict and had a duty to study. St. Jerome (ca. 427–520), who translated the Bible into Latin, and St. Augustine (354–430), one of the most influential Doctors of the Church, were Fathers of the Church meant to serve as models for the monks.

In both frescoes the attention the saints are paying to their studies is obvious. They are sitting writing at their desks, surrounded by books and scientific instruments. Both artists have arranged the scholars' chambers so that the corners of the rooms are motifs formally related to each other, and the saints are placed within the space in such a way that, in their original location, they would have been facing each other. In Ghirlandaio's fresco, which was probably based on a Flemish composition by a student of Jan van Eyck (the painting is now in the Institute of Arts, Detroit), the scholar is characterized by a contemplative concentration.

Botticelli's fresco, in contrast, is founded on a dramatic concept. St. Augustine is emphatically sitting upright and is agitatedly moving his right hand in front of his chest. It is unmistakable that he has just been busy writing, for his left hand is clutching the inkwell in which he has replaced his quill. St. Augustine's studies have been interrupted by a divine visitation, as is indicated by the light falling onto the scene from the top

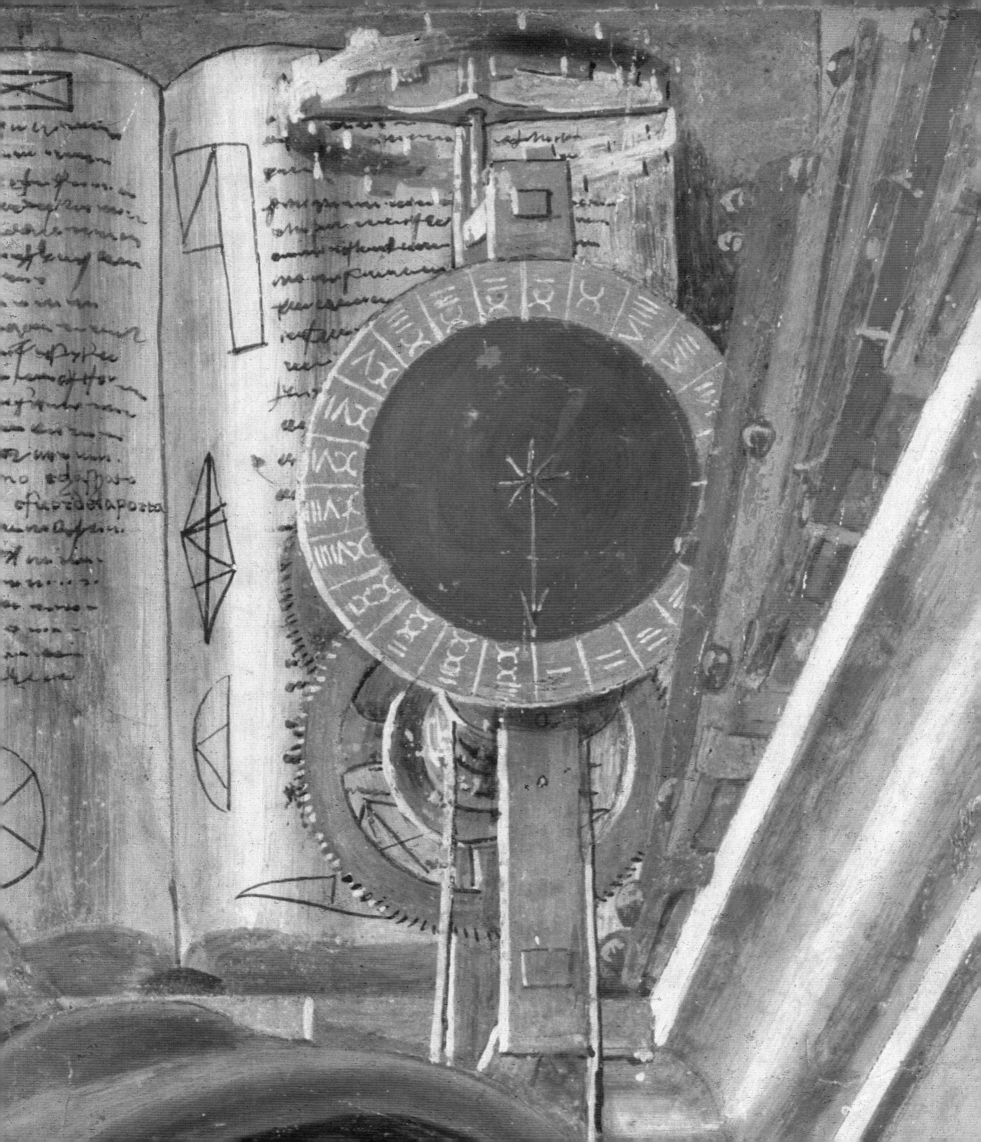

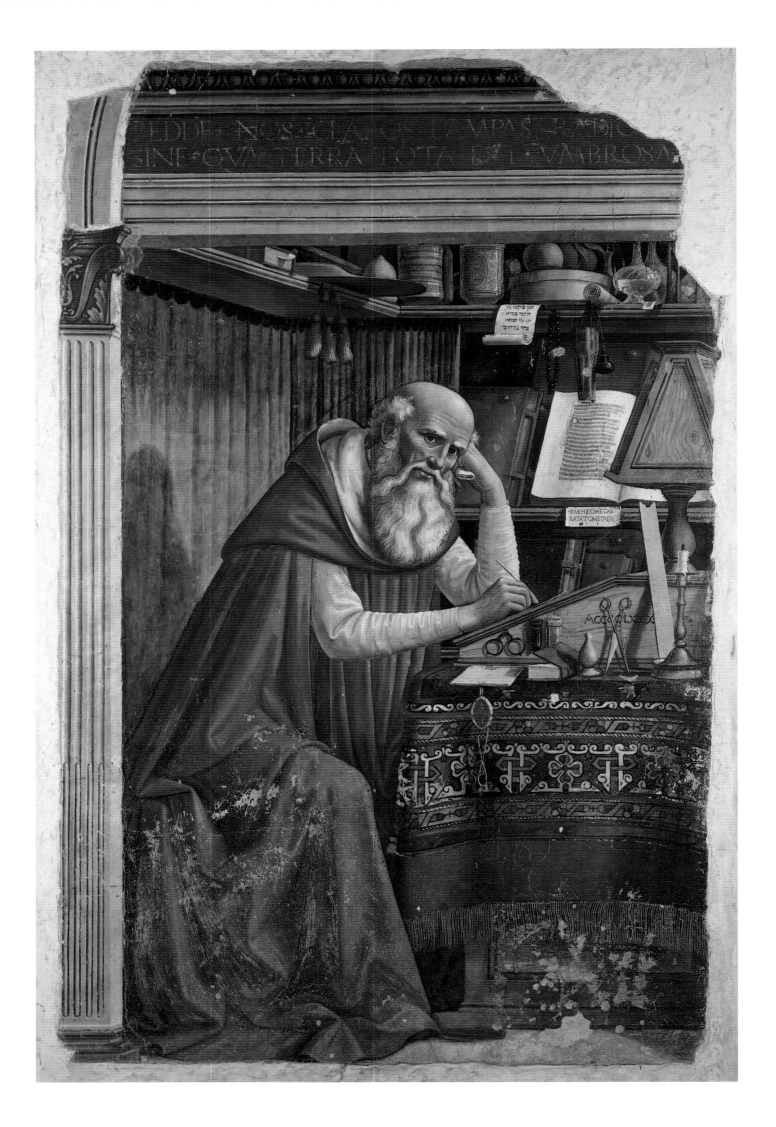

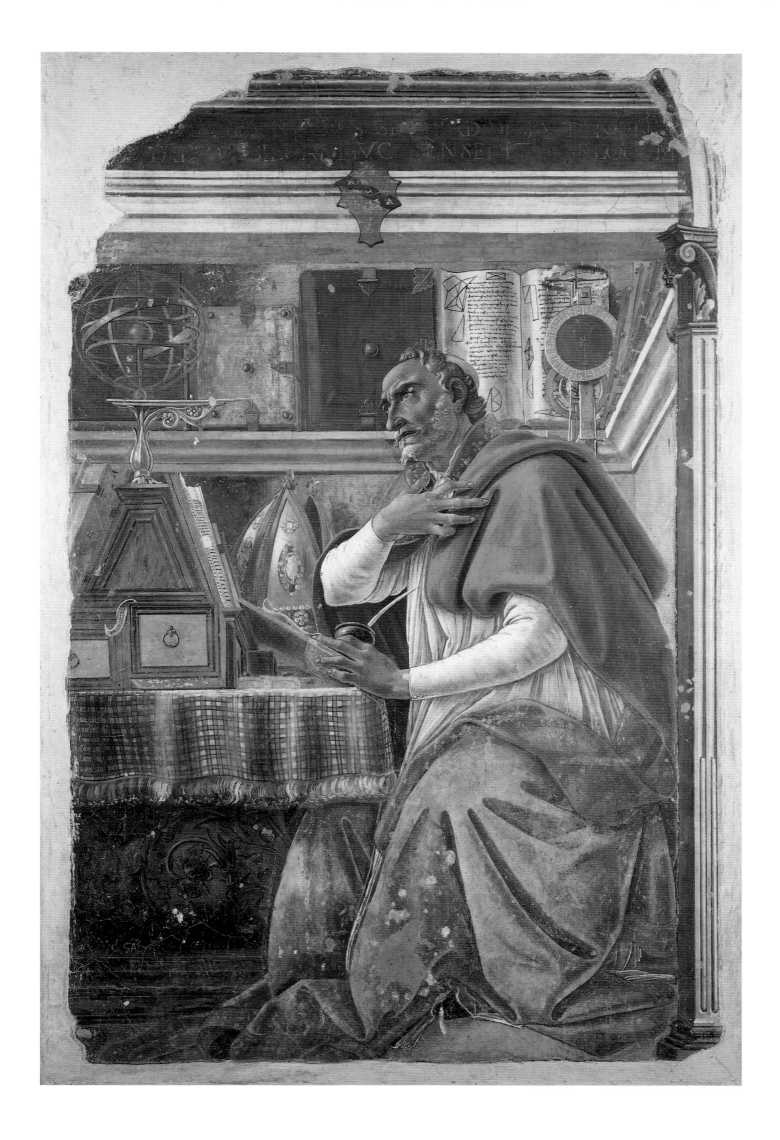

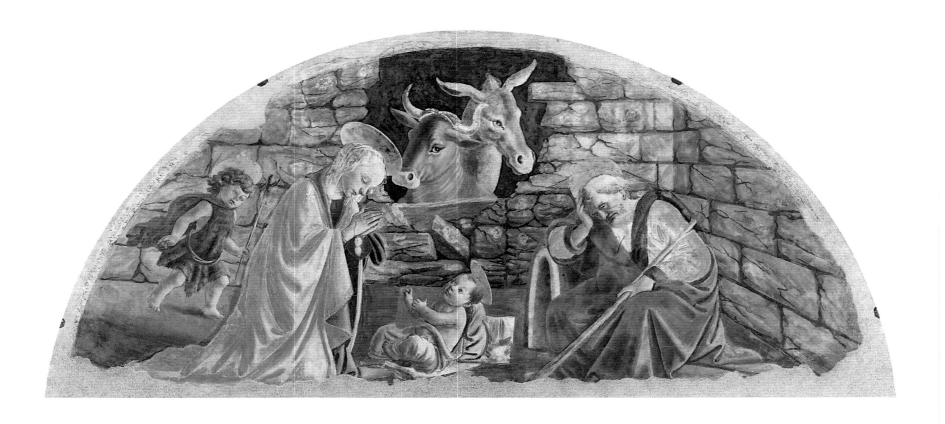

44 *The Birth of Christ*, ca. 1476–1477
Fresco, ca. 200 x 300 cm
Santa Maria Novella, Florence

Bedded on a cloth, the child is sleeping on a hewn stone, surrounded by the adoring Mary and Joseph, who is leaning wearily against his saddle. Behind them, the ox and ass are looking through a hole in the ruined stable wall. The small John the Baptist, who is hurrying up impetuously, is an exceptionally rare figure in this peaceful pictorial theme. The composition of the picture, as an arch, suggests that this fresco was once in one of the lunettes in the church.

left towards which the saint has lifted up his eyes. Botticelli's subject matter was indeed a vision of St. Augustine, which at the time formed part of a well-known legend. According to this, St. Augustine was in the process of writing a letter to St. Jerome as the latter lay dying in Bethlehem. He died shortly before sunset and then, accompanied by sweet airs and an indescribable light, appeared to St. Augustine in his cell. Botticelli has precisely recorded the time of the event on the clock behind St. Augustine.

Next to the clock, some lines can be made out on the open manuscript which reveal the artist's humorous commentary. On it, Botticelli wrote down a conversation between two monks that he had probably overheard while working on the painting: "Where is Brother Martin?" – "He has just left." – "And where has he gone?" – "He left the city via the Porta al Prato." The artist appears to have found the monks amusing, for instead of following the example of these scholarly saints, they were pursuing their own pleasures.

Vasari's comments on the fresco of St. Augustine show how greatly he admired it, and he mentions that the artist received a good deal of praise for the work. One year later he had another opportunity to demonstrate his abilities as a painter of frescoes, with a quite enormous wall painting showing the *Annunciation* (ill. 46) produced for the church of San Martino della Scala. The fresco was originally located in a loggia above the entrance door to the hospital that belonged to the

church of San Martino. The refinement of the colors and impressive composition of the pictorial space are still captivating features, despite the considerable damage that the work suffered in the 17th century. In 1920 it was finally taken down and moved to the Uffizi in Florence. It is not known who commissioned the work, but we do know from the records of payment of a Florentine bank that the painting was produced starting in April 1481, and probably finished within the space of a mere two months.

Botticelli has divided the picture surface symmetrically and arranged the angel of the Annunciation and the Virgin in two separate areas. While there is an unusually large distance between the two figures, they are nonetheless playing their parts on a clearly defined stage in the foreground, for the two sections are connected by the doorway behind the central pilaster. While we see Mary in her bedchamber, on the left we can look out over a garden and onto a broad, hilly landscape. The artist made considerable efforts to make sure that the perspective of the two halves of the picture matched. The main parallel lines of the tiled floors converge on the angel's face, and his dynamic appearance is effectively underlined by the perspective construction.

Botticelli gained considerable recognition as a painter of frescoes during these years, and it culminated in his being called to Rome; this was the only occasion when the artist spent a long period outside Tuscany. In the

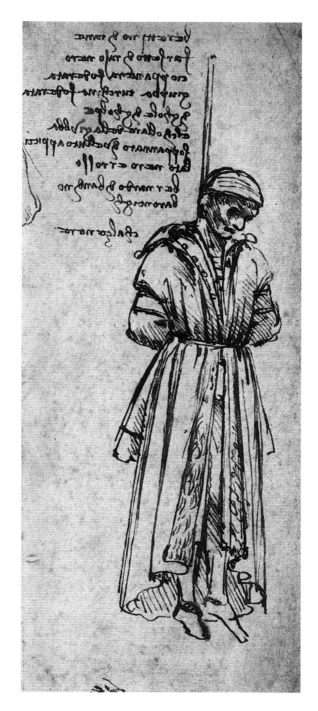

45 Leonardo da Vinci
The Hanged Medici Murderer, Bernardo di Bandini Baroncelli
(detail), ca. 1479
Drawing, 19.2 x 7.8 cm
Musée Bonnat, Bayonne

Botticelli painted the murderer of Giuliano de' Medici, who was
hanged in 1479, on the façade of the Bargello in a fresco which has
since been destroyed. Leonardo's drawing gives us an idea how
horrible the picture would have been – and shows that he obviously
also attempted to gain the commission. The notes dispassionately
give the name of the hanged man, with details of the color of his
clothing.

summer of 1481, together with his Florentine artistic
colleagues Domenico Ghirlandaio, Cosimo Rosselli and
Pietro Perugino, he was commissioned by Pope Sixtus
IV to decorate his *cappella magna*, which had just been
finished, with frescoes.

This building, which was begun between 1475 and
1477, and which was later renamed the Sistine Chapel
after the man who commissioned it, was not intended
to be a place for the Pope to meditate in private, but a
hall suitable for official functions on church feast days
as well as important ceremonies and receptions. In
addition, it was conceived as an assembly room for the
Conclave, the meeting of cardinals that assembles after
the death of the Pope in order to elect a new head of the
Church. It was important that the fresco decorations in
the chapel should reflect these requirements, and the
Pope and his advisors devised a complex theological and
political pictorial program for it: there was a large-scale
legitimation of the Pontificate, celebrating the successor
of St. Peter in the tradition of Moses and Christ, who
had founded the Old and New Covenants.

It was decided that the pictorial cycle should consist
of scenes from the lives of Moses and Christ, extending
right around the middle wall register of the chapel. Seen
from the altar, the Old Testament episodes are on the
right, and the New Testament episodes on the left side.
As individual events from the life of Moses are
interpreted as models of the life of Christ, the frescoes
placed opposite each other always matched in this
typological sense. Originally there were 16 separate
picture fields, but now only the twelve frescoes on the
side walls remain – those on the wall behind the altar
had to make way for Michelangelo's *Last Judgment* in the
1530s. The wall register underneath the scenes is
decorated with painted curtains on which the family
coat of arms of Sixtus IV is emblazoned. The upper wall
register, next to the chapel windows, is filled with over
life-size imaginary portraits of the first Popes (ill. 47).
The design and even the execution of some of them can
be traced back to Botticelli, but it is very difficult to
judge the works due to over-painting at a later date.

There is a remarkably uniform appearance to the main
frescoes. The colors and basic arrangement of the
compositions varies little. The landscapes and spaces
where the events unfold all have a clear center and rise
at the sides, so that the overall impression is of a regular
rhythm of graduated scenes connecting the individual
pictures with each other. Closer observation makes clear
the extent to which the artists were also tied to a
common concept in the formal way they structured
their works. There is, though, nothing to lead us to
believe Vasari's assertion that Botticelli was put in charge
of the entire work on the frescoes by the Pope. While
the artist was able to paint three important pictures in
the cycle, those contemporary documents that are

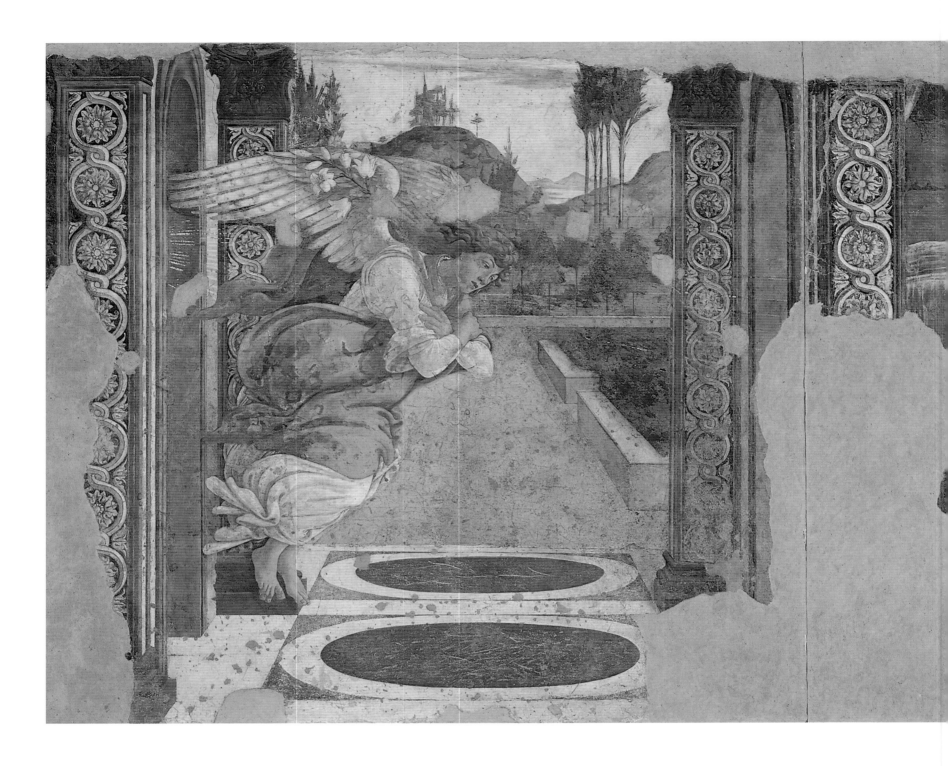

46 *Annunciation of San Martino della Scala*, 1481
Fresco, 243 x 550 cm
Galleria degli Uffizi, Florence

Gabriel is soaring, accompanied by golden rays of light, into Mary's chamber. A gust of air is tugging at his hair and the lily which he is carrying. The Virgin has already noticed him, for she has stopped reading and is bowing to him. While Botticelli keeps to tradition by depicting Mary as being humble, he gives the angel a new power of movement. He depicts him while he is still flying.

known to us do not show that he was treated in any preferential manner.

Like all the other artists taking part, Botticelli first had to carry out a trial fresco, before being allowed to paint two further picture fields during a later phase in the work. This first fresco was the *Temptation of Christ* (ill. 48), and its title, like all the other pictures, is given by a Latin inscription on the cornice above the painting. The three Temptations of Christ by the Devil take place in the background. Meanwhile, in the foreground of the picture, an Old Testament sacrificial ceremony is taking place in front of the central temple building. The content of this composition is at first puzzling. It can however be explained, as Ronald Lightbown has done most recently, in the typological conception of the picture. According to this, the bowl of blood that the priests are consecrating is a prophecy of Christ's death on the Cross, which is reflected in the celebration of Holy Communion with the symbolic gifts of bread and wine. Christ, who is depicted a fourth time in the middle distance on the left and surrounded by a circle of angels, appears to be explaining the significance of the scene to his companions.

In addition to the Biblical figures, Botticelli also included a series of contemporary clothed figures in his sacrifice scene. Their individual features suggests that these are portraits, but so far it has not been possible to identify any one of them with certainty. It is likely, however, that these are public figures from the family and circle of Sixtus IV. For example, one of the youths

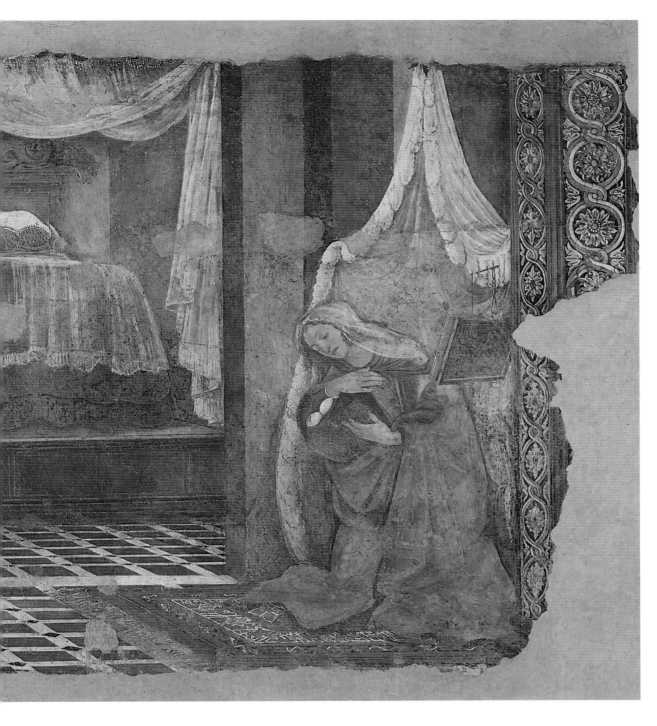

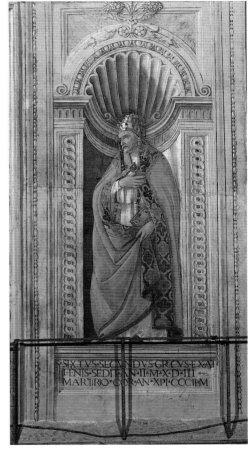

sitting on the marble bench on the left is wearing a cloak decorated with oak leaves. This is the central heraldic symbol on the coat of arms of the della Rovere family, of which Sixtus IV was a member.

The *Scenes from the Life of Moses* (ill. 50), the fresco opposite the *Temptation of Christ*, was also painted by Botticelli. The two pictures are typologically related in that both of them deal with the theme of temptation. Botticelli integrated seven episodes from the life of the young Moses into the landscape with considerable skill, by opening up the surface of the picture with four diagonal rows of figures.

Botticelli's second contribution to the Moses cycle was one of the key pictures to the entire program of frescoes, the *Punishment of Korah* (ill. 53). It relates three

acts of disobedience of the Hebrews to God's law as represented by Moses and his brother Aaron, and on the left is the punishment of the rebellious Sons of Levi. In common with the other pictures in the Moses cycle, the scenes, which Botticelli has arranged in three groups, should be read from right to left. Moses is now depicted as a bearded old man, and only his yellow robe and green cloak ensure continuity with the previous frescoes.

Each of the three episodes has architectural elements behind it, and a massive triumphal arch focuses attention on the altar scene in the center. Here Aaron, swinging a golden censer with dignity, is maintaining his authority against his sons and the Sons of Levi who are aspiring to his office of priesthood. In front of them, Moses is calling for God's judgment and punishment

47 *St. Sixtus II*, 1481
Fresco, 210 x 80 cm
Sistine Chapel, Rome

In the register above the history paintings, there were originally 28 portraits of popes decorating Sixtus IV's *cappella magna*. They are imaginary portraits, some of which are derived from Botticelli's designs. As can be seen in the figure of Sixtus II, a namesake of the pope who commissioned the work, they were full length figures placed in niches and painted, so as to be seen from far below, high up on the walls of the room. The emphatic gestures that St. Sixtus is making remind us of the figure of *St. Augustine* (ill. 43).

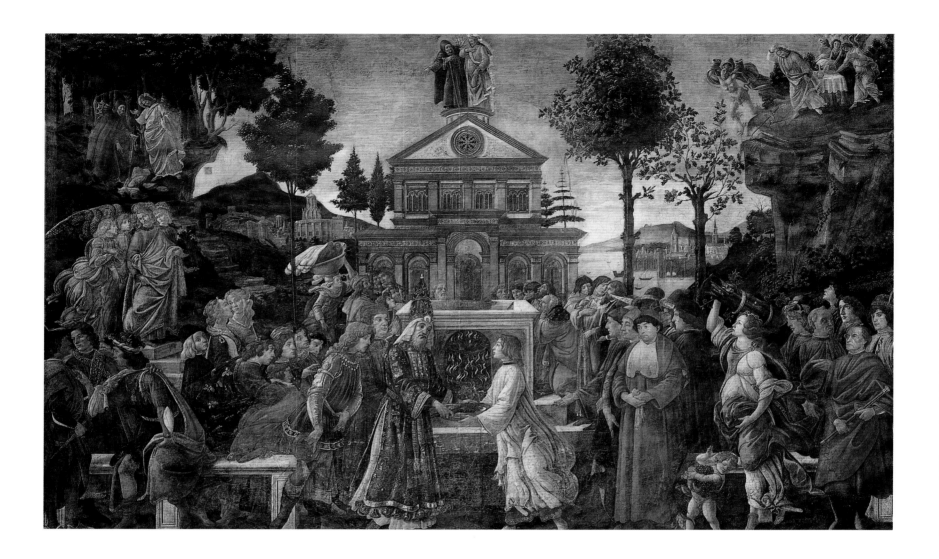

48 *The Temptation of Christ*, 1481–1482
Fresco, 345 x 555 cm
Sistine Chapel, Rome

In the foreground an Old Testament sacrificial scene is taking place; behind it, in the top third of the picture, Botticelli depicts Christ being tempted on three occasions by the Devil, who is disguised in a monk's habit. After forty days of fasting, Christ is being challenged by him to turn stones into bread, and in the center he is being told to throw himself from the towers of the temple so that his angels can catch him. Finally, the Devil shows Christ all the riches of the world, which he will deliver up to him if he will worship him. Afterwards, Satan is unmasked.

which will smite his brother's sacrificing competitors to the ground.

The inscription on the triumphal arch leaves us in no doubt as to the intentions of the program which this fresco formulates for the entire cycle: "Let no man claim an honor if he has not, like Aaron, been called by God." As Aaron was the first high priest and, in consequence, the predecessor of the Popes – the papal tiara on Aaron's head is an allusion to this – this is a sentence which must be clearly taken as a warning to all those who might have considered rebelling against God's representatives, which in the age of the New Covenant were the Popes. Typically enough, the counterpart in the Christ cycle, painted by Perugino, depicts the Delivery of the Keys to St. Peter. It shows the story of the foundation of the

Roman pontificate, according to which Christ made St. Peter and his successors the leaders of the Church.

During his period in office, Sixtus IV was very much concerned with strengthening the papacy. Papal sovereignty was brought into question repeatedly after the end of the Great Schism (1378–1417). One group favored a general council made up of the holders of high ecclesiastical offices, which should have greater powers than the Pope. The pictorial program of the *capella magna*, which was officially consecrated on 15 August 1483, vehemently expresses the Pope's claim to supremacy.

It is assumed that Botticelli, Ghirlandaio and Perugino returned to Florence before the entire fresco cycle was completed in May 1482, for Luca Signorelli,

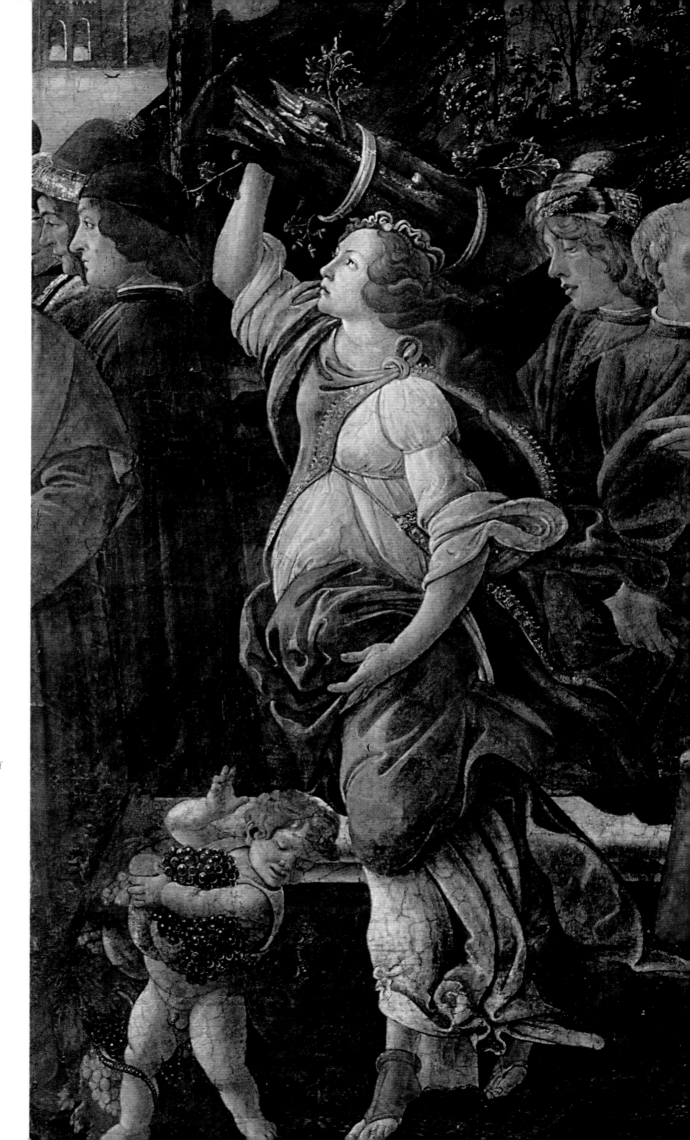

49 *The Temptation of Christ* (detail ill. 48), 1481–1482

Once Botticelli had developed motifs, he would
constantly vary them in his compositions. The woman
carrying the bundle of twigs is almost the mirror image of
the maid who is carrying up two cockerels in a bowl on
her head (ill. 48). This in turn goes back to the design of
the maid in the early small panel on the Story of Judith
(ill. 8). In contrast, Botticelli borrowed the small boy
holding bunches of grapes, and who has been frightened
by a snake, from Hellenistic sculpture.

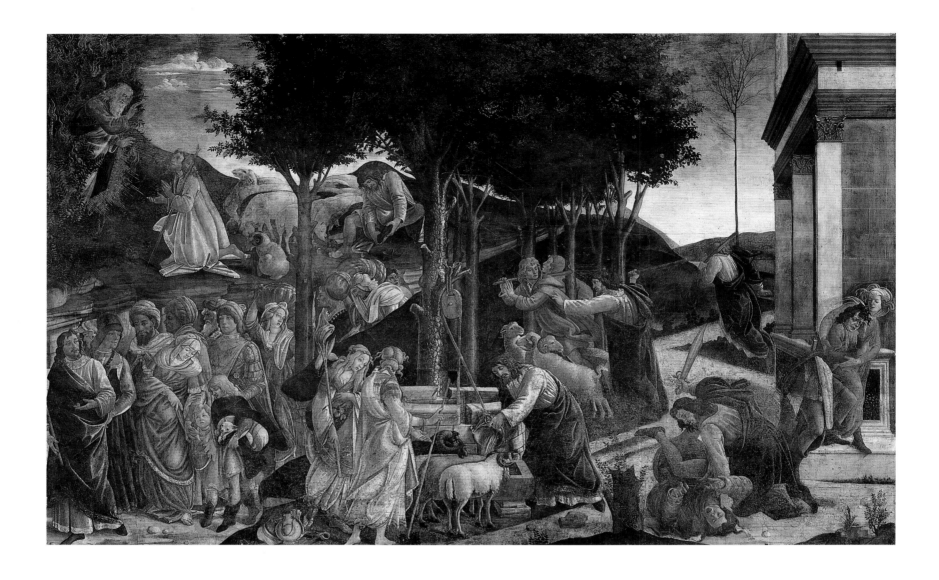

50 *Scenes from the Life of Moses*, 1481–1482
Fresco, 348.5 x 558 cm
Sistine Chapel, Rome

As the Moses cycle starts on the wall behind the altar, the scenes should, unlike the pictures of the temptations of Christ, be read from right to left: Moses, in a shining yellow garment, angrily strikes an Egyptian overseer and then flees to the Midianites. There he disperses a group of shepherds who were preventing the daughters of Jethro from drawing water at the well. After the divine revelation in the burning bush at the top left, Moses obeys God's commandment and leads the people of Israel in a triumphal procession from slavery in Egypt.

from Umbria, was working on the wall paintings during one of the last stages of work. It is likely that disputes over payment for the frescoes caused their early departure, because as late as 1483 Botticelli was still making attempts, with the aid of a relative living in Rome, to have money he was still owed by Sixtus IV paid.

In Florence, in 1482, the artist, together with Ghirlandaio, received a large commission from the city government to produce frescoes in the Palazzo della Signoria. These pictures, however, no longer exist, and neither does what was probably the most important secular cycle to be ordered in Florence in the 1480s, the mythological frescoes for the villa of Lorenzo de' Medici in Spedaletto. Ghirlandaio, Filippino Lippi and

Perugino joined Botticelli on this project; the work was completely destroyed during a fire at the beginning of the 19th century.

The only secular frescoes by Botticelli that still exist were not discovered until 1873 in a villa between Florence and Fiesole, where they had been concealed under old coats of paint for centuries. They are in a poor state of preservation, which in part is because the pictures were produced using not just the normal fresco technique but were also overpainted *a secco*, once they had dried. In addition, the pictures were damaged when they were taken down off the wall, because two of the three fragments found were transferred to canvas and later sold to the Louvre in Paris (ills. 57, 58).

Even though these frescoes are not mentioned in any

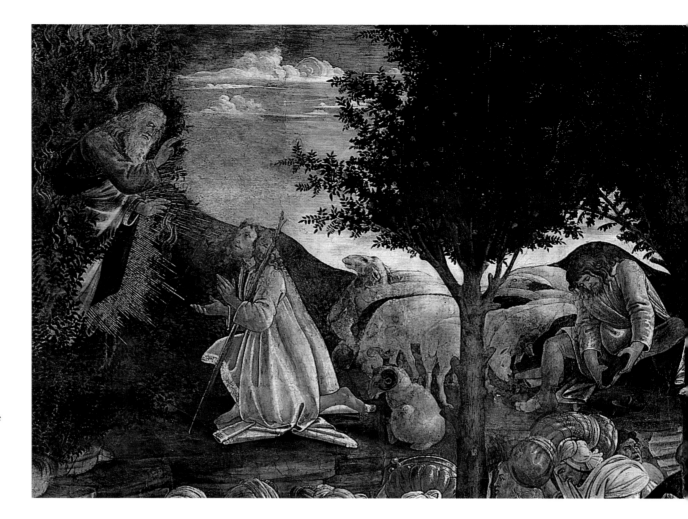

51 *The Life of Moses* (detail ill. 50), 1481–1482

As it was such an important event, Botticelli depicted the calling of Moses in two scenes. While Moses is looking after the sheep belonging to his stepfather, God appears to him in the burning bush and orders him to take off his shoes before approaching. Then he commands him to lead the children of Israel from Egypt into the Promised Land.

52 *The Life of Moses* (detail ill. 50), 1481–1482

The central scene, in which Moses is watering the sheep belonging to Jethro's daughters – one of them, Zipporah, later became his wife – is one of the most charming genre pictures in the entire cycle. According to the typological interpretation, it is a reference to Christ, who looks after his Church.

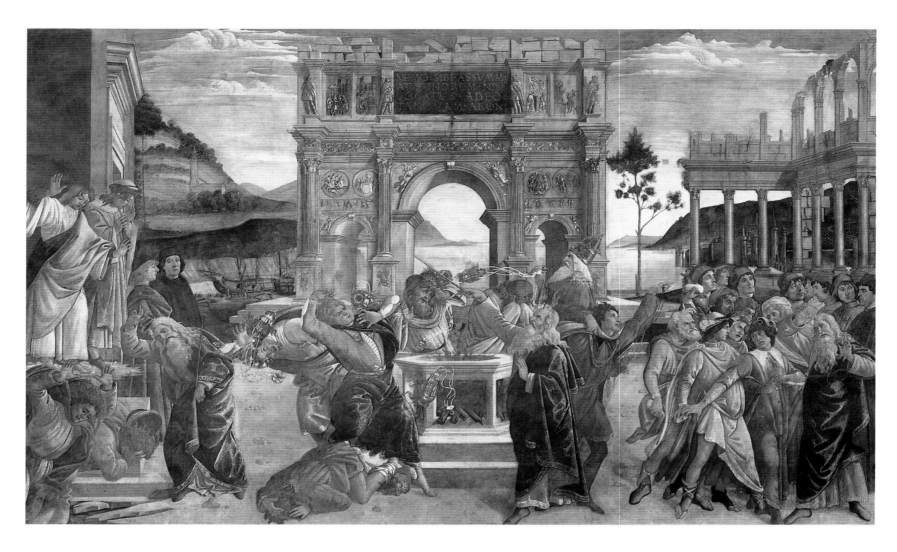

53 *The Punishment of Korah*, 1481–1482
Fresco, 348.5 x 570 cm
Sistine Chapel, Rome

From right to left, the fresco shows three episodes of the
revolt against Moses' and Aaron's authority. On the right,
Joshua is defending Moses from the rebellious people who
want to stone him. In the center, the sons of Aaron and
Levi are attempting to dispute Aaron's right to be priest.
On the left, the earth is opening up on Moses' command
and is swallowing the rebels. Only the innocent are saved.
Botticelli shows them floating on a cloud.

54 *Adoration of the Magi*, 1481–1482
Panel, 70 x 103 cm
National Gallery of Art, Andrew W. Mellon Collection,
Washington D.C.

Botticelli did not just paint frescoes during his stay in
Rome. This at any rate is what this Adoration painting
suggests, for its origins can be traced back to the city on
the banks of the Tiber. The figure of the groom in the
kings' retinue who is trying to bring a horse under control
is Botticelli's allusion to the famous classical *Dioscuri
group*, the horse tamers on the Quirinal.

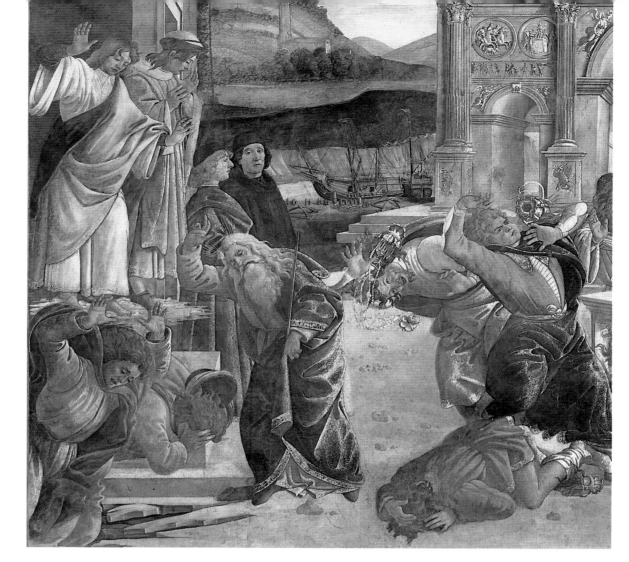

55 *The Punishment of Korah* (detail ill. 53), 1481–1482

Botticelli also included two of his contemporaries in the biblical scene. They are standing in front of the façade of an Italian Renaissance palace, and in the background, as is frequently the case with Botticelli, a motif from paintings north of the Alps has been added: it is a church with a pointed tower. The magnificent ships may well be a reference to the Pope's fleet.

56 *The Punishment of Korah* (detail ill. 53), 1481–1482

Aaron's sons and the sons of Levi are sacrificing in competition with him; Aaron himself is dressed in blue robes and is wearing a blue and gold hat which is similar to the papal tiara. Struck by their censers, they are being forced to the ground by the power of God, called on by Moses. Apart from the different inscription and less lavish decoration, the triumphal arch in the background is an almost exact copy of the Roman Arch of Constantine.

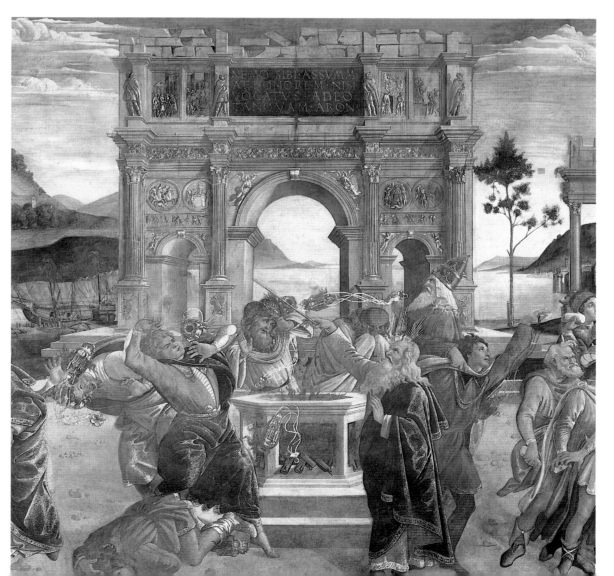

57 *Venus and the Three Graces (?) presenting Gifts to a
Young Woman*, ca. 1484–1486
Fresco, transferred to canvas, 211 x 284 cm
Musée du Louvre, Paris

There is a strange lack of certainty as to the identity of the
group of four young classically dressed women, who are
gracefully stepping towards a young woman in front of
the splashing spring in order to bring her gifts. They may
be Venus and the Three Graces, symbolizing chastity,
beauty and love.

of the early sources, there can be no doubt that they were
painted by Botticelli. The slender, overlong figures are
well in keeping with the artist's ideals, and tie in
stylistically both with his work in Rome and the
mythological panel paintings dating from the 1480s.

The two compositions were originally separated only
by a window. We know from descriptions written in the
19th century that the fresco, which shows a young man
in contemporary dress being led into the circle of the
seven liberal arts (ill. 58), used to display the coat of arms
of the Albizzi family. The little boy to the man's left held
the coat of arms, and the putto in the corresponding wall
painting also held one, though we no longer know

which coat of arms it was. As the villa belonged to the
Tornabuoni family in the 15th century, it is possible that
the frescoes were commissioned on the occasion of a
marriage between members of the two families. For a
long time the view was held that the couple in question
were Giovanna degli Albizzi and Lorenzo Tornabuoni,
who married in 1486. This assumption has, however,
since been proven wrong, for the face of Giovanna that
we know from a medallion does not agree with the lady
in Botticelli's fresco. A possible alternative could be
Nanna Tornabuoni and Matteo degli Albizzi, who
married in about 1484.

58 *A Young Man being introduced to the Seven Liberal Arts*, ca. 1484–1486
Fresco, transferred to canvas, 238 x 284 cm
Musée du Louvre, Paris

Even in this poor condition, the two frescoes still have some of the elegance which is a feature of Botticelli's best compositions. The fact that the figures cannot be entirely identified in no way detracts from their distant charm. It is, however, assumed that this is an allegorical celebration for a newly married couple. Even though the young man is obviously being led towards the female allegories of the seven liberal arts, rhetoric, dialectics, arithmetic, grammar, geometry, astronomy and music, it is unclear who is leading him there.

SECULAR PAINTINGS FOR PRIVATE PALACES

59 *Primavera* (detail ill. 64), ca. 1482

The dance of the Graces was described by the Roman poet Seneca and was also known in 15th century because Alberti recommended it as an excellent subject for a picture in his treatise on painting: "What shall we say too about those three young sisters …? The ancients represented them dressed in loose transparent robes, with smiling faces and hands intertwined."

The 1480s were Botticelli's most productive years. While he was one of the most desirable painters in Florence even before he left for Rome, by the time he returned, after the large project working on the frescoes for the Pope, his reputation was firmly established. He gained commissions from the families in high society. Increasingly they chose classical themes for the luxurious decoration of their town houses, but they also included some from contemporary literature. In order to be able to carry out his multiple commissions, Botticelli had to work together with other painters as well as members of his own workshop. The four-part *Nastagio degli Onesti* cycle (ills. 60–63), Botticelli's reworking of a novella in Boccaccio's Decameron, was produced with the aid of Bartolomeo di Giovanni, an artist who had also worked for Ghirlandaio.

The occasion for which Botticelli's patron, Antonio Pucci, ordered these pictures was the wedding of his son Giannozzo to Lucrezia Bini. The paintings originally decorated a room in the old Pucci palace and were set into a *spalliera*, a type of wall panelling. Botticelli was the first to adapt Boccaccio's story for panel painting, and his pictures, which were freely copied shortly afterwards, were in many respects exemplary for *spalliera* painting.

While the first two paintings (ills. 60, 61) restricted themselves to the events in the novella, the third and fourth panels (ills. 62, 63) translated the story, which takes place in Ravenna, to the situation in Florence. The father of the bridegroom, Antonio Pucci, is portrayed on the third painting amidst the guests, and on the fourth is even shown in a group of other prominent public figures in the city. Above each of the banqueting tables are Florentine family coats of arms, on the left that of the father of the bridegroom, on the right that of the newly-founded Pucci-Bini family. In the center, the Medici coat of arms is emblazoned. It is probable that Lorenzo de' Medici arranged the marriage.

Apart from an intimidatingly didactic piece of advice for the bride, the paintings document the public requirements of the client. Above all it is the fourth picture that bears witness to this, showing as it does the triumphal celebration with which the magnificent wedding is carried out, and to which very little space is devoted in Boccaccio's novella. This is where the client had himself and his followers immortalized amidst the most respected of Florence's families. The paintings clearly present the political and strategic importance of marriages: such family unions were used to extend position and power.

In the 1480s, Botticelli also created the large format mythological and allegorical paintings that are some of his best-known works. Despite research by art historians that has continued for over a century, they are still a mystery. The difficulty in deciphering them lies in the fact that there are no known predecessors, nor can their pictorial programs be conclusively derived from written sources. Rather, they are a blending of classical and modern sources. These paintings were not originally intended to be seen by a larger audience, but were hung in private rooms, tailored precisely to the requirements of the client and reflecting their particular interests in the classical body of thought. The study of antiquity was particularly encouraged in the humanist circle associated with the Medicis, and Botticelli's patrons also belonged to it.

In 1550, Vasari wrote that a picture which according to him announced the arrival of spring (ill. 64) was in the Medici villa in Castello (ill. 67). In 1477, the estate was acquired by Lorenzo di Pierfrancesco de' Medici, who was a second cousin of Lorenzo the Magnificent. This is why it was long assumed that the *Primavera*, as the painting continues to be called, was painted for the fourteen year old Lorenzo di Pierfrancesco when the villa was bought. He came from the junior branch of the Medici family, and upon the death of his father was raised in the care of Lorenzo the Magnificent. His teachers included the philosopher Marsilio Ficino and Giorgio Antonio Vespucci, Botticelli's neighbor and patron. An inventory dating from 1499, which was not discovered until 1975, lists the property of Lorenzo di Pierfrancesco and his brother Giovanni and states that in the 15th century the *Primavera* had been displayed in Florence's city palace. The painting decorated an anteroom attached to Lorenzo di Pierfrancesco's chambers and was hung above a *lettucio*, a large wooden bench with a back which was a type of predecessor of the modern sofa.

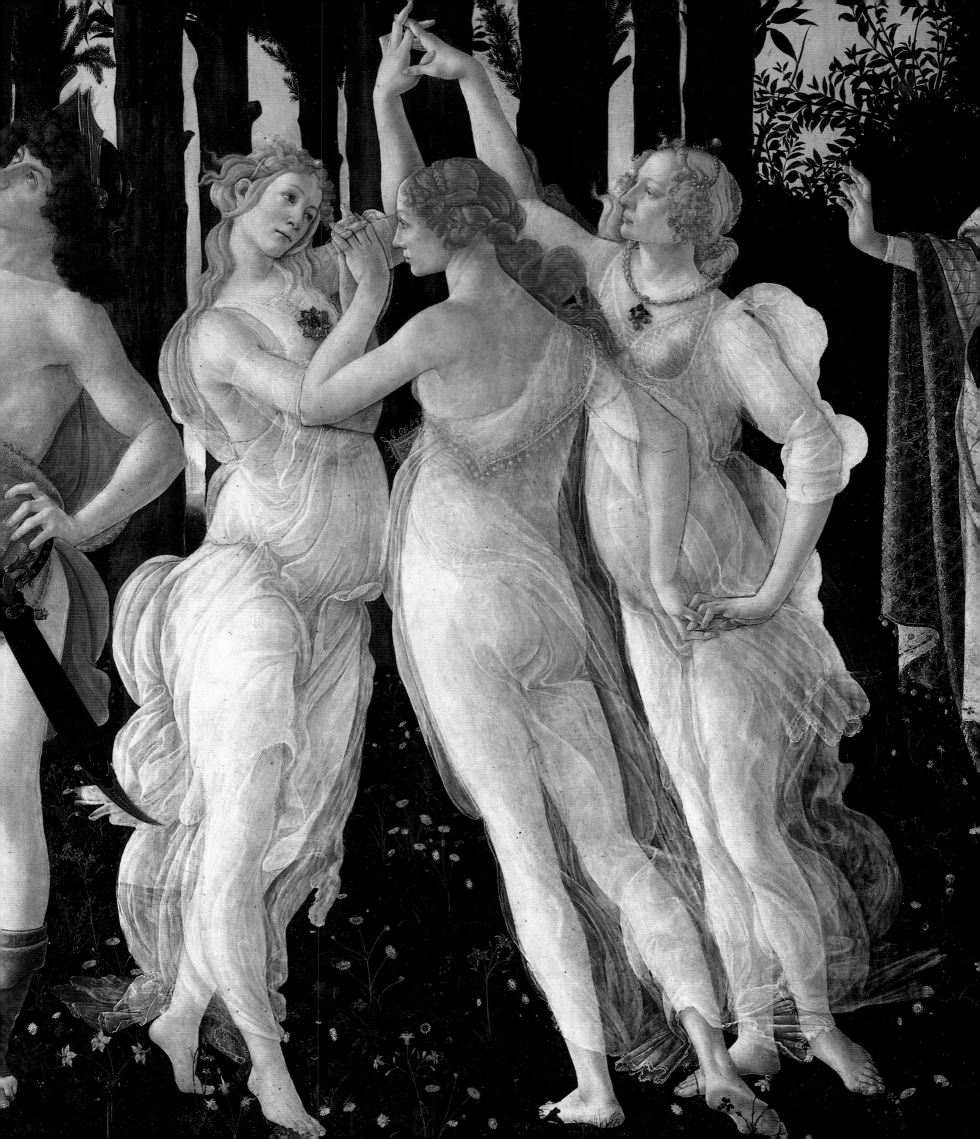

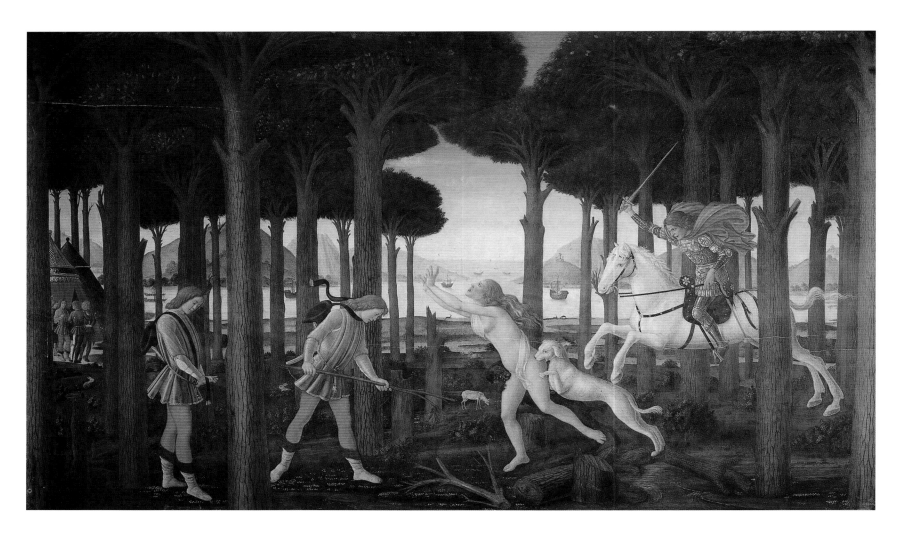

60 *The Story of Nastagio degli Onesti: The Encounter with the Damned in the Pine Forest*, 1482–1483
Panel, 83 x 138 cm
Museo del Prado, Madrid

This four-part cycle depicts the famous novella about Nastagio degli Onesti by Boccaccio. It tells the story of the young Nastagio from Ravenna, who cunningly uses a horrific event in order to persuade his beloved to marry him. Rejected by the lady he admires, he retires to the pine forest of Classe. He sends his servants away and walks broodingly through the forest. There he suddenly comes upon a knight on horseback who is hunting a naked woman with his hounds. Nastagio seizes a branch in order to protect the defenceless woman.

61 *The Infernal Hunt*, 1482–1483
Panel, 82 x 138 cm
Museo del Prado, Madrid

Nastagio watches with dismay as the knight tears out the woman's heart and entrails and feeds them to his dogs. Then the armed rider is once more hounding his victim along the shores of the ocean. This chase is hell's punishment for the hunter, whose despairing love caused him to kill himself, and for the naked woman, who was cruel to her lover; it is a punishment that will be repeated eternally.

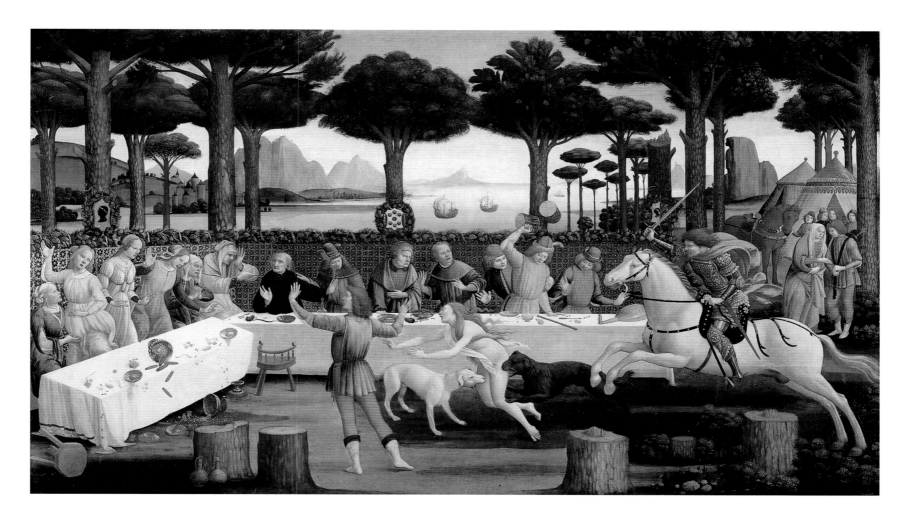

62 *The Banquet in the Pine Forest*, 1482–1483
Panel, 84 x 142 cm
Museo del Prado, Madrid

Nastagio has hatched a cunning plan. He has invited
guests to the pine forest in order to show them the
horrible chase. The woman he desires, wearing the white
dress, has always rejected his advances but now watches
the events in dismay. As she is afraid of suffering a similar
fate, she sends a servant to Nastagio, as we can see in a
second scene on the right, and agrees to become his wife.

63 *The Wedding Banquet*, 1482–1483
Panel, 84 x 142 cm
Private collection, Florence

Nastagio's wedding is celebrated on a splendid scale under
a monumental loggia. The coats of arms suggest that the
cycle of paintings was commissioned on the occasion of a
wedding in Florence between the Pucci and Bini families.
The coat of arms of the Medicis is emblazoned in the
center, as a sign of respect for the city's ruling family.

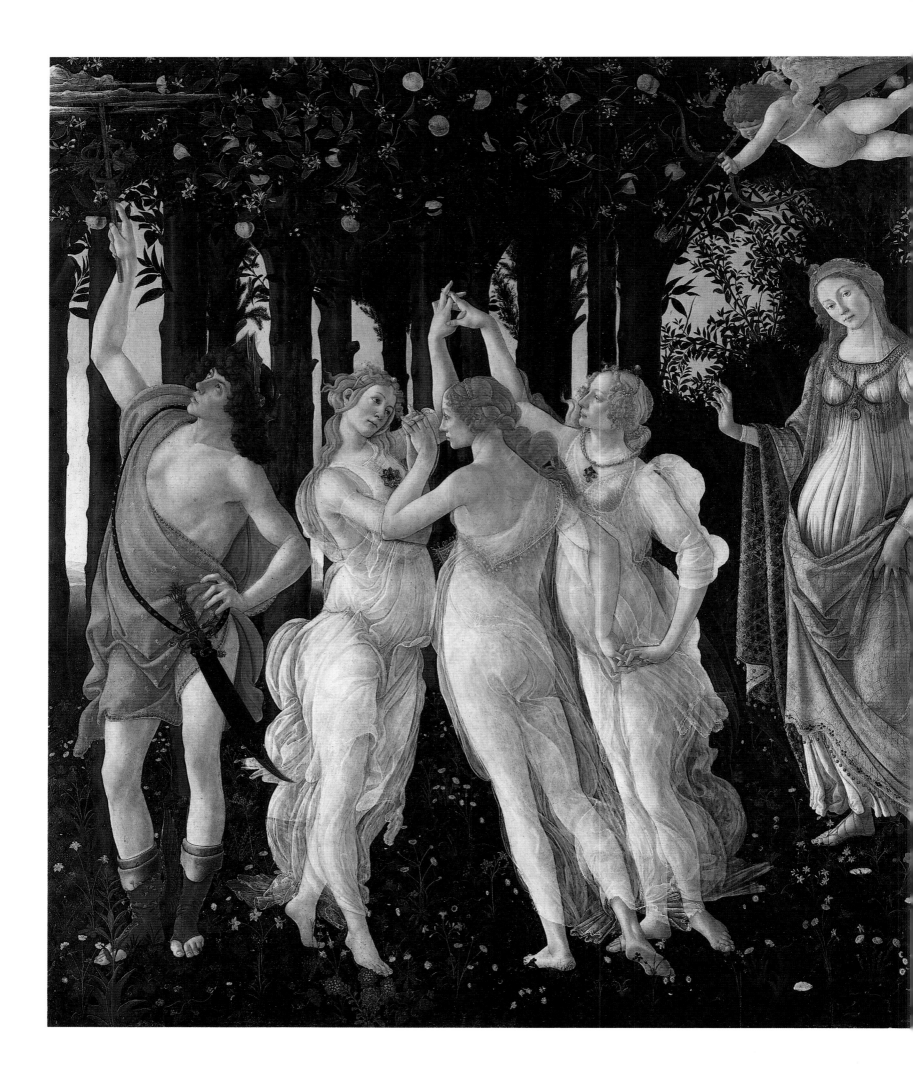

65 *Hora of Autumn*, Roman copy of a Neo-Attic statue
Marble, 151 cm
Galleria degli Uffizi, Florence

The figure of Flora, scattering flowers as she walks, was probably
modelled on a classical statue. The *Hora of Autumn* in the Uffizi was
kept in a private Roman collection during the time when Botticelli
was in Rome, and the artist may have seen it there. Botticelli only
deviated slightly from his model, altering her stance and the
position of her arms.

64 *Primavera*, ca. 1482
Panel, 203 x 314 cm
Galleria degli Uffizi, Florence

Venus is standing in the center of the picture, set slightly back from
the other figures. Above her, Cupid is aiming one of his arrows of
love at the Three Graces, who are elegantly dancing a roundel. The
garden of the goddess of love is guarded by Mercury on the left.
Mercury, who is lightly clad in a red cloak covered with flames, is
wearing a helmet and carrying a sword, clearly characterizing him as
the guardian of the garden. The messenger of the gods is also
identified by means of his winged shoes and the caduceus staff
which he used to drive two snakes apart and make peace; Botticelli
has depicted the snakes as winged dragons. From the right, Zephyr,
the god of the winds, is forcefully pushing his way in, in pursuit of
the nymph Chloris. Next to her walks Flora, the goddess of spring,
who is scattering flowers.

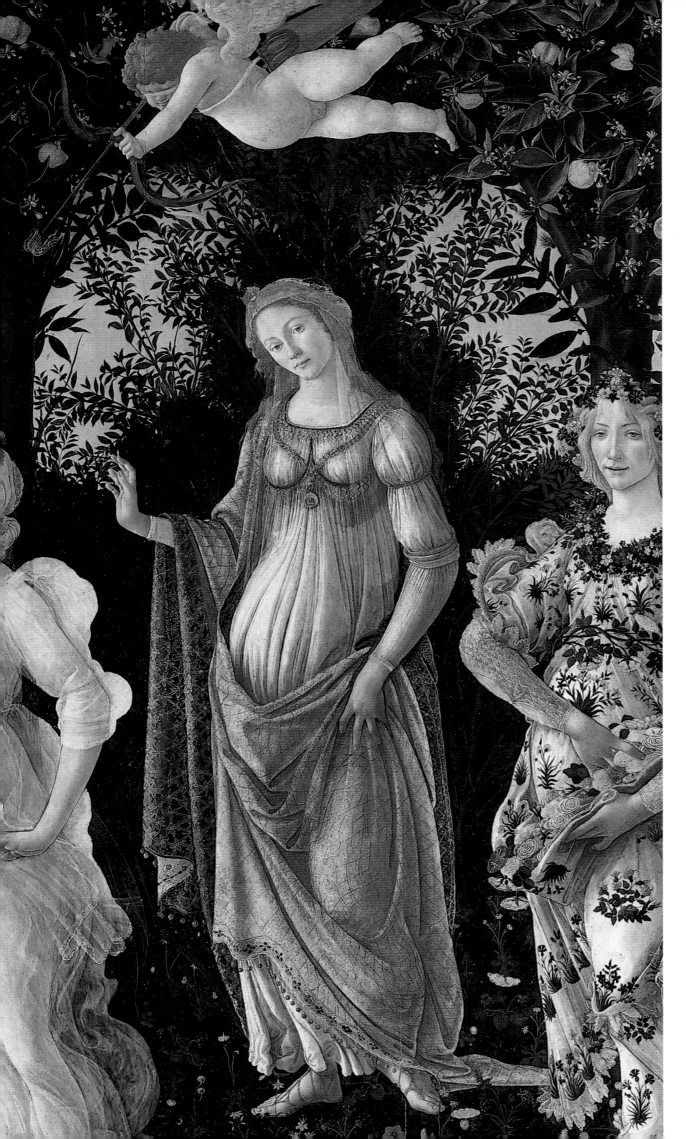

66 *Primavera* (detail ill. 64), ca. 1482

The divine spring garden, in which hundreds of species of plants and flowers are growing, nearly all of which flower in April and May, is being looked after by Venus, the goddess of love. Behind her is a myrtle tree, one of her symbols. She is raising her hand in greeting and welcoming the observer to her kingdom.

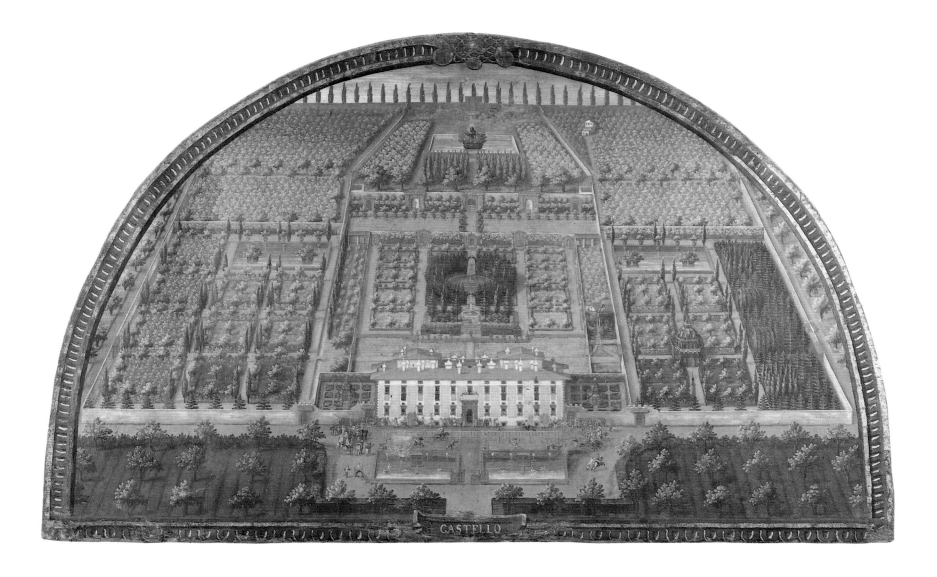

CASTELLO

Such large format paintings were nothing new in high-ranking private residences. The *Primavera* is, however, special in that it is one of the first surviving paintings from the post-classical period which depicts classical gods almost naked and life-size. Some of the figures are based on ancient sculptures. These are, however, not direct copies but are translated into Botticelli's own unconventional formal language: slender figures whose bodies at times seem slightly too long. Above all it is the women's domed stomachs that demonstrate the contemporary ideal of beauty.

The painting shows nine figures from classical mythology gathered in a flowering spring garden, bordered by a lush grove of orange trees and a few pine and bay trees. The figures, whose feet are carefully feeling their way on the ground – almost as if they are reluctant to destroy the splendor of the spring meadow – seem to be strangely lost in reverie. Their gazes scarcely meet. Each seems to be lost in her own thoughts, without being part of the overall events. Botticelli shows little interest in opening out the picture space through the use of perspective, which was the great achievement of the Quattrocento. Instead, the figures are arranged in a row, almost like a frieze, on a narrow oval strip of grass, and the plants form a backdrop almost like a carpet of flowers.

The only figure to be set back from the scene is that of Venus, the goddess of love and beauty. Above her, the orange trees form an arch as a sign of her majesty. Her blindfolded son, Cupid, is pointing a fiery arrow of love at the three Graces, who are part of Venus' entourage. Their transparent garments do little to conceal the beauty of their naked bodies. Mercury, who is using his caduceus staff to drive off the clouds, is protecting the heavenly garden.

However, the peace and harmony of the garden is disturbed by Zephyr, the god of the wind, who is making a forceful entrance from the right. His cheeks are puffed out as this winged being pushes his way forward amongst the swaying bay trees in order to seize a nymph who is hurriedly fleeing away from him. She is turning her head back towards her pursuer; flowers are pouring from her mouth and falling onto the magnificent dress, decorated with flowers, of the woman next to her. The latter is Flora, the goddess of flowers and youth.

One source for this scene is Ovid's *Fasti*, a poetic calendar describing Roman festivals. For the month of May, Flora tells how she was once the nymph Chloris, and breathes out flowers as she does so. Aroused to a fiery passion by her beauty, Zephyr, the god of the wind, follows her and forcefully takes her as his wife. Regretting his violence, he transforms her into Flora,

67 Giusto Utens
View of the Castello Villa, 1599–1602
Canvas, 147 x 233 cm
Museo Storico Topografico "Firenze com'era", Florence

Lorenzo di Pierfrancesco de' Medici bought the villa in 1477. In the 16th century, it was where the *Primavera* and *Birth of Venus* were located. At that time the estate belonged to Lorenzo's descendants, the Grand Duke Cosimo de' Medici, and he commissioned the Flemish artist Utens to paint all the Medici residences as lunettes.

and as his gift gives her a beautiful garden in which eternal spring reigns. Botticelli is depicting two separate moments in Ovid's narrative, the erotic pursuit of Chloris by Zephyr and her subsequent transformation into Flora. This is why the clothes of the two women, who also do not appear to notice each other, are being blown in different directions. Flora is standing next to Venus and scattering roses, the flowers of the goddess of love. In his philosophical didactic poem, *De Rerum Natura*, the classical writer Lucretius celebrated both goddesses in a single spring scene. As the passage also contains other figures in Botticelli's group, it is probably one of the main sources for the painting: "Spring-time and Venus come,/ And Venus' boy, the wingèd harbinger, steps on before,/ And hard on Zephyr's foot-prints Mother Flora,/ Sprinkling the ways before them, filleth all/ With colors and with odors excellent."

Angelo Poliziano, the Medici court poet, also described the kingdom of Venus as a place of spring in his poems, which were inspired by classical models. None of these sources, however, contains the complete group of figures as depicted by Botticelli. Mercury, above all, is not mentioned. He is however known as the leader of the three Graces; in addition, his amorous affair with Venus produced the god of love, Cupid. This threesome is also connected by the symbolism of the flames of love visible on Cupid's arrow, the neckline of Venus' dress and Mercury's cloak.

These flames also appear to contain a reference to the man who commissioned the work. They are the symbol of St. Lawrence (Lorenzo in Italian), who was roasted to death on a gridiron and was the patron saint of Lorenzo di Pierfrancesco. In spring, which is still considered to be the season of love, the wedding of Lorenzo di Pierfrancesco to Semirade d'Appiano was meant to take place. When, however, the mother of Lorenzo the Magnificent died, the ceremony was postponed to July 1482. It is possible that the *Primavera* was commissioned as a celebration of love and the spring on the occasion of this wedding.

According to the already mentioned inventory of 1499, the painting *Pallas/Camilla and the Centaur* (ill. 68) hung above a door in the same room as the *Primavera*. Its bare landscape focuses one's gaze on the two figures. The centaur is pacing nervously in front of a high cliff face and turning to look worriedly at the somewhat taller woman standing next to him, who is

68 *Pallas/Camilla and the Centaur*, ca. 1482–1483
Canvas, 207 x 148 cm
Galleria degli Uffizi, Florence

A centaur has trespassed on forbidden territory. This lusty being, half horse and half man, is being brought under control by a guard armed with a shield and halberd, and she has grabbed him by the hair. The woman has been identified both as the goddess Pallas Athena and the Amazon Camilla. What is undisputed is the moral content of the painting, in which virtue is victorious over sensuality.

69 (opposite, above) *Pallas/Camilla and the Centaur* (detail ill. 68),
ca. 1482–1483

The centaur, whose forehead is furrowed and eyebrows knitted, is turning his head backwards. In his face, Botticelli has depicted the amazement and displeasure of this hybrid creature, whose slightly opened mouth suggests he is complaining.

70 (opposite, below) *Pallas/Camilla and the Centaur* (detail ill. 68),
ca 1482–1483

The garment that the female figure is wearing, decorated with olive twigs, is embroidered with diamond rings, the symbol of the Medicis. It dates back to Cosimo de' Medici and was then

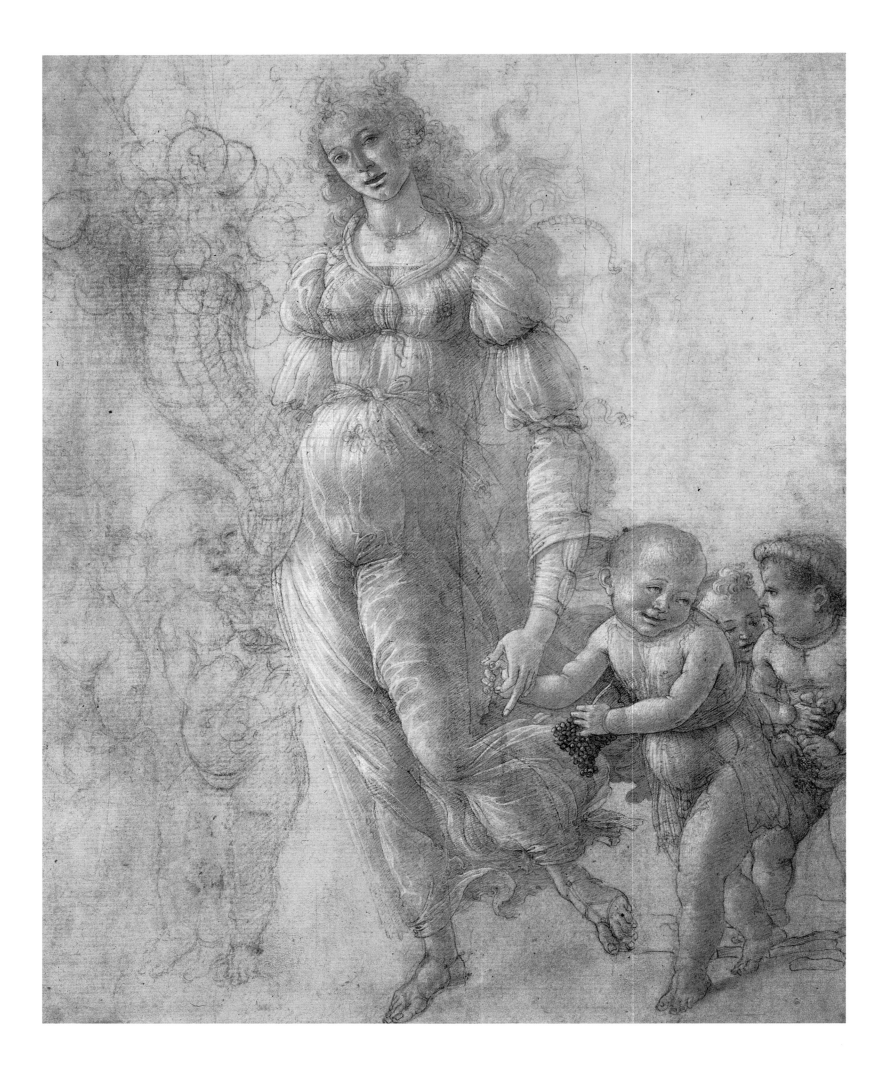

imperiously grabbing at his hair. Armed with a halberd and carrying a shield on her back, she might be the guardian of the area, protected by a lattice fence, onto which the centaur has trespassed onto in order to hunt without permission; he was probably in the process of testing the tautness of his bow when he was ordered to stop.

This strict wardress, whose dress is embroidered with the Medici imprint of entwined diamond rings, has frequently been identified as Pallas Athena or Minerva, the virgin goddess of wisdom. It is true that she is decorated with olive twigs, one of the attributes of Pallas. Her most important hallmark, the shield showing the head of the Gorgon, is however missing. In contrast, the inventory mentioned above names this figure as Camilla. She is the Amazon-like, chaste heroine of Virgil's "Aeneid", and in particular it was Boccaccio's book "De claris mulieribus" ("On famous women") that presented her as a model for women about to be married. The wardress in the picture is firmly and convincingly putting the centaur, known as a lustful being, in his place. This suggests an interpretation as a moral allegory for the painting: chastity and virtue triumph over lust and sensuality. The Medici symbol on the garment worn by Pallas/Camilla suggests that the painting was an honorable reference to Semirade, the wife of Lorenzo di Pierfrancesco.

The painting of *Venus and Mars* (ill. 73), in contrast, deals with an amorous victory. A grove of myrtle trees, the tree of Venus, forms the backdrop to the two gods who are lying opposite each other on a meadow. Venus is clothed and is attentively keeping watch over Mars as he sleeps. The god of war has taken off his armor and is lying naked on his red cloak; all he is wearing is a white loin cloth.

Botticelli let himself be inspired by classical models. The mischievous little satyrs playing practical jokes nearby were probably suggested by a description of the famous classical painting *Wedding of Alexander the Great to the Persian princess Roxane*, written by the Greek poet Lucian. Botticelli replaced the amoretti which Lucian describes playing with Alexander's weapons with little satyrs. His painting is one of the earliest examples in Renaissance painting to depict these boisterous and lusty hybrids in this form. They are playing with the war god's helmet, lance and cuirass. One of them is cheekily blowing into his ear through a sea shell. But he has as little chance of disturbing the sleeping god as the wasp's nest to the right of his head. The wasps may be a reference to the clients who commissioned the painting. They are part of the coat of arms of the Vespucci family, whose name derives from *vespa*, Italian for wasp. Given that its theme is love, this painting was possibly also commissioned on the occasion of a wedding.

The title of the *Birth of Venus* (ill. 74) can be traced back to the 16th century. What is depicted is not, however, the moment of the goddess' birth – the classical poet Hesiod describes her as rising from the foaming sea after Chronos cut off his father Uranus' penis and threw it into the ocean. Instead, we see the moment when she comes ashore. Inspired by classical tradition, Botticelli's

72 (right) *Pallas*, ca. 1485–1490
Pen and bistre over black chalk, heightened with white, on a pink ground, pricked and squared off for enlargement, 22 x 14 cm
Galleria degli Uffizi, Gabinetto degli Disegni e delle Stampe (Inv. No. 201E), Florence

The drawing is based on the same female figure as the *Allegory of Abundance* (ill. 71). The olive branch and the armor, the appearance of the latter can only be guessed at due to the way the paper has been trimmed, show her to be Pallas Athena, the classical goddess of the arts and sciences. The drawing was part of the design process for a tapestry which is now privately owned in France.

71 (opposite) *Allegory of Abundance*, ca. 1480–1485
Pen, brown ink, gentle brown wash, heightened with white, over black chalk and pink tinted paper, 31.7 x 25.3 cm
The British Museum, Department of Prints and Drawings (Inv. No. 1895–9-15–447), London

This study is one of the most technically practised and gentle that the artist produced. Putti carrying fruit accompany the figure, and the cornucopia shows her to be an allegory of Abundance. She corresponds to Botticelli's female ideal of the 1480s. Flora (ill. 64) or Pallas/Camilla (ill. 68) could be her sisters.

contemporary Angelo Poliziano described this scene in his epic poem "Stanze per la Giostra", thereby providing what was probably the most important source of inspiration for the painting. He described Venus as being driven towards the shore on a shell by Zephyr; and how an onlooker would have seen the flash in the goddess' eye and the Horae of the seasons standing on the shore in white garments, their flowing hair caressed by the wind.

It is not just the winged beings, in their close embrace, that give this painting its lightness. The playful wind streams their hair and makes their garments billow out in huge folds. All of these vivid details are a form of expression derived from antiquity, which inspired Poliziano's poem to an equal extent and was recommended to artists by Alberti as early as 1435 in his treatise "On Painting".

The degree to which Botticelli was seeking to achieve a vigorous expressiveness in the frieze-like composition of figures becomes clear on examination of the decorative landscape background. It is true that the cool shades and blue and green of the sky, ocean and shore harmonize with the soft accented colors of the figures, and golden brushstrokes produce vivid highlights across the entire painting. Nonetheless, the landscape seems to be little more than a backdrop behind the figures and provides little sense of depth. The waves stand next to the giant shell rather like a carpet pattern and the proportions of the trees, whose branches are reaching right towards the center of the picture almost as if they

73 *Venus and Mars*, ca. 1483
Panel, 69 x 173.5 cm
The National Gallery, London

The goddess of love, who is clothed in a costly gown, is watching over the sleeping naked Mars, while little fauns are playing mischievously with the weapons and armor of the god of war. Botticelli's theme is that the power of love can defeat the warrior's strength. The boisterous little fauns that form part of the retinue of Bacchus, the god of wine, are depicted by Botticelli, in accordance with ancient tradition, with little goats' legs, horns and tails. The Triton's shell with which one of the fauns is blowing into Mars' ear was used in classical times as a hunting horn.

are welcoming the goddess, are strangely small in relation to the figures.

The goddess of love, one of the first non-biblical female nudes in Italian art, is depicted in accordance with the classical *Venus pudica* (ill. 75). She is, however, as little a precise copy of her prototype as the painting is an exact illustration of Poliziano's poetry. The group comprising Venus and the Hora of spring demonstrates Botticelli's flexible use of Christian means of depiction. It is based on the widespread iconographical scheme of the Baptism of Christ, such as the versions produced by Verrocchio's workshop (ill. 18).

It is uncertain who commissioned the painting. In the first half of the 16th century, it was kept in the Castello villa, owned by the descendants of Lorenzo di Pierfrancesco de' Medici. However, it was never mentioned in inventories of his property. It is, though, extremely likely that the *Birth of Venus* was commissioned for a country seat. In contrast to the *Primavera* (ill. 64), the painting is painted on canvas. This was a medium normally chosen for paintings that were destined to decorate country houses, for canvas was less expensive and easier to transport than wooden panels. As is still the case today, the primary function of

country seats was to provide their owners with a peaceful place where they could relax; they did not have the public role of town palaces whose valuable furnishings were a demonstration of power. In the more private, retired idyll of the countryside, cheerful and secular themes were more likely to be chosen for the artistic decorations. In another Medici villa in Careggi, for example, the rooms were decorated with landscapes containing animals, singers, and bathing and dancing figures.

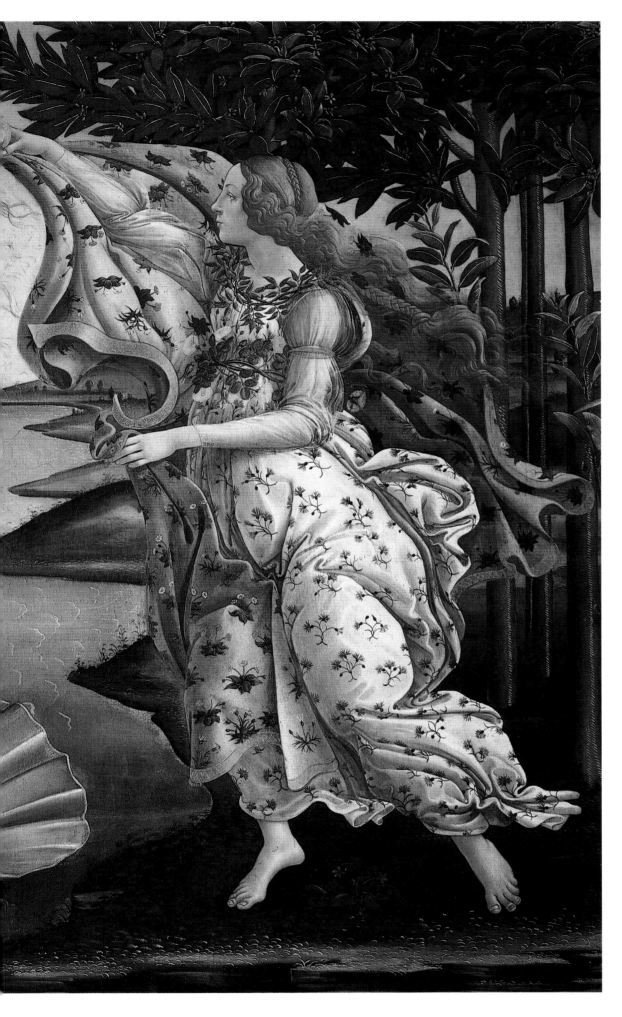

75 *Capitoline Venus*, Roman copy of a late Hellenistic statue
Marble, 187 cm
Musei Capitolini, Rome

Botticelli kept to the type of the classical *Venus pudica* (modest
Venus) when creating his *Birth of Venus*. The *Capitoline Venus* was
not found until the 17th century. However, sources tell us of a
comparable figure which was known in the *Quattrocento*.

74 *The Birth of Venus*, ca. 1485
Canvas, 172.5 x 278.5 cm
Galleria degli Uffizi, Florence

The god of the winds, Zephyr, and the breeze Aura are in a tight
embrace, and are gently driving Venus towards the shore with their
breath. She is standing naked on a golden shining shell, which
reaches the shore floating on rippling waves. There, a Hora of
Spring is approaching on the tips of her toes, in a graceful dancing
motion, spreading out a magnificent cloak for her. Venus rises with
her marble-colored carnations above the ocean next to her, like a
statue. Her hair, which is playfully fluttering around her face in the
wind, is given a particularly fine sheen by the use of fine golden
strokes. The unapproachable gaze under the heavy lids gives the
goddess an air of cool distance. The rose is supposed to have
flowered for the first time when Venus was born. For that reason,
gentle rose-colored flowers are blowing around Zephyr and Aura in
the wind.

GREAT ALTARS FOR FLORENTINE CHURCHES

Portrayed as the so-called *Madonna lactans*, the Virgin is baring her breast in order to feed her child. The client, Giovanni de' Bardi, chose the two saints John the Baptist and John the Evangelist, his patron saints, as intercessors. The Baptist, being the patron saint of Florence, was accorded the place of honor to the right of the Mother of God, and he is pointing the observer towards the Madonna and child. At his feet lies the instrument of his work, the baptismal bowl. The Evangelist to the left of Mary is an old man; he is holding a quill and book, and the eagle behind him is his evangelist's symbol.

Even though Botticelli's present reputation and fame are primarily based on his mythological paintings, he, like all the artists of his age, created mainly religious works. There was a considerable demand for religious paintings centering on the Madonna. Botticelli's workshop assistants carried out the less important of the numerous commissions, either following his designs or copying his own paintings. Large altar panel paintings from Botticelli's hand still exist which date from the 1480s, commissioned by private patrons or guilds.

Botticelli painted one of his most impressive altar paintings, known as the Bardi altarpiece (ill. 76), for Giovanni de' Bardi. Bardi, who came from Florence, was known as the "great English merchant" by his contemporaries; he had directed the London branch of the Medici bank for a long period and had made his money exporting wool. When Bardi returned to his native city from England in 1483, he built a chapel in Santo Spirito for his spiritual salvation. The church, one of the most important Early Renaissance buildings, was constructed between 1454 and 1482 according to the plans of Brunelleschi, the great Florentine architect. Still in its original condition, the decoration of the chapels shows that there appear to have been regulations governing the way it was carried out. One obvious condition was that each chapel must have a *mensa* (altar top), a *paliotto* (altar panelling) and a framed altarpiece. The altar top and panelling is still in the Bardi Chapel today, in a prominent location to the left of the choir. The altarpiece, in contrast, is now in the Berlin Gemäldegalerie; the original frame, produced by the wood carver and architect Giuliano da Sangallo, has been lost.

As a merchant, Bardi kept a precise record of his expenditures. This means that it is possible both to date the painting precisely and to see what payments were made to the participating artists. The last payments to Botticelli and Sangallo were made in 1485. Sangallo received 24 florins for the frame, and Botticelli received a total of 78 florins and 15 soldi. The greater part of Botticelli's wages was, however, needed to pay for the materials: it was calculated that the gold and expensive blue ultramarine paints would cost 40 florins, and the artist received 38 florins "for his brushstrokes", or labor.

The cost of paintings was judged according to their size, the number of figures depicted and the material used. In comparison to other altarpieces that Botticelli produced, he was very highly paid for the comparatively small Bardi altarpiece, and the client appears to have been willing to recognize the artist's virtuoso technique. Of course Botticelli had to hold his own in competition with those artists who produced similar altarpieces for other chapels.

The composition of this *Sacra Conversazione* clearly shows his originality. Botticelli produced a different solution to the classical three-part structure of such paintings, showing the enthroned Madonna and Child flanked by saints, from that of his artistic colleagues. He did not simply use architectural elements to structure the picture surface, but mainly used naturalistically painted niches of foliage to form a deferential backdrop for the holy figures.

He used a fine style of painting to reproduce the lavish vegetation, richly decorated marble architecture and carefully draped robes. This artistic stage scenery is very pleasing to the eye of the beholder and at the same time contains a complex theological program. The *Hortus Conclusus*, which is closed off by the architecture and niches of foliage, is decorated with numerous plants whose symbolism is explained on banderoles. They quote biblical verses from the Book of Ecclesiasticus and the Songs of Songs which worship Mary's purity and wisdom. The closed jar in front of the Virgin's throne is also a symbol of the Mother of God: it is the chosen vessel in which the divine fruit, Christ, is ripening, whose death will be mankind's salvation. This correlation is illustrated by the panel of the Crucifixion in front of the vessel. In addition, the banderoles mention the Immaculate Conception, the way in which the Virgin was saved from committing the original sin from the moment of her own conception, which was incorporated into standard ecclesiastical doctrine under Pope Sixtus IV in 1477.

The *Sacra Conversazione*, a type of picture that was widespread in Italy, was also Botticelli's theme for the San Barnabas altarpiece (ill. 78). On the feast day of St. Barnabas in the 13th century, Florence's army had won important victories on two separate occasions, and in

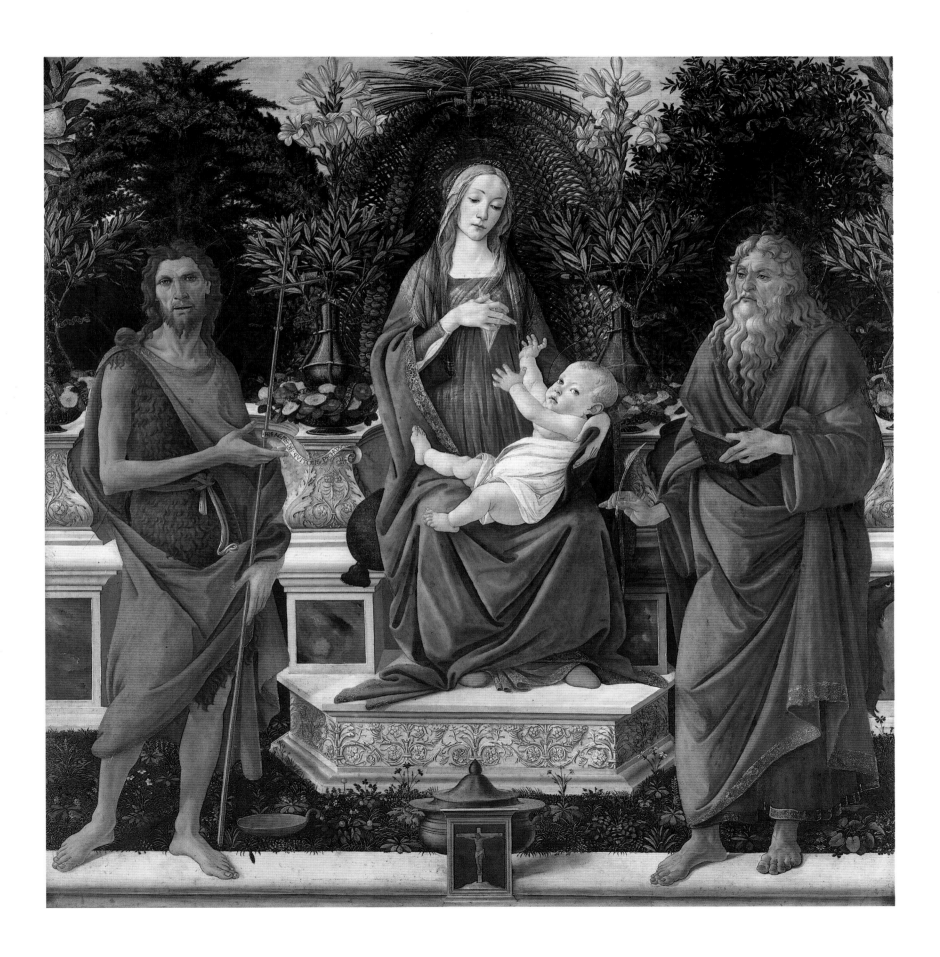

77 *St. John the Baptist*, ca. 1485–1490
Pen with bistre, delicate brown shading and white
heightening on pink primed paper, 36 x 15,5 cm
Galleria degli Uffizi, Gabinetto degli Disegni e delle
Stampe (Inv. No. 188E), Florence

The strikingly confidently drawn figure varies very little
from the monumental figures of St. John the Baptist in
the San Barnabas (ill. 78) and Trinity altarpieces (ill. 102).
The figure of the Baptist who is facing towards the left in
the Bardi altarpiece (ill. 76) also displays a considerable
affinity to this work. The series clearly demonstrates just
how well Botticelli was able to vary a single basic figure
according to the requirements of individual compositions.

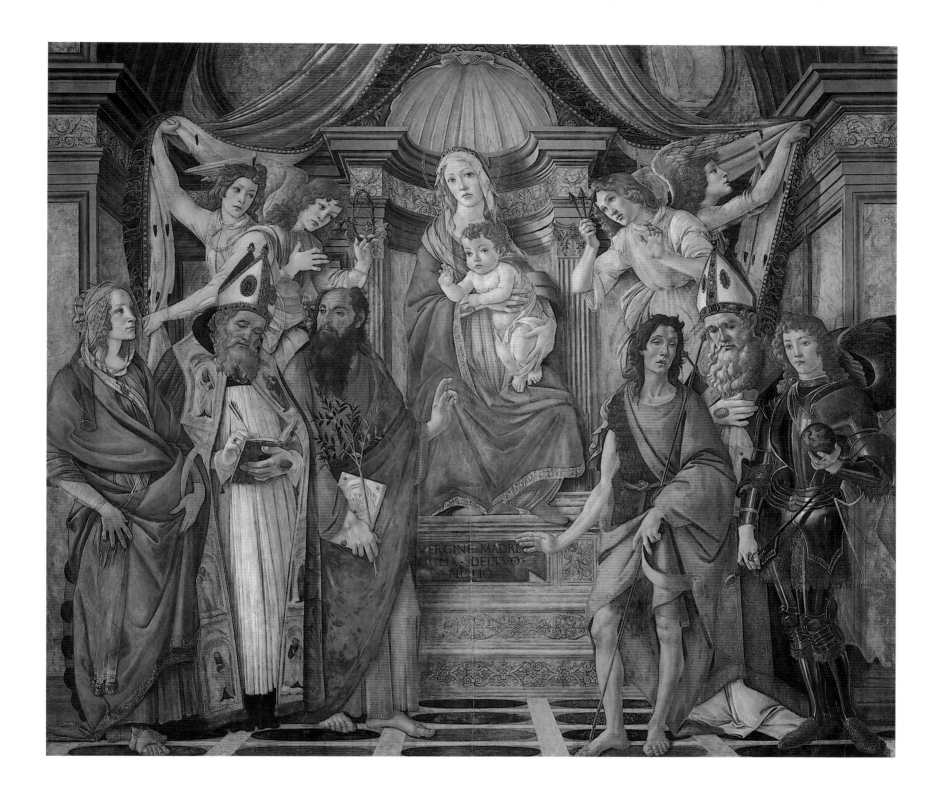

the 14th century therefore the Republic of Florence founded a church devoted to him. The guild of doctors and apothecaries was responsible for the maintenance and decoration of San Barnaba. It is probable that they commissioned Botticelli to produce the altarpiece for the main altar.

The regrettably poor state of preservation of the painting is to some extent the result of attempts at restoring and overpainting it in the early 18th century. The horizontal rectangular format of the picture was not in accordance with the fashion of the times, and so the painting was enlarged to form a vertical rectangle by the addition of smaller paintings at the top and bottom. Not

until 1930 was it restored to its original size. What is particularly impressive about the painting is the detailed structure and rich ornamentation of the architecture which provides a correct perspective view into the niche. Contact with Florentine architects such as Giuliano da Sangallo may well have inspired Botticelli to come to grips with contemporary forms in this way. He also gives a masterly display of his ability in his reproduction of the most diverse materials: the various types of marble and stone are painted just as brilliantly as is the cold shining metal of the armor and the heavy damask curtains lined with ermine.

The Madonna takes her place at the center of the

78 *Virgin and Child with Four Angels and Six Saints* (San Barnabas altarpiece), ca. 1487
Panel, 268 x 280 cm
Galleria degli Uffizi, Florence

The Virgin's throne, designed as a niche, is crowned by a shell. The two circular reliefs on either side show the Annunciation. An unusual feature is the inscription on the throne's base. It honors and characterizes the Madonna in the words of Dante, the famous Florentine poet: VERGINE MADRE, FIGLIA DEL TUO FIGLIO (Virgin mother, daughter of your son).

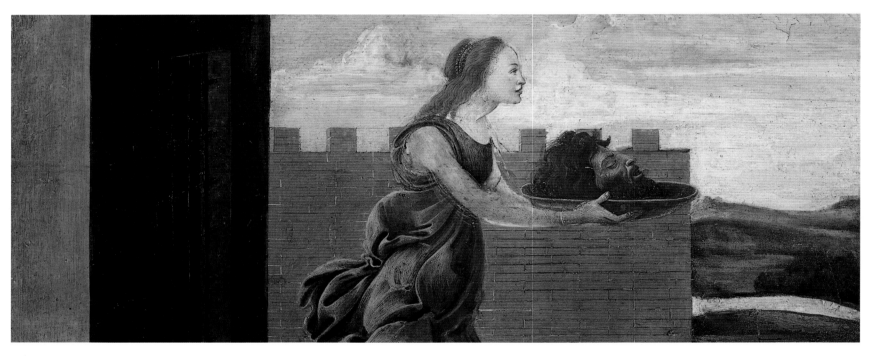

adoration scene, high above the saints; this meant that she would be seen by the faithful the moment they entered the church. The child she is holding, which is raising its hand in blessing, is leaning well forward and appears to be trying to free itself of its mother's care. Two angels are holding the instruments of Christ's Passion, the crown of thorns and nails, as a reference to his future fate. There are six saints gathered at the foot of the throne, and Barnabas, the patron saint of the church, has the place of honor to the right of the Virgin. Next to him is St. Augustine dressed as a bishop, the patron saint of the Church's choir masters, and St. Catherine of Alexandria. On the left of the Virgin is St. John the Baptist, St. Ignatius of Antioch as a bishop, and the

archangel Michael, who provides aid in battles. Only four of the original seven small panel paintings (ills. 79–82) of the altar's predella still remain, and as was customary these depict scenes from the lives of the saints in the main altar painting; the probable center was the panel showing *Christ in the Sepulchre* (ill. 79).

In the *Cestello Annunciation* (ill. 83), Botticelli enables the observer to look through a room structured according to the laws of perspective and across the red floor tiles, along its converging lines, out onto a landscape. The lively movement of the figures contrasts with these spatial dynamics, which lead towards the background. There is a diagonal line running from the edge of Gabriel's robes to his raised hand, and it

79 (top) *Christ in the Sepulchre* (predella panel of the San Barnabas altarpiece), ca. 1487
Panel, 21 x 41 cm
Galleria degli Uffizi, Florence

The Passion of Christ, to which the large main panel also alludes, is the theme of the predella panel. Christ is standing in a stone sarcophagus, displaying his stigmata. In front of him lie the instruments of his Passion, the crown of thorns and nails. To the right, in the background, the Bearing of the Cross can be made out. To the left, swans are swimming on a river. They were well-known for their delightful death songs.

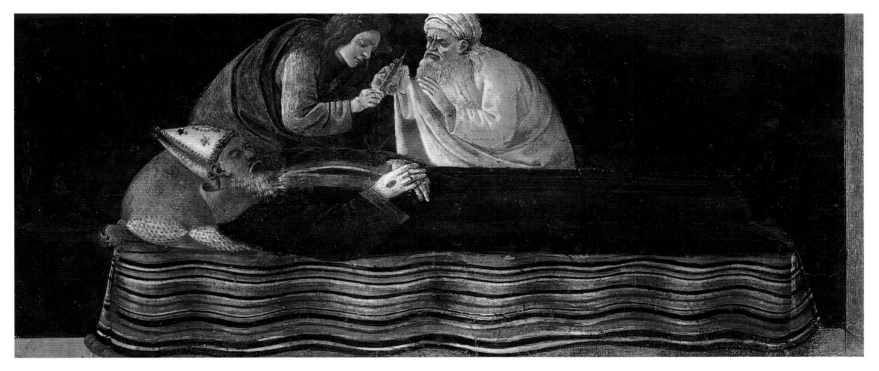

80 (opposite, bottom) *Salome with the Head of St. John the Baptist* (predella panel of the San Barnabas altarpiece), ca. 1487
Panel, 21 x 40.5 cm
Galleria degli Uffizi, Florence

As a reward for her dancing, Salome has received the head of the Baptist from Herod. She is standing in front of the barred entrance to the prison in which St. John the Baptist was held prisoner.

81 (top) *Vision of St. Augustine* (predella panel of the San Barnabas altarpiece), ca. 1487
Panel, 20 x 38 cm
Galleria degli Uffizi, Florence

According to a legend, St. Augustine the bishop, while he was thinking about the Holy Trinity, met a child on the beach who was attempting to use a spoon to transfer the waters of the ocean into a small hole. When Augustine explained to him that this was not possible, the child replied that it was far more foolish to try to find an explanation for the mystery of the Trinity.

82 (bottom) *Extraction of St. Ignatius' Heart* (predella panel of the San Barnabas altarpiece), ca. 1487
Panel, 21 x 38 cm
Galleria degli Uffizi, Florence

While being martyred, the saint told his tormentors that they would find the name of Christ written on his heart. After his death two curious Christians attempted to find out if this was true. They miraculously discovered golden letters, invisible in this painting, on his heart.

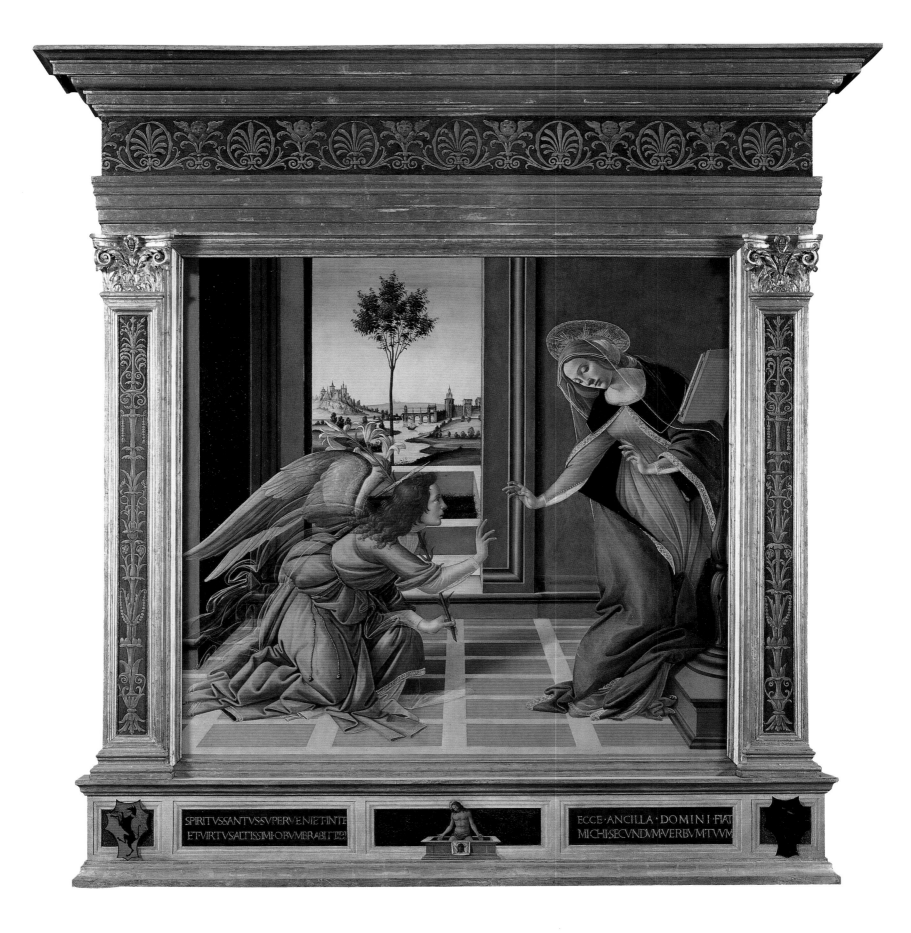

continues in the arm which Mary is holding across her chest. The angel's robes, which are billowing in great folds, show that he has just made a sweeping landing.

Gabriel is kneeling reverently in front of Mary and his mouth, which is slightly open, suggests that he is in the process of speaking the words of St. Luke's Gospel, which are written underneath him in Latin on the painting's original frame: "The Holy Ghost shall come upon thee, and the power of the Highest shall overshadow thee."

83 (opposite) *Cestello Annunciation*, 1489–1490
Panel, 150 x 156 cm
Galleria degli Uffizi, Florence

Botticelli kept to tradition in the way in which he structured the space of the painting. The angel is placed in the exterior, and Mary in the interior space. As a result, the view through the window is part of the angel's sphere – his wings reflect the colors of the landscape – while Mary herself is standing in the protective shadow of the gray wall. The areas occupied by the two protagonists are divided by the right window jamb, in front of which their hands are reaching towards each other in greeting.

84 (right) *Cestello Annunciation* (detail ill. 83), 1489–1490

The river landscape in the background, which is bathed in cool light, in particular the architectural features such as the mediaeval castle with its pointed towers behind the precipitous jagged cliffs, is clearly influenced by the style of painting north of the Alps.

Mary, who was probably reading when the angel surprised her, is turning to face him with a sharp movement of her body. One should not interpret the gesture she is making with her hand as a defensive one, but as a response to his greeting. Mary is leaning forward, a sign of her humility and submission. Her reply can also be read on the painting's frame: "Behold the handmaid of the Lord; be it unto me according to thy word." The somewhat artificial S-shaped movement of her body is Botticelli's attempt to depict her state of inner turmoil described in St. Luke's Gospel.

Leonardo da Vinci did not like such eventful portrayals of the Annunciation. He may even have had such a painting by Botticelli in mind when making a famous criticism that he wrote in his treatise on painting. In it, he says how just a few days ago he has seen a picture of an angel of the Annunciation who appears to be driving Mary out of the room, with movements very reminiscent of the sort of attack one

might make on an enemy; Mary seems about to throw herself out of the window in dismay. He warns young artists against making similar mistakes.

On the frame of the painting, to the left and right of the predella containing the depiction of Christ as the Man of Sorrows, are the coats of arms of the client, Benedetto di Ser Francesco Guardi (ca. 1436–1491), who commissioned the altarpiece for the chapel which he had had built in the Cestello church (now Santa Maria Maddalena dei Pazzi). Guardi came from a rather more modest background than the other known clients of Botticelli's in the 80s. He originally worked as a tanner, but from 1477 had worked as a banker and achieved a certain degree of wealth. The endowment of a private chapel with an altar by Botticelli was an expression of his rise in social class.

The *Coronation of the Virgin* (ill. 86) with four saints used to be in such poor condition that for half a century it was not possible to exhibit the picture. Following

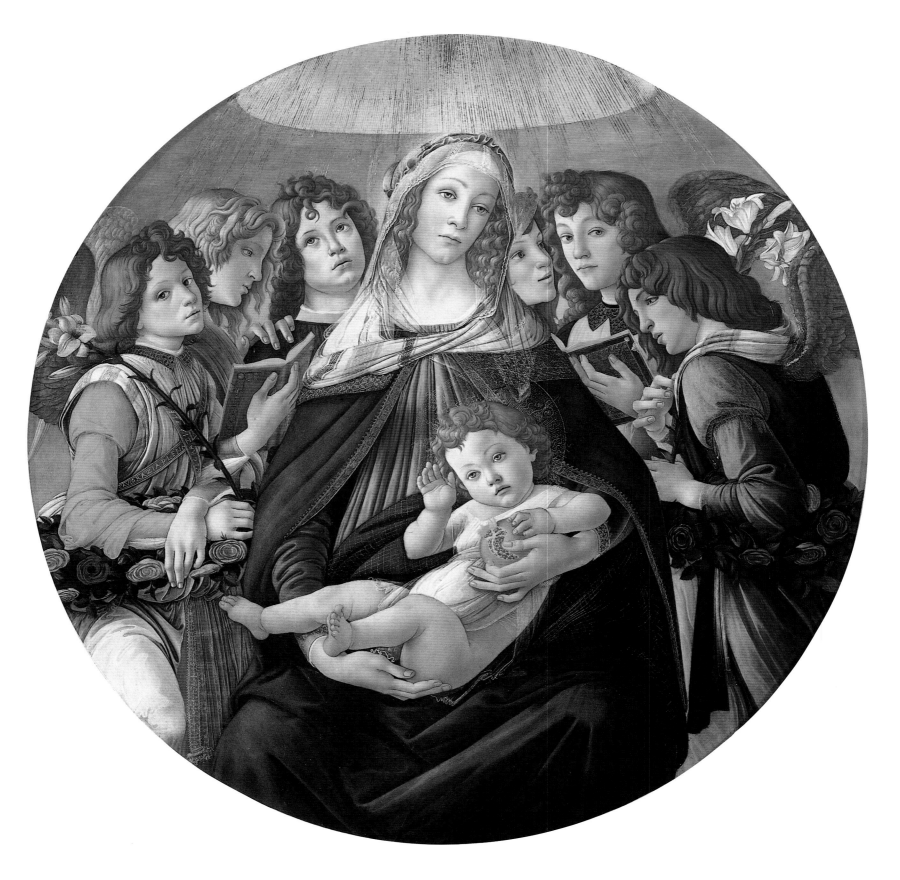

85 (above) *Madonna of the Pomegranate*, ca. 1487
Panel, ø 143.5 cm
Galleria degli Uffizi, Florence

The pomegranate after which the painting is now named is a symbol of the Resurrection of Christ. The Christ Child, whose hand is raised in blessing, is lying securely in the arms of Mary, but the sad, melancholy expression on the faces of mother and

child are intended to remind the observer of the torments the Son of God will suffer in the future. The angels are worshipping Mary with lilies and garlands of roses. The Rosary is a prayer that was created in its present form in the 15th century, and rapidly became widespread. The beginning of this prayer is embroidered on the left angel's stola: AVE GRAZIA PLENA (Hail Mary, full of grace).

86 (opposite) *Coronation of the Virgin with the Saints John the Evangelist, Augustine, Jerome and Eligius* (San Marco altarpiece), ca. 1490–1492
Panel, 378 x 258 cm
Galleria degli Uffizi, Florence

The heavenly events are impressively added within the arched upper section of the painting, above the four saints standing in front of a landscape. The dance of angels creates a sense of depth and at the same time connects the heavenly and earthly spheres, as the feet of the heavenly messengers at the front are almost touching the heads of the saints standing below them.

extensive restoration, which mainly consisted of
reattaching those pieces of paint that had become loose,
it was possible to put the painting on show once more
in 1990.

Botticelli painted this altarpiece, which is the largest
of those works still in existence and which, according to
the most recent research, was created as early as the
1490s, for the church of the Dominican monastery of
San Marco in Florence. The guild of goldsmiths, which
was responsible for the maintenance and decoration of
this church, ordered the altar for their own chapel. It
was dedicated to their patron saint Eligius. The lavish
use of the expensive gold paint was probably due to the
identity of the clients, who wanted to make a sumptuous
display of their profession. The gold background in the
upper part of the painting marks the dividing line
between the heavenly and earthly spheres. Nonetheless,
both worlds meet within the confines of a single picture,
something which was extremely unusual in the painting
of the age.

The four saints – John the Evangelist, the Fathers of
the Church St. Augustine and St. Jerome, and St. Eligius
– are standing in a semicircle on a meadow. Behind
them, on either side of a lake, is an extensive landscape.
As is typical of Botticelli's economical and schematic
composition, it is merely a decorative addition to the
monumental figures. The coronation of the Virgin in a
glory of seraphs and cherubs is all the more lavish. God
the Father and the Virgin are enthroned on an airy
carpet of clouds, setting them apart from the dancing
groups of angels. Two artistic qualities become clear in
this heavenly scene: Botticelli's exceptional feeling for
the ornamental structuring of forms and his artistic
inventiveness. He fits the heavenly aureole into the
semicircular top of the picture, which reflects the domed
architecture of the Eligius Chapel. He playfully groups
the whirlwind round dance of the angels about the
heavenly scene and this creates an illusion of depth.

The altar's predella is painted onto one continuous
panel (ills. 89–93). Painted wooden balusters separate
the individual scenes. In addition to the *Annunciation*
(ill. 91), there are important episodes from the lives of
the four saints.

Towards the end of the century, there was a distinct
preference for commissioning paintings with a religious
content. The newly-awakened religious zeal, stimulated
by the visionary preaching of the Dominican monk
Savonarola, also influenced the choice of artistic theme.
The Dominican demanded that one turn one's back on
this world and its love of splendor, and consciously come
to terms with death and the hereafter. Works of art

should primarily address the minds of the faithful.
Artists increasingly turned to visionary themes that
emphasized feelings. A key figure in Botticelli's
Coronation of the Virgin is St. John the Evangelist, who
at the time was thought to have written the Book of
Revelation. Here, in contrast to the Bardi altarpiece (ill.
76) where he appears in a pose of solemn composure,
he is drawing the observer's attention to the heavenly
vision with grand gestures and an ecstatic expression. In
his hand he holds the divine book of Revelation, which
strangely enough shows no signs of writing on it. It is
probably being annotated by St. Augustine, who is
industriously writing in a book of the same color next
to St. John. It can come as no surprise that in 1490, the
year that Botticelli presumably started work on the altar,
Girolamo Savonarola was preaching on the subject of
St. John's Revelation in the church of San Marco.
Savonarola's patron saint, St. Jerome, displays pious
emotion as he reverently lays his hand on his breast. The
painting radiates a solemn religious intensity, placing it
on the threshold of Botticelli's late work.

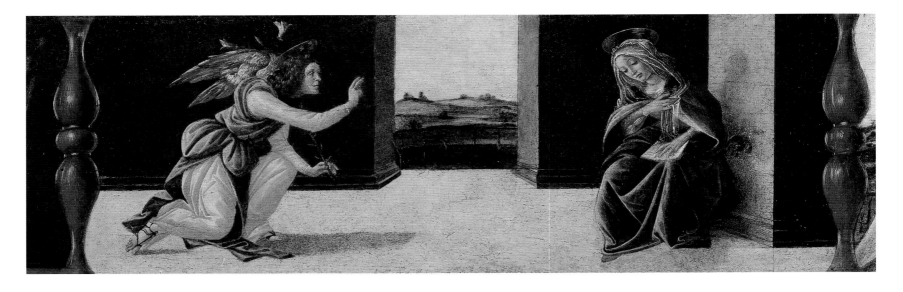

89 (opposite, top) *St. John on Patmos* (predella of the San Marco altarpiece), ca. 1490–1492
Panel, entire predella, 21 x 269 cm
Galleria degli Uffizi, Florence

St. John was exiled to the Greek island of Patmos by the Roman Emperor Domitian (81–96). This is where he was believed to have written the Book of Revelations. Surrounded by the waves, the saint is sitting with his legs crossed on a bare rock and is writing down his visions.

90 (opposite, center) *St. Augustine in his Cell* (predella of the San Marco altarpiece), ca. 1490–1492
Panel, entire predella, 21 x 269 cm
Galleria degli Uffizi, Florence

The scholar bishop is sitting thoughtfully at his desk. Next to him, an open book is lying on the chest seat, and there is a pile of other manuscripts in the wall cupboard behind him. The divine light entering the room from the left is painted as a gold hatching. It appears to be inspiring the saint, for he is holding his hand to his chest in a gesture of great emotion.

91 (opposite, bottom) *Annunciation* (predella of the San Marco altarpiece), ca. 1490–1492
Panel, entire predella, 21 x 269 cm
Galleria degli Uffizi, Florence

The angel Gabriel has just made a sweeping entry into Mary's astonishingly bare chamber, and is kneeling reverently before her and raising his hand in blessing. The Virgin has stopped reading and is humbly bowing her head. There is a door in the center of the plain, gray walls, opening out onto a broad landscape.

92 (this page, top) *St. Jerome in Penitence* (predella of the San Marco altarpiece), ca. 1490–1492
Panel, entire predella, 21 x 269 cm
Galleria degli Uffizi, Florence

Scantily clad in a red cloak, St. Jerome is kneeling as a penitent on a bare rock and is holding a stone in his hand in order to castigate himself. The book lying next to him refers to his translation of the Bible, and the red cardinal's hat hanging from a branch to his sacred office.

93 (this page, bottom) *A Miracle of St. Eligius* (predella of the San Marco altarpiece), ca. 1490–1492
Panel, entire predella, 21 x 269 cm
Galleria degli Uffizi, Florence

According to legend, St. Eligius shod a horse that was possessed by devils. He cut one of the horse's legs off, and after completing his work reattached it while making the sign of the Cross. The Devil, portrayed as a woman with horns, is watching the holy smith. A groom is having considerable difficulty controlling the impetuous horse.

The Dominican monk Girolamo Savonarola (1454–1498), who came from Ferrara, was to have a decisive influence on the culture and politics of Florence at the end of the 15th century.

In 1490 he was called to the monastery of San Marco, which was under the patronage of the Medicis, by Lorenzo de' Medici upon the recommendation of the philosopher Pico della Mirandola. In 1491, Savonarola became the prior there. In his enthusiastic sermons and writings he conjured up visions of the Apocalypse at the imminent turn of the century, and warned people to repent and embrace asceticism. He condemned the extravagance of the upper strata of society and called upon people to be virtuous, humble and live modestly. His public sermons of repentance were heard by the masses and led to him becoming extremely popular. Lorenzo de' Medici probably did not see the monk as an opponent who needed to be taken seriously. The educated Dominican also mixed with the Medicis' circle of scholars and even many of the humanists who thought Savonarola's fanatical behaviour repugnant found it difficult not to succumb to his fascinating power. In 1492, when he lay dying, Lorenzo called for the preacher. His son Piero

(1474–1503) soon proved to be an awkward politician and diplomat. During these times of crisis, the political and ideological influence of the monk grew. In 1494, when the French king Charles VIII besieged Florence with a mighty army on his way to Naples, and Piero handed several cities including Pisa over to him, the outraged inhabitants drove the Medicis out of Florence and plundered their palaces. The departure of the French, to which Savonarola had contributed as a government envoy, appeared to confirm a prophecy the monk had made: in a vision, he claimed to have seen the sword of God over Florence, but that it would move on. There followed radical political reforms, with a new, more democratic constitution as the basis for a *consiglio maggiore*, a great council with 3,000 members; Savonarola and his *frateschi* played their part in this assembly.

His most fervent supporters, who were mockingly called *piagnoni* (wailers), were drawn from the ordinary people whose rights he championed and who, in those crisis-wracked times, he impressed with his talk of God's imminent judgement. Florence was to play a leading role in the battle against the Antichrist, just as church reform was

95 (opposite) Fra Bartolomeo
Girolamo Savonarola, ca. 1498
Panel, 53 x 47 cm
Museo di San Marco, Florence

Fra Bartolomeo, who entered the Dominican order, probably painted this portrait of Savonarola while the latter was still alive. We see the sharp profile of the ascetic painted against a black background under a dark hood. The Latin inscription on the panel below the portrait proves that the monk was considered to be a prophet: "Portrait of the prophet Jerome of Ferrara, sent by God."

94 Unknown artist
Execution of Savonarola on the Piazza della Signoria, ca. 1498
Panel
Museo di San Marco, Florence

The monk Savonarola was put on trial in the city in which he had hoped to bring about a political and moral revival. Accused of heresy, he was hanged with two other Dominican monks on 23 May 1498 on the Florentine Piazza della Signoria, and then burned at the stake. Their ashes were scattered in the Arno.

HERONYMI·FERRARIENSIS·A·DEO·
✦·MISSI·PROPHETÆ·EFFIGIES·✦

PREDICHE DEL REVERENDO PADRE Fra Girolamo Sauonarola da Ferrara, sopra il Salmo QVAM BONVS Ifrael Deus, Predicate in Firenze, in fanta Maria del Fiore in vno aduen, to, nel. M.CCCCXCIII. dal medefi, mo poi in Latina lingua raccolte. Et da Fra Girolamo Giannoti da Piftoia ·in lingua volgare tradotte. Et da molti eccellentiffimi huomini diligentemente reuifte & emendate, & in lingua Tofcha impreffe.

MDXXXIX.

96 (left) Unknown artist
The Preaching Savonarola, woodcut from "Prediche del Reverendo Padre Fra Giralomo Savonarola, sopra il Salmo Quam Bonus Israel Deus [...]", Unknown location, 1539 Biblioteca Nazionale, Florence

The monk delivered scorching sermons during his appearances in Florence, and gained many followers who were rather derisively called *piagnoni* (wailers). Women were considered to be inferior by Savonarola and were not always allowed to hear his sermons. As a result, here it is also mainly men who are following the raised index finger of the preacher. On another woodcut in the same edition, a curtain separates the female and male listeners. Editions of Savonarola's sermons, decorated with woodcuts, were widespread until the mid-16th century.

97 (opposite page, left) *Venus*, ca. 1485–1490
174 x 77 cm
Galleria Sabauda, Turin

All that surrounds this figure is the suggestion of a transparent veil. Her stance accords with the classical type of the *Venus pudica* (ill. 75), who modestly covers her private parts. This beautiful nude, painted against a black background, is one of three remaining workshop copies of the main figure in the painting *The Birth of Venus* (ill. 74).

98 (opposite page, right) Lorenzo di Credi
Venus, ca. 1485–1490
Canvas, 151 x 69 cm
Galleria degli Uffizi, Florence

Vasari tells us that Credi burnt many of his pictures of nudes as a result of the political climate produced by Savonarola. Whether this painting dates from that period is just as disputed as its relationship to Botticelli's paintings of Venus against a black background. The head of this nicely balanced *contrapposto* figure has many of the features of a portrait.

to spread from the city on the banks of the Arno. The monk promised that the future would once more bring power and wealth.

Savonarola was not an opponent of the arts, but demanded that they concentrate on religious themes. Any unnecessary ornamentation was to be avoided, and clear expressive forms should be used to support the religious messages. He vehemently condemned Florentine citizens who allowed their portraits to be immortalized in religious paintings.

The traditional "Bonfire of the Vanities" with which Florence's carnival season ended on the Piazza della Signoria was turned into a great ideological event by Savonarola in 1497 and 1498. Luxury articles such as jewelry, mirrors,

robes, wigs, board games and musical instruments, as well as books, paintings and sculptures that were thought to be infamous, were piled up and burnt in a huge bonfire. Artists such as Lorenzo de' Credi and Fra Bartolomeo are thought to have destroyed some of their secular works in the flames.

But his denunciations of the Papal court in Rome and his policy of friendship towards France earned Savonarola the enmity of Pope Alexander VI. He was forbidden to preach in 1495, and this was followed by excommunication in 1497. Even the *Signoria*, the government of Florence, soon considered the charismatic Dominican to be a danger and withdrew its support. In 1498 he was arrested and tortured, and finally hanged and burned to death on 23 May, in the same square where he had staged his bonfire of the vanities.

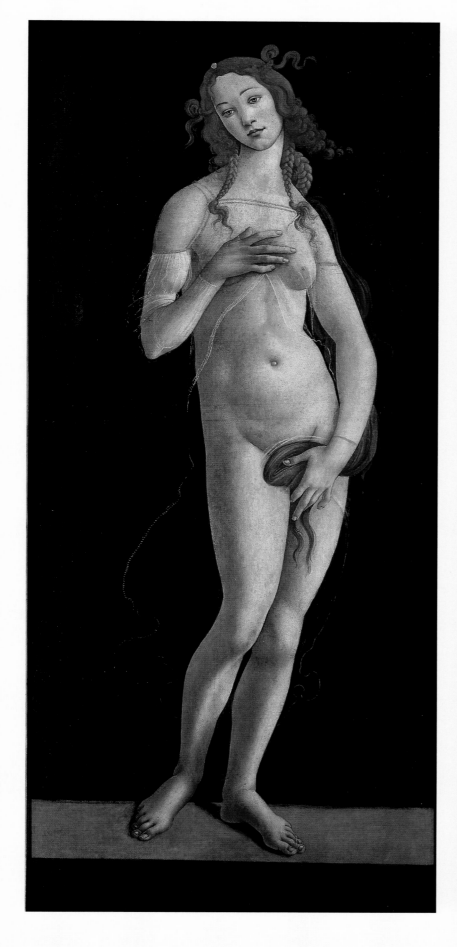

THE LATE WORK

99 *Lamentation over the Dead Christ with the Saints Jerome, Paul and Peter*, ca. 1490
Panel, 140 x 207 cm
Alte Pinakothek, Munich

The dead Christ is lying lifelessly on a fine cloth in his mother's lap, and she has fallen back in a swoon against the shoulders of his favorite disciple, John. The two Marys are gently supporting the head and feet of the crucified man. Mary Magdalene is fearfully and sorrowfully gazing at the crucifixion nails. St. Jerome, St. Paul and St. Peter are observing the moving scene.

The political and religious crisis of the 1490s clearly left its mark on Botticelli's late work. He created fewer monumental works and devoted himself principally to producing devotional pictures and small altars. His themes were now almost exclusively religious ones. In his style there was a decisive change to a hitherto unknown degree of soberness and strictness. In his compositions, he increasingly dispensed with lively decorations, concentrating instead on expressive structuring of the figures. It would be oversimplifying the matter to ascribe this evident change in Botticelli's later works exclusively to the influence of Savonarola, the charismatic preacher of repentance, as Vasari does. If he is to be believed, Botticelli was a keen *piagnone*, a follower of Savonarola, and neglected his work to such an extent that he became impoverished. But quite the opposite must have been the case: Botticelli was reasonably well off, because in 1494 he bought a country house with a piece of land. He also continued to work until after 1500, as is proven by existing works and documents. His patrons would have been both supporters and opponents of Savonarola's. One can therefore safely assume that Botticelli did not take a particularly active part in the disputes between the two opposing parties.

We do, however, know that the artist did not remain unaffected by the events of his time. After all, from 1494 he lived together with a zealous champion of Savonarola's cause, his brother Simone. These topical events were also, as a contemporary reports, actively discussed in Botticelli's workshop. The change in Botticelli's style appears to be an indicator of the spirit of the times shortly before the end of the century, shaped as it was by political unrest and a belief that the last days were at hand.

Two paintings showing the *Lamentation over the Dead Christ* (ills. 99, 101), now kept in Munich and Milan, bear witness to this deep piety, and they are two of the most impressive works of the 1490s. The fascination of these altarpieces lies in the expressive power of the lines and colors as well as the exploration of the feelings of the grieving figures. The intention was for the holy figures to move the faithful to feelings of compassion. The artist has therefore decided against a detailed depiction of the space, doing without anything that might detract from the main events.

In the horizontally rectangular Munich panel painting of the *Lamentation over the Dead Christ* (ill. 99), including St. Jerome, St. Paul and St. Peter, the dark sepulchre in the rock, in which a stone sarcophagus is standing, forms the frame for the moving scene. On the small meadow the traditional group of mourners is gathered, namely Mary, John and the three Marys, and these are joined by three further saints: the two leaders of the apostles, Paul holding a sword and Peter carrying the keys, as well as St. Jerome, who as a penitent and scholar symbolically embodied the religious spirit of the times, and who might also have been the patron saint of the unknown client. St. Paul is present as the patron saint of the church of San Paolino in Florence, for which the work was painted.

The events take place at the very front of the picture, overlapping its edges, and this brings the scene closer to the observer. The composition is permeated by a harmonic rhythm: the heads of the figures at the rear move up and down like waves, and their postures, leaning forward, are in response to the bent body of the dead Christ over which they are lamenting. Only in the figure of the third Mary does Botticelli create a more obvious display of mourning: she is the only one who is urgently lifting her eyes upwards. Her face is full of pain as she gazes on the nails, the instruments of Christ's Passion, and reminds us of the crucified man's suffering.

Botticelli achieved an even greater intensification of the expression of feelings in the Milan *Lamentation over the Dead Christ* (ill. 101), which was probably created a few years later. The vertically rectangular format of the painting made it necessary to group the figures rather closer together. Within the confines of the space, Botticelli organized the figures as a pyramid, within which they also form a cross. He restricted himself to the main group of mourners, joined only by Joseph of Arimathea. According to biblical tradition, it was he who petitioned Pilate to release Christ's body for burial, and made his own tomb available. He is at the top of the lamentation group, presenting the instruments of Christ's Passion as he gazes sorrowfully towards heaven.

100 *Adoration of the Child*
Pen shaded with brown, white heightening and pink wash, 25.8 x 16.1 cm
Galleria degli Uffizi, Gabinetto degli Disegni e delle Stampe (Inv. No. 209E), Florence

The lively kicking child between the melancholy Joseph and adoring Mary is, at first sight, closely related in its motifs to the fresco of the Nativity dating from the 1470s (ill. 44). However, when one looks at the firmer folds and contours, it becomes clear that this work must surely have been created some time later, and there are possible stylistic similarities to the two great Lamentation altarpieces (ills. 99, 101).

101 (opposite) *Lamentation over the Dead Christ*, ca. 1495
Panel, 107 x 71 cm
Museo Poldi Pezzoli, Milan

As in the earlier *Lamentation* in Munich, the scene is brought vividly close to the observer, in order to create feelings of sympathy in him. The group of mourners in front of the dark rock tomb is arranged in the form of a cross. At its top is Joseph of Arimathea. He is gazing painfully up to heaven as he holds out the instruments of Christ's Passion.

This upward movement contrasts with the heavy, bending postures of the other figures, whose weighty robes appear to express the burden of their grief. John is holding and consoling the Mother of God, who has collapsed, in accordance with Christ's request who recommended her to his care before he died. The body of the dead Christ is lying in his mother's lap, and is being gently caressed by the other two Marys. But he almost seems to be sliding towards the observer. Botticelli has reduced the spatial dimensions even more dramatically than in his earlier *Lamentation* and concentrates his viewers' gaze on the most important aspect, the grief being expressed over the dead man. In addition, with the figure of the woman on the left who is completely wrapped in her robes and is hiding her face in her garments, the artist created a bold figure with a degree of urgency in the emotions she expresses which had until then been unknown. She was the figure with which the observer would identify. The painting was indeed commissioned for the remembrance of the dead

in a mortuary chapel, namely that of the Cioni family in Santa Maria Maggiore.

The large altarpiece showing the *Holy Trinity with Mary Magdalene, St. John the Baptist and Tobias and the Angel* (ill. 102) was created for the main chapel in the monastery church of Sant' Elisabetta della Convertite. The patron saint of this monastery, which took in repentant prostitutes, was Mary Magdalene. The nuns called themselves the Magdalenes, after the sinner who was converted by Christ. This explains her prominent position in the altarpiece. She is not dressed in costly garments as in the *Lamentation* pictures, but is wrapped unadorned in her flowing hair; she is standing to the left as an exemplary penitent and ascetic and is worshipping the Holy Trinity in the center of the picture. St. John the Baptist, the patron saint of Florence, is also indicating this point. What we see in the center at first seems unusual, at least if we consider the painting to represent an event in an actual space. For what we see is a particular form of depiction of the Holy Trinity, the

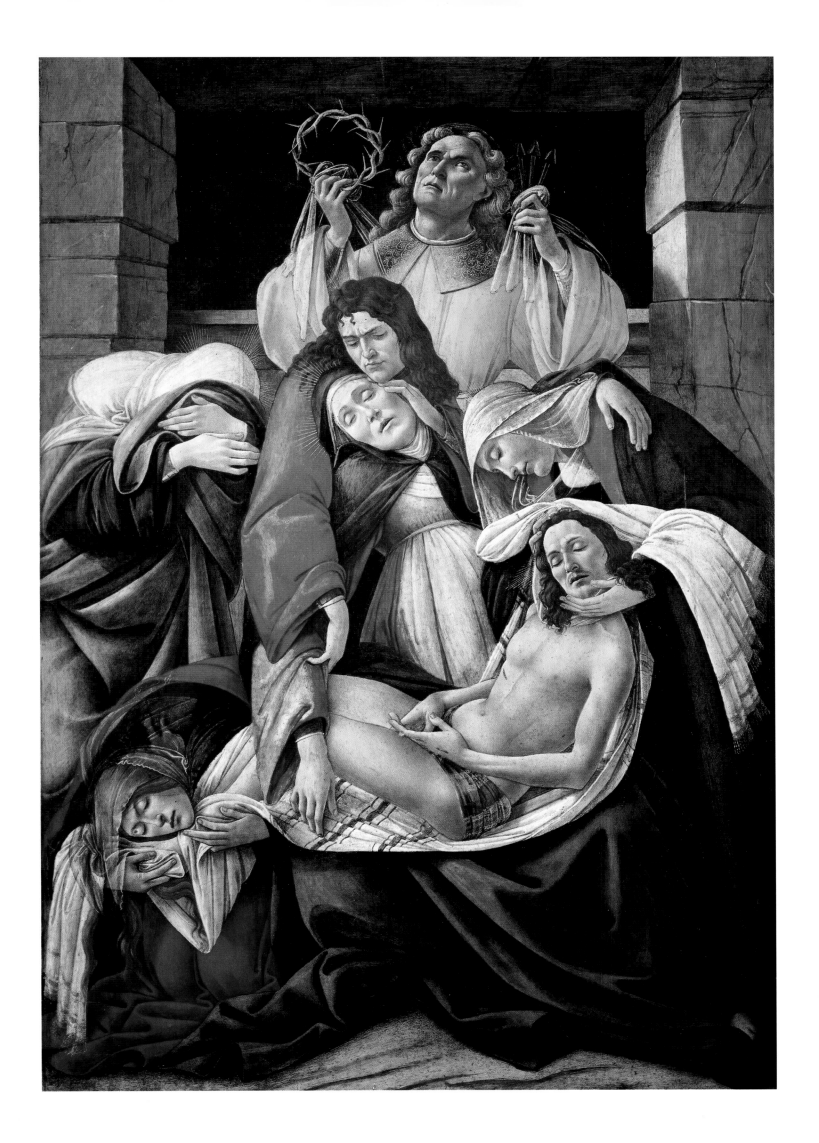

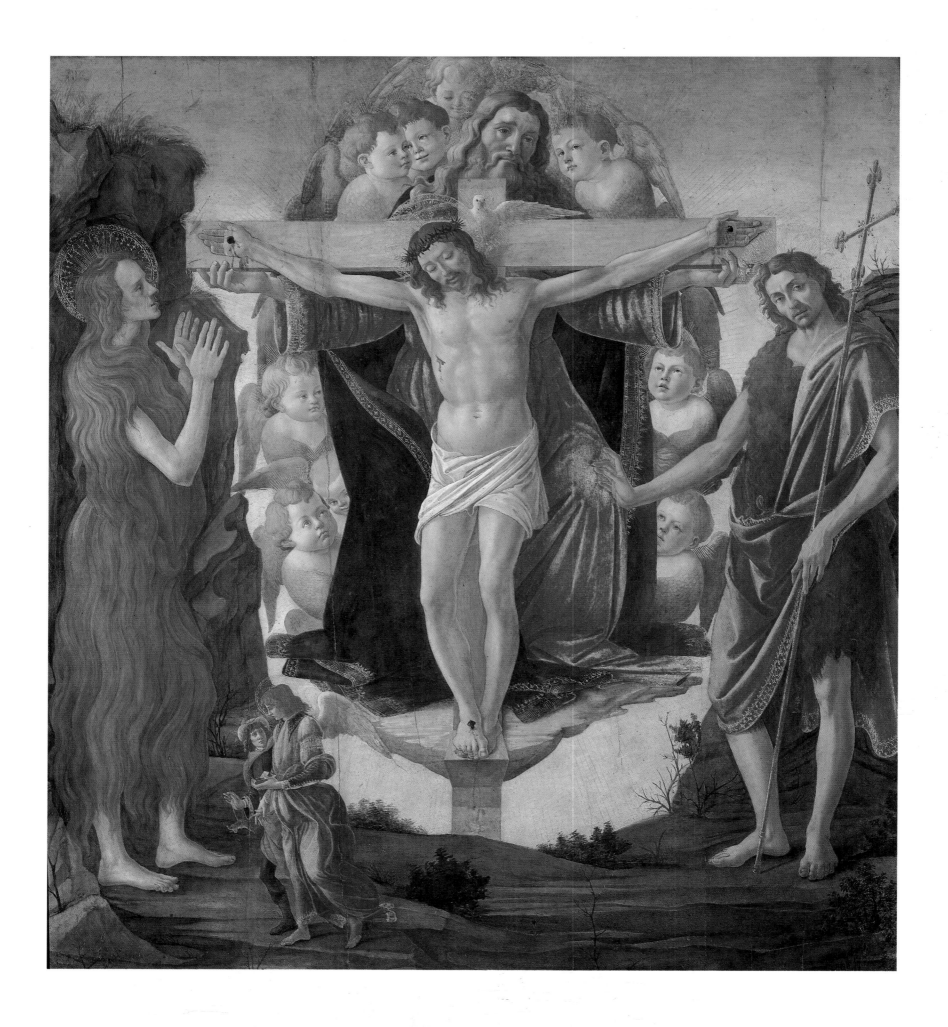

102 (opposite) *Holy Trinity with Mary Magdalene, St. John the Baptist and Tobias and the Angel* (Pala della Convertite), ca. 1491–1493
Panel, 215 x 192 cm
Courtauld Institute Galleries, London

The Holy Trinity appears as a vision between the penitent saints Magdalene and John in a bleak desert landscape. The Baptist is inviting the observer to worship the Trinity, and Mary Magdalene is turning to face it full of emotion. The penitent sinner was the patron saint of the nuns' monastery of the Magdalenes, and this pala or altarpiece was ordered for their church.

103 (right) *Holy Trinity with Mary Magdalene, St. John the Baptist and Tobias and the Angel* (Pala della Convertite), (detail ill. 102), ca. 1491–1493

The archangel Raphael is leading the young Tobias by the hand. He is holding a small box, and Tobias is carrying a fish in a noose. The fish is Tobias' attribute. He was advised by the angel to use its gallbladder to restore his blind father's sight; the miraculous gallbladder was kept in the box.

104 (below) Donatello
St. Mary Magdalene, ca. 1455
Wood, 188 cm
Museo dell'Opera del Duomo, Florence

The exhausted figure of the penitent, a late work of Donatello's, had a decisive influence on Botticelli's Magdalene. Her long flowing hair is covering the ascetic as if it were a garment. Beneath it the shape of her body can be made out, and Donatello depicted it with anatomical precision.

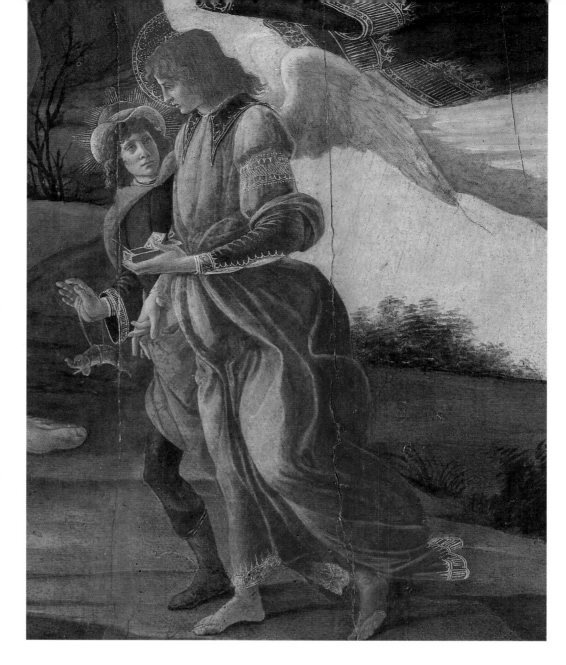

so-called Mercy Seat, in which God the Father is holding his crucified son, above whose head the dove of the Holy Spirit is floating. The Trinity is solemnly surrounded by a mandorla of seraphs. The heavy corporeality of the central figures dominates the scene and appears just as real as Mary Magdalene and John the Baptist. But they nonetheless belong to a quite different level of reality: the two penitents are standing in a desolate and bleak rocky landscape, in the desert in which, according to legend, Mary Magdalene lived for 30 years, and to which John the Baptist also withdrew. There are no sources saying that Mary Magdalene had a vision of the Trinity during this period, but this appears to be just what Botticelli is depicting; for the woman is raising her hands in enraptured astonishment at that which she is seeing. Botticelli makes it clear that the Trinity is 'only' appearing to her by painting the cross so that it does not stand in the landscape but rises above the horizon, in front of the sky.

The figures of Tobias and the angel, which are very small compared to the others, seem puzzling at first as they bear no obvious relationship to the theme of the painting. They might, however, be a reference to the donors of the altar, the guild of doctors and apothecaries. Their patron saint was the archangel Raphael, who used the gallbladder from a fish to help the young Tobias restore his blind father's sight.

The simplification of composition which is so characteristic of Botticelli's later works is also a feature of the small devotional picture *St. Augustine in his Cell* (ill. 105). In contrast to the earlier, much more detailed, though also more monumental fresco showing St. Augustine (ill. 43), we are surprised by this work's bare and less colorful interior. The only signs of life are the crumpled pieces of paper and old quills on the floor. This introduces an element of time into the composition and shows the observer that the scholar has already been sitting and writing at his table for many hours, and, failing to be satisfied with his work, has thrown his notes away. The curtain hanging underneath the coffered vaulted ceiling has been sweepingly pushed to one side, enabling us to see St. Augustine, whose monk's cell is depicted as a narrow classical-style chapel. Botticelli designed this space with great care, as is shown

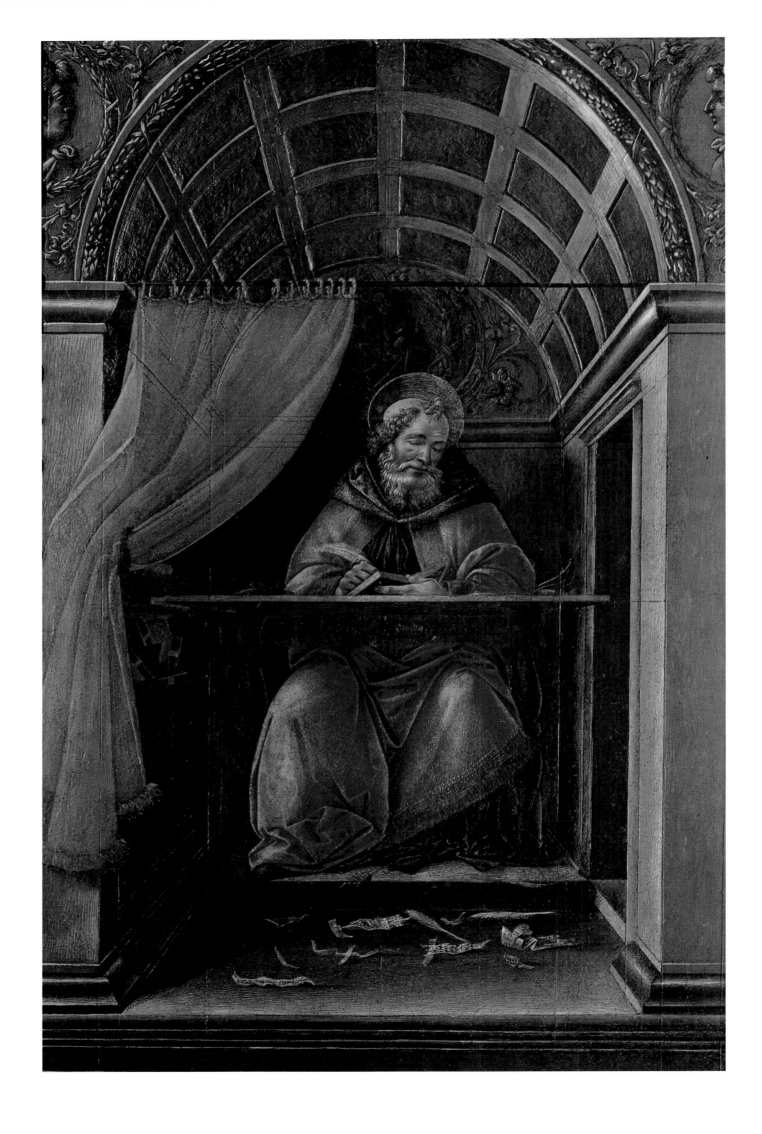

106 *Last Communion of St. Jerome*, ca. 1495
Panel, 34.5 x 25.4 cm
Metropolitan Museum of Art, New York

The painter has opened one of the walls of the hut and has depicted the events in a bare room covered with wickerwork. According to apocryphal tradition, the saint died in a monastery close to Bethlehem. The painting, which is designed for the observer's spiritual edification, presents an exemplary view of the saint's modest way of life.

105 (opposite) *St. Augustine in his Cell*, ca. 1490–1494
Panel, 41 x 27 cm
Galleria degli Uffizi, Florence

This small devotional picture shows St. Augustine the scholar. The worn-out quills and crumpled pieces of paper on the floor are signs of his intensive studies. Under the red bishop's cloak the saint is wearing the habit of an Augustinian hermit, even though he was never a monk. As a result it is assumed that the painting was produced for a prior of Santo Spirito, the only Augustinian hermit monastery in Florence.

by the scratched lines that remain visible underneath the curtain. There are reliefs decorating this structure built of *pietra serena*, a gray stone that was a popular construction material in Tuscany. Botticelli was not interested in the relationship of the figure to the room, for if he was standing St. Augustine would not have enough space in his cell, and the tiny door to the right is also not in any natural proportion to the figure.

The small panel painting of the *Last Communion of St. Jerome* (ill. 106) was also intended as a private devotional picture; it was frequently copied and in the 16th century was considered to be a most singular work. It was probably commissioned by the wealthy wool merchant Francesco del Pugliese, who is known to have been an avid collector of select works of art. His will describes a painting on this theme by Botticelli. The centralized perspective of the construction of the room reminds us of the small painting of St. Augustine, though in this case it is a modest hut made of simple wattle and daub. The artist was primarily interested in the figure of St. Jerome, as he was to be the one honored. For that reason, the saint has a considerably larger head

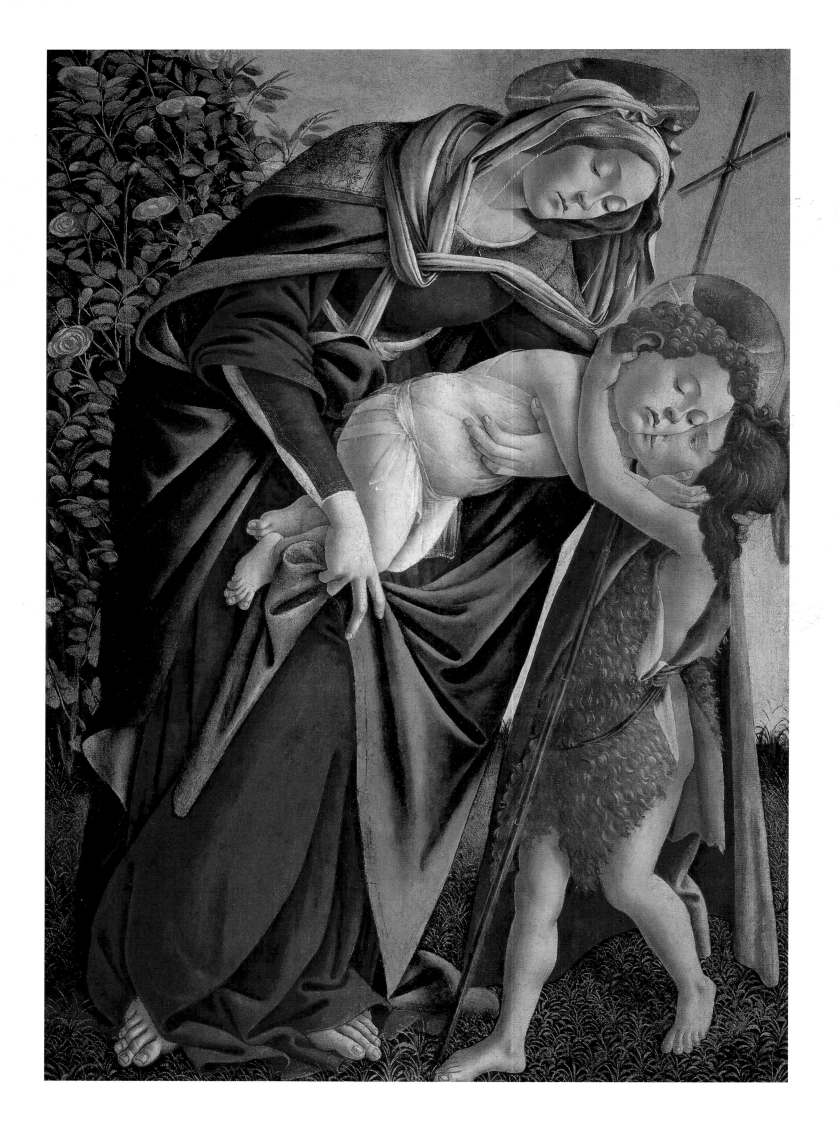

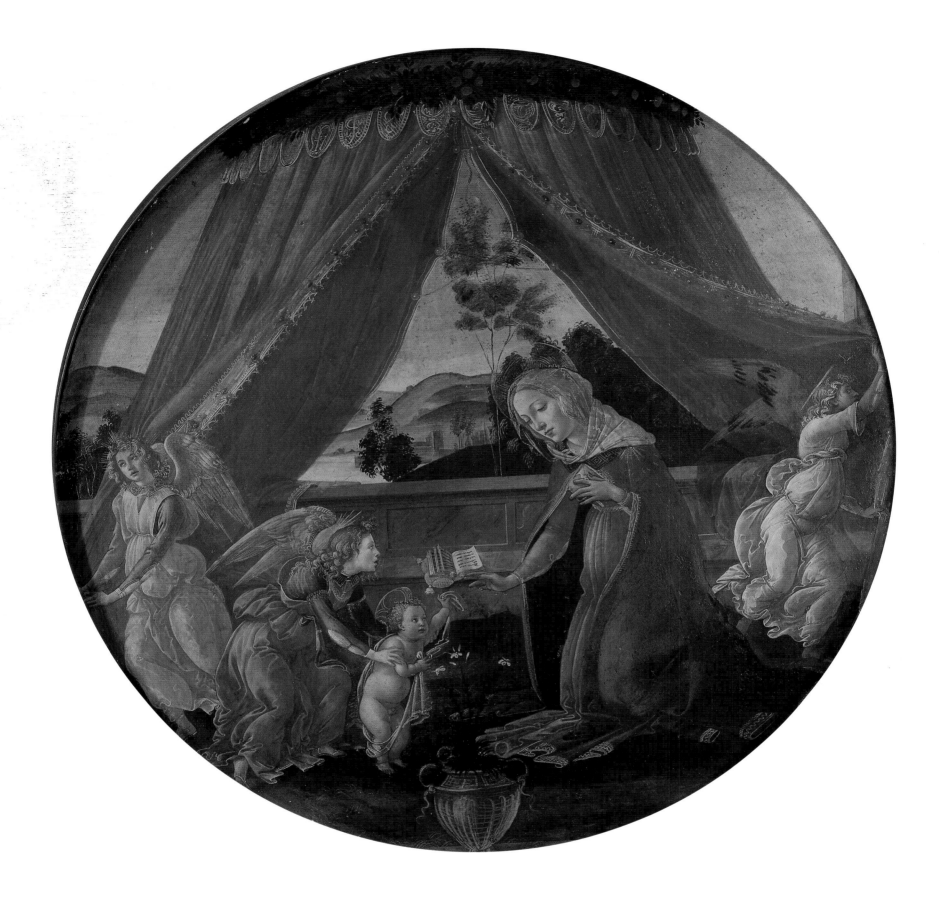

107 (opposite) *Madonna and Child and the young St. John the Baptist*, ca. 1490–1495
Canvas, 134 x 92 cm
Palazzo Pitti, Galleria Palatina, Florence

The Virgin is solemnly handing the Christ Child down to the young Baptist for him to embrace. It is a devotional scene that positively forces the observer to his knees. Its sentimental character reflects the emphatic piety of the early 1490s. The painting was produced in collaboration with Botticelli's workshop. It must have become extremely popular with the public, for several surviving replicas produced by the workshop are known.

108 (above) *Madonna del Padiglione*, ca. 1493
Panel, ø 65 cm
Pinacoteca Ambrosiana, Milan

Two angels are ceremoniously opening the curtains of a baldachin-like tent, underneath which a further heavenly messenger is carrying the Christ Child to his mother. Mary is kneeling and has bared her breast in order to feed the child. The unusual size of the figure of Mary is a characteristic of Botticelli's late work; he frequently emphasized the importance of the main figures in his scenes by increasing their size.

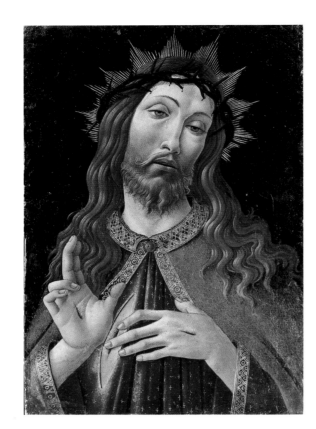

109 Botticelli and workshop
Christ Crowned with Thorns displaying the Stigmata
Canvas, 47.6 x 32.3 cm
Accademia Carrara, Bergamo

Two further versions of the same theme also still exist, and they are now kept in Detroit and Cambridge. There are only slight differences between the three devotional pictures, and they were produced by Botticelli's workshop in accordance with his designs. There are iconographical models in Flemish painting, such as the works of Hans Memling.

110 (opposite) *Crucifixion with the Penitent Magdalene and an Angel (Mystic Crucifixion)*, ca. 1497
Canvas, 73.5 x 50.8 cm
Fogg Art Museum, University of Harvard, Cambridge, Massachusetts

This severely damaged painting is an expression of the fears that arose as the new century came closer. Behind the Cross, in the dark clouds, are devils throwing flames. At the top left, God has sent out angels in order to protect the city of Florence, visible in the distance. Repentance will be needed in order to procure salvation, as is made clear by the figure of Mary Magdalene at the bottom of the Cross.

than the other figures. Even the features of the old man, already bearing the signs of his impending death, are far more strikingly modelled.

Emphasizing the main figure by making it larger, a form of perspective used repeatedly in mediaeval works, can also be seen in various paintings of the Madonna, including the tondo of the *Madonna del Padiglione* (ill. 108). This appears to be the small circular painting that Vasari saw in the room of the abbot of the Camaldolese monastery of Santa Maria degli Angioli in Florence. Though she is kneeling, the Mother of God appears to be gigantic in comparison to the angels and the marble balustrade behind her. In her, Botticelli is depicting a variation of a previously used motif, that of the *Madonna lactans*. The child is not sitting on Mary's lap, but is being carefully brought to her by an angel in order to be fed. To the amazement of the angel, a jet of milk can be seen coming from Mary's bare breast. In contrast, the motif of the two angels holding the red curtains of the baldachin-like tent to one side comes from an earlier painting, the San Barnabas altarpiece (ill. 78). Both the *Hortus conclusus*, bordered by the marble wall, and the lilies in the vase are signs of Mary's purity. In the background we see a landscape, but it plays a subordinate role compared to the main events in the painting and is therefore a standardized view. Leonardo da Vinci criticized his artistic colleague for having

neglected his study of landscapes, and expressed the opinion that Botticelli must have considered such studies unnecessary, as he clearly felt it sufficient to throw a sponge soaked in various colors against the canvas and allow the observer to imagine a beautiful landscape in the stain thus created.

Informative evidence of the unrest and fears towards the end of the century is provided in the form of the extremely poorly preserved, small format painting of the *Mystic Crucifixion* (ill. 110) which shows the penitent Mary Magdalene and an angel. Savonarola and other preachers prophesied that the impending evil would pass Florence by with God's help, but only if people repented and did penance. The *Mystic Crucifixion* appears to reflect the three stages of flagellation, repentance and divine salvation. The right part of the picture is dominated by little devils throwing flames and dark clouds of smoke. An angel is using his sword to attack an animal that is difficult to identify, though it is probably a lion, possibly used as a symbol of the sin of pride. At the foot of the Cross, which is covered with the blood streaming from Christ's wounds, a beautiful woman is kneeling in penitence. She is a combination of the figure of Mary Magdalene, who was frequently depicted in this position, and a personification of the city of Florence, which contemporary poetry often referred to as *bella donna* (beautiful woman). Hurrying off to the left, under her heavy cloak, is either a fox or wolf. These animals are ancient symbols of miserliness and fraud. God's mercy saves the city of Florence, which is lit up brightly in the background. God the Father is sending angels from his throne at the top left, though these are scarcely recognizable any more today. They are behind the shields bearing the coat of arms of the city of Florence, fighting the devils. An edict was issued on 8 May 1497, ordering that this coat of arms, a red cross on a white background, should replace the coat of arms of the exiled Medici family in all public places. This date gives us an indication as to when this painting was produced, and the man who commissioned it would surely have been a supporter of Savonarola.

There were probably similar reasons behind the creation of the only painting which Botticelli dated and signed, the *Mystic Nativity* (ill. 111). A zigzagging path leads through the rising foreground towards the main scene, a combined depiction of the Birth and Adoration. Mary is adoring the child in the cave of its birth, which also functions as a stable with an ox and ass. Joseph is sitting next to her. Other figures, two shepherds on the right and three men dressed in more stylish robes on the left, are adoring the child under the guidance of angels. On the banderole the angel on the left is holding it says: "Behold the Lamb of God". Three angels on the stable roof are singing to the child, and the round dance of angels in the golden heaven above are praising Mary.

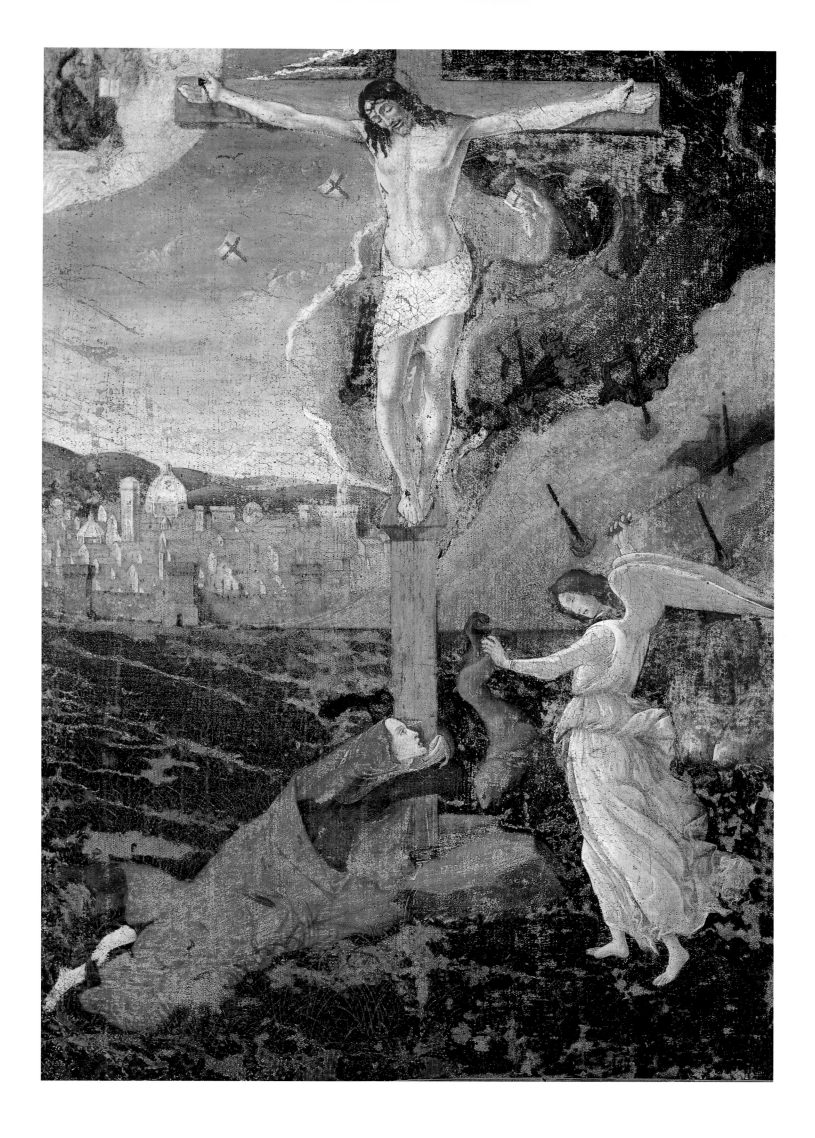

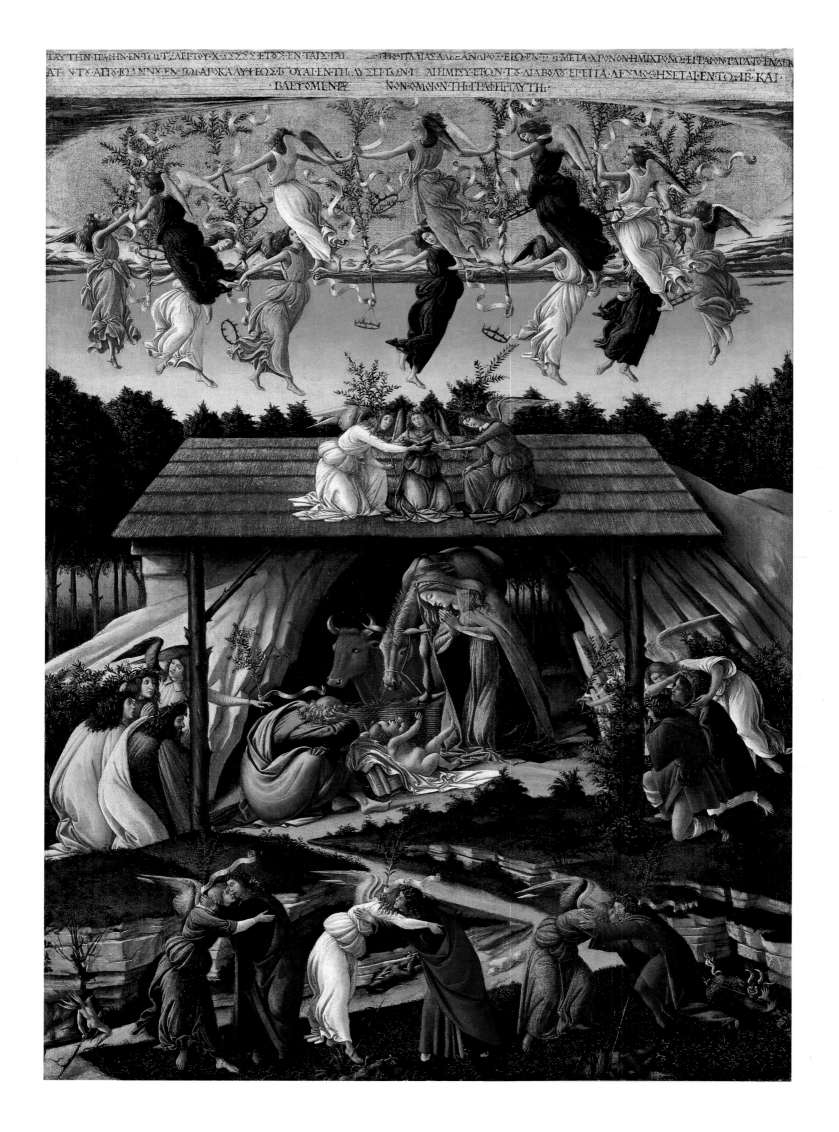

The words on their banderoles are glorifying the Mother of God. Due to her disproportionately large size, she is the main figure in the painting. In defiance of the laws of perspective, the figures in the foreground, both angels and the people who are embracing each other tenderly, are depicted as being smaller than the figures in the background. The key to this mysterious painting is the Greek inscription that Botticelli wrote at the top of the picture. It reads:

"This picture, at the end of the year 1500, in the troubles of Italy, I Alessandro painted, in the half time after the time, at the time of the fulfilment of the 11th of St. John in the second woe of the Apocalypse, in the loosing of the devil for three and a half years. Then shall he be chained according to the 12th and we shall see [him fall] as in this picture."

The inscription relates to the Revelation of St. John. Botticelli considered Italy to be suffering the second of the prophesied woes, which he interpreted as the threat of the loosed devil. His picture, however, shows how the devil is vanquished in accordance with the twelfth chapter of Revelation. There is a peaceful state of harmony, and the little devils are creeping back into their holes. As a sign of peace, the people and angels are wearing wreaths of olive twigs, or carrying them in their hands. The banderoles fluttering from the branches which the figures in the foreground are holding read: "Peace, good will toward men."

The twelfth chapter of Revelation speaks of the woman of the Apocalypse and her child. They are both threatened by a dragon, the symbol of Satan; but he is defeated by angels. In the interpretation of the Bible, this woman was equated with Mary and also considered to be a symbol of the Church. Botticelli is depicting the birth of the Redeemer as an allusion to the apocalyptic vision and, at the same time, the renewal of the Church by Mary. His painting is full of hope that a new age of peace will dawn as surely as the bright light of day that is growing stronger behind the stable.

It is quite rightly thought that Botticelli's pictorial program was strongly influenced by Savonarola, who was eventually excommunicated and sentenced to death by the Church. There are a series of symbolic references in the painting which are derived from his body of thought. They include the olive branches, which were carried and worn in the hair by children during the monk's processions of repentance, or the words on the banderoles held by the angelic round dancers, which are quotations from one of the monk's treatises. The pictorial program was probably specified by the client himself, and it is safe to assume that Botticelli himself was receptive to this body of thought. In his diary his brother Simone, who was a strong supporter of Savonarola and therefore had to leave Florence after his death, writes about a conversation that Botticelli held in 1499 with one of the examining magistrates from the trial of Savonarola. According to this conversation,

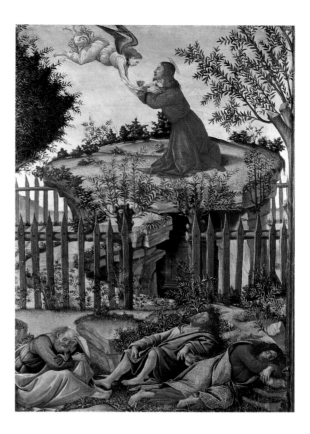

Botticelli quite openly asked why the monk was to be put to such an ignominious death and what sins he had been found guilty of committing. This shows that he spent some time considering Savonarola's ideas and was eager to discuss them.

The small devotional panel painting *Christ Praying in the Garden of Gethsemane* (ill. 112) was probably created at roughly the same time as the *Mystic Nativity*. This is suggested by the similar conception of the landscape: lumps of rock covered with grass are spread out across the bottom of the picture, and a path snakes its way into the background. The cave containing the sarcophagus is an allusion to Christ's tomb and thus his impending death. Botticelli emphasizes the main scene by means of the wooden fence that encloses the garden. In his attempts to visualize the scene as described in the Gospels, he achieves an almost naive degree of vividness. As the Garden of Gethsemane was on the Mount of Olives, he shows Christ kneeling on a hill surrounded by olive trees. An angel floating down from heaven is carrying a chalice; according to the Gospels, Jesus was in such an agony of fear that he begged that this cup should be removed from him. It does not appear to have interested the artist that these events are supposed to have taken place at night. But he does keep more closely to the text in his depiction of the apostles Peter, John and James who are lying, overcome by sleep, in front of the garden.

112 (right) *Christ Praying in the Garden of Gethsemane*, ca. 1500
Panel, 53 x 35 cm
Museo de la Capilla Real, Granada

In 1504, the painting was housed in the royal mortuary chapel of Isabella the Catholic of Castile. It is the only work by Botticelli that we know left Italy while the artist was still alive. It is possible that it was taken to the court of Castile by a businessman. Due to its size it would have been easy to transport.

111 (opposite) *Mystic Nativity*, 1500
Canvas, 108.5 x 75 cm
The National Gallery, London

The Greek inscription at the top edge of the painting defines its theme from the Book of Revelations. The birth of this child will bring salvation. Angels and people are embracing, and little devils are hiding themselves in holes in the earth. This is the only work that Botticelli signed and dated.

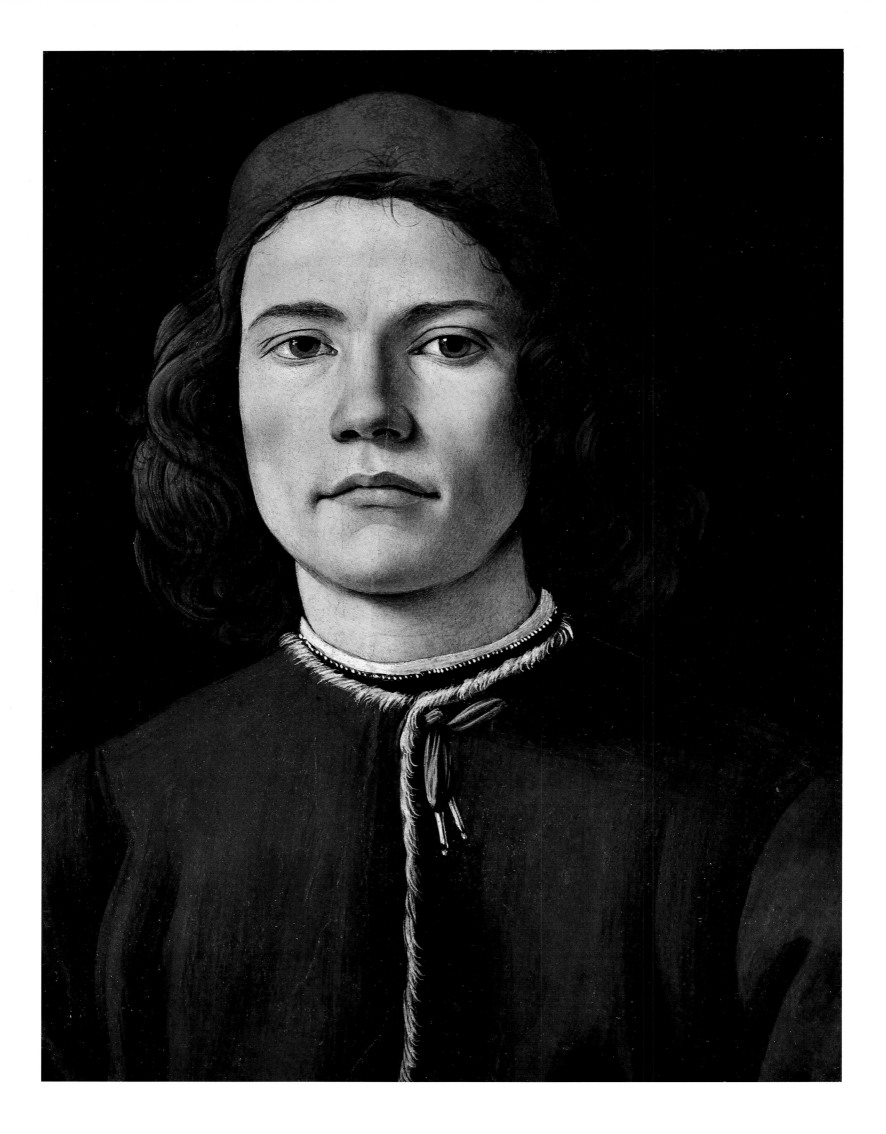

113 (opposite) *Portrait of a Young Man*, ca. 1485
Panel, 37.5 x 28.2 cm
The National Gallery, London

In his later portraits Botticelli frequently dispensed with landscapes or interiors in the background, instead concentrating solely on the person being portrayed. One of his most beautiful portraits is that of the unknown young man wearing a red cap, the only known *en face* portrait by the artist. It is captivating due to the vivid and alert presence of the model, whose youthful informality the artist has succeeded in capturing masterfully.

114 (right) *Portrait of a Man* (Michele Marullo Tarcaniota?), ca. 1489–1494
Panel transferred to canvas, 49 x 53 cm
Colección Guardans-Cambó, Barcelona

This is probably Botticelli's portrait of Michele Marullo Tarcaniota (ca. 1454–1500), a famous Greek poet, soldier and humanist who frequently stayed in Florence as a guest and friend of Lorenzo di Pierfrancesco de' Medici. This is confirmed by comparing the picture with another portrait of the poet. It is likely that the work dates from the period between 1489 and 1494, when Marullo spent a long period in Florence, and this also ties in with the age of the man in the portrait.

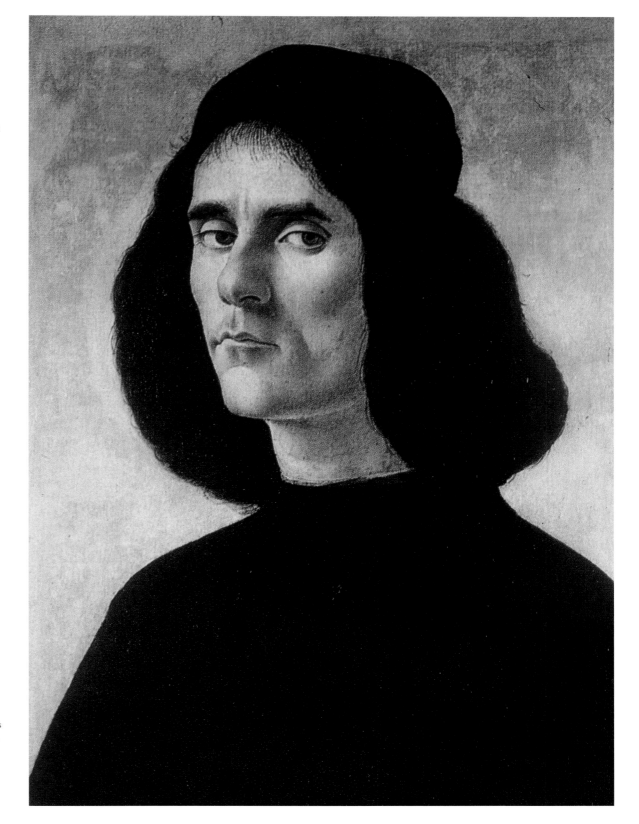

The book illustrations for the "Divine Comedy" written by the famous Florentine poet Dante Alighieri (1265–1321) are amongst the finest examples of Botticelli's work. There still exist 94 drawings for an illustrated manuscript, and they are now in the collections of the Berlin Kupferstichkabinett and the Vatican Library. In addition, the designs for nineteen copper engravings, probably produced by Baccio Baldini to illustrate the first Florentine edition of 1481, are also attributed to Botticelli. In his Comedy (Commedia), which was first called the "Divine" ("La Divina") by his biographer Giovanni Boccaccio, Dante wrote over 14,000 verses describing his visionary journey through the kingdoms of Hell (*Inferno*), Purgatory (*Purgatorio*) and Paradise (*Paradiso*). The epic is divided into 100 cantos: 34 for Hell, and 33 each for Purgatory and Paradise. Dante is at first guided on his journey by the classical poet Virgil, but in Paradise he is led by his muse, Beatrice. During his journey Dante meets a large number of nameless people, and also famous personalities from the past and his own age. Every one of them has received the place he deserves as a result of the offences or merits of his life. Procurers and seducers, for example, belong in Hell and are forced to run neverendingly in a circle, whipped by furious devils (ill. 119).

An illustration was originally planned for each of the cantos of the "Divine Comedy", the publishing of which in 1481 was an ambitious project on the part of the Florentine humanist Cristoforo Landino, who wrote an extensive commentary on the text. In the end, only the copper engravings for the first nineteen cantos were carried out. As the majority of them were added to the books at a later stage, it is likely that they were produced over a longer period of time, though they would surely have been completed by 1487 at the latest, the year the copper engraver, Baldini, died. As Botticelli returned from Rome to Florence in 1482, it is assumed that the designs were produced from this year onwards.

Botticelli also appears to have started work in the 1480s on the drawings for the manuscript, and they are a development of the compositions for the copper engravings. It is probable that he continued work on the project into the late 1490s. According to a 16th century source, his client was Lorenzo di Pierfrancesco de' Medici (1463–1503), a cousin of Lorenzo the Magnificent. It is not clear why the book illuminations were not finished, as all the drawings, on fine sheepskin parchment, were presumably to be colored like the sheet for the 18th canto in Hell (ill. 119) and the *Abyss of Hell* (ill. 116). The drawings, which were produced in silver point and mostly retraced with pen and ink, are so vivid and elegant that they fascinate us despite their lack of color. On several occasions, Botticelli – who also left his signature on two sheets for Paradise (canto XIV and XXVIII) – depicted the main figures in Hell and Purgatory in a unified pictorial space, so that the reader could follow their ongoing journey. The illustrations are a most singular visualization of Dante's text, which the artist must have studied in great detail.

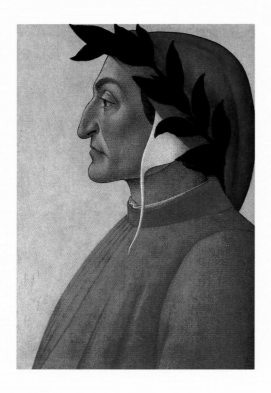

115 *Portrait of Dante*, ca. 1495
Canvas, 54.7 x 47.5 cm
Private collection, Geneva

The striking profile of the poet, which has been drawn over in black, clearly contrasts with the light background. In accordance with traditional depictions, Dante is wearing a red cloak and red cap above a white bonnet. Botticelli was surely familiar with Domenico de Michelino's fresco of Dante in Florence Cathedral, as this was the first to show the poet with a laurel wreath on his head.

116 *The Abyss of Hell*
Colored drawing on parchment, 32 x 47 cm
Biblioteca Apostolica Vaticana, Vatican City, Rome

Dante imagined Hell as being an abyss with nine circles, which in turn divided into various rings. Botticelli's cross-section view of the underworld is drawn so finely and precisely that it is possible to trace the individual stops made by Dante and Virgil on their descent to the center of the earth.

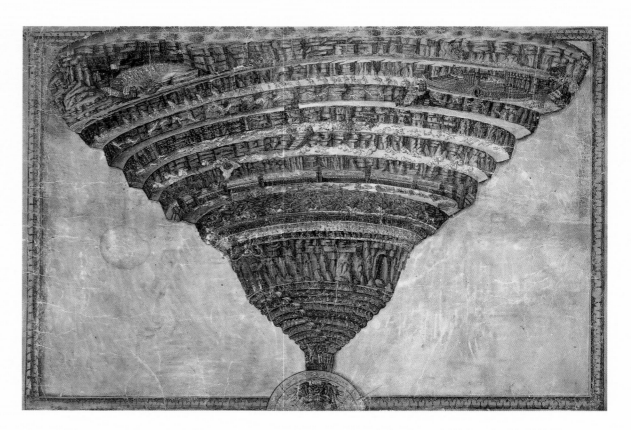

117 Baccio Baldini after Botticelli
Inferno I, ca. 1481
Copper engraving
Biblioteca Riccardiana, Florence

Botticelli's designs for the copper engravings were
probably the starting point for his manuscript drawings.
This is not the only place where the marvellously pensive
figure of Dante was reused. Botticelli also repeated this
figure twice in his paintings, on both occasions in the first
panel of the picture cycles on the *Story of Nastagio degli
Onesti* (ill. 60) and the *Story of St. Zenobius* (ill. 127).

118 *Inferno I*
Drawing on parchment, 32 x 47 cm
Biblioteca Apostolica Vaticana, Vatican, Rome

The drawing for the introductory canto shows Dante
before he begins his journey. He is thoughtfully walking
through a gloomy forest. His onward journey to the
sunny peak of the mountain is hindered by a panther, a
lion and a she-wolf. They are symbols of the sins of Lust,
Pride and Avarice. Virgil appears from behind a hill in
order to lead Dante through Hell and Purgatory. Due to
damage to the parchment, it is almost impossible to make
out the second drawing of Dante, probably in a sitting
position.

The connection between the pictures and text in the
work, which was originally produced as a bound
manuscript, has since been lost. Its well-considered
conception has, however, been reconstructed in a fascimile
by Peter Dreyer. It shows that Botticelli's Dante drawings, in
contrast to earlier Florentine illuminated manuscripts,
would have been full page illustrations enjoying equal
prominence with the text itself. The landscape format pages
were bound along their long edge. One turned the pages
from bottom to top, so that the drawings could always be
admired at the top, and below them, on the following page,
the complete text of the particular canto being illustrated
could be read. In this equally strict and happy juxtaposition
of text and illustration, as well as the complexly conceived
and sensitively executed drawings, Botticelli's adaptation of
Dante marks a milestone in European book and art history.

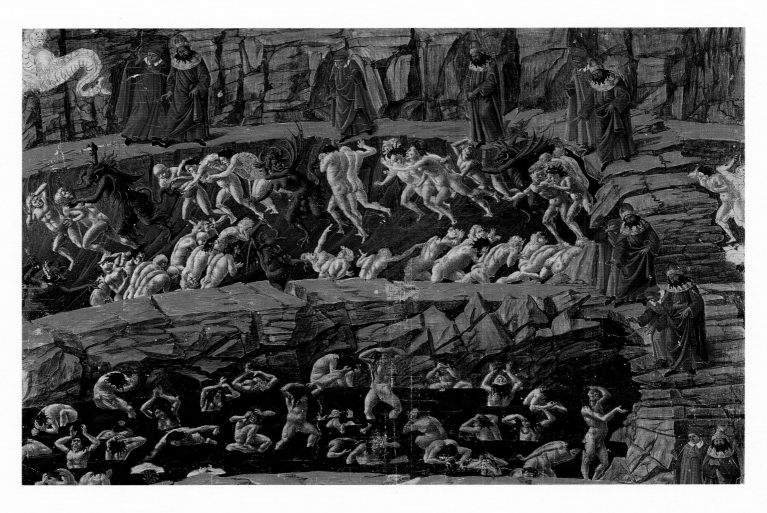

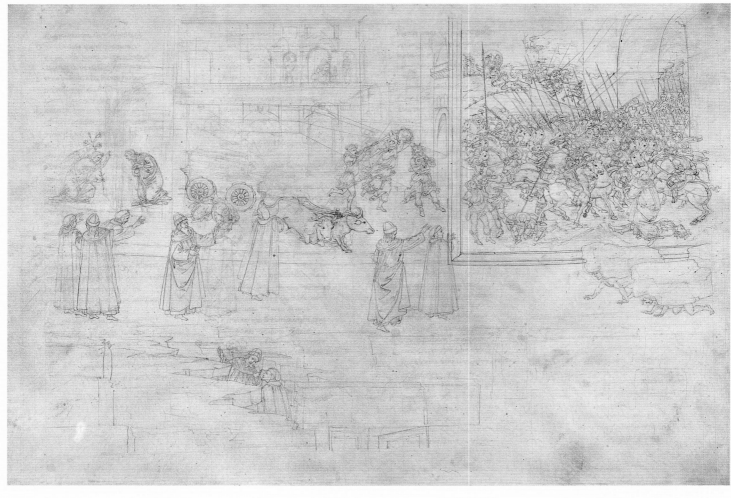

119 (opposite, top) *Inferno XVIII*
Colored drawing on parchment, 32 x 47 cm
Staatliche Museen Preußischer Kulturbesitz, Kupferstichkabinett,
Berlin

This almost completely colored page gives us an impression of the
magnificent way in which all the miniatures were to be produced.
The main figures, Dante and Virgil, are emphasized by their
vibrantly shining robes. While journeying through the ditches of
Hell, they first encounter the souls of procurers and seducers
being tortured by devils, and then those of sycophants and
prostitutes, who are being made to suffer while immersed in
ordure.

120 (opposite, bottom) *Purgatory X*
Drawing on parchment, 32 x 47 cm
Staatliche Museen Preußischer Kulturbesitz, Kupferstichkabinett,
Berlin

Dante and Virgil climb up between rock crevices to the first circle
of purgatory. They admire reliefs depicting deeds of exemplary
humility on the huge marble walls: the Annunciation to Mary, the
dance of David in front of the Ark of the Covenant and the justice
of the Emperor Trajan. Two of the proud are creeping up from the
right, bent beneath the weight of heavy stones.

121 (above) *Paradise XXX*
Drawing on parchment, 32 x 47 cm
Staatliche Museen Preußischer Kulturbesitz, Kupferstichkabinett,
Berlin

In the Empyrean, the upper heaven, Dante and Beatrice are
carried upwards in a river of light, from which fly sparkles which
Botticelli depicts as little putti. They disappear in the meadows of
flowers along the banks on either side. The one on the right had
not been retraced with ink and was a preliminary drawing carried
out in silver point.

THE LAST SCENIC WORKS

The ability to give the written word visual form in painted pictures is also something that sets Botticelli's later scenic works apart. The small painting of the *Calumny of Apelles* (ill. 122) was probably not a commissioned work. Botticelli presumably created the work on his own initiative, for Vasari tells us that he made a present of it to his friend Antonio Segni. Botticelli chose a classical theme dating back to a painting by the great Greek painter Apelles. It was a well-known work in the 15th century. Lucian's description of this lost work by the classical artist had been widely translated, and in his treatise "On Painting", the art theoretician Alberti recommended this "beautiful invention" to artists. Apelles produced his painting because he was unjustly slandered by a jealous artistic rival, Antiphilos, who accused him in front of the gullible king of Egypt, Ptolemy, of being an accomplice in a conspiracy. After Apelles had been proven to be innocent, he dealt with his rage and desire for revenge by painting this picture.

In his own painting, Botticelli kept the scenic structure of the composition of the figures both to Lucian's description and Alberti's instructions, and created a lavishly decorated architectural backdrop for them consisting of sculptures and reliefs: it is a large loggia divided by three barrel vaulted arches. They open out onto a peaceful gray-green sea under a pale blue sky. A defenceless youth is being dragged before the king's throne. Two beautiful women are standing on either side of the king, and they are personifications of Ignorance and Suspicion. They are gesturing imploringly as they whisper into his large and apparently all too receptive ears. Pressured in this way, the king is leaning forward and stretching his hand out for help. He is looking down, and for that reason does not see the sinister man in front of him, dressed in a dark habit, who is making imperious gestures and is the embodiment of Envy. Envy is drawing Calumny behind him, and she in her turn fixes a cold stare on the youth, dressed only in a loin cloth, as she mercilessly drags him along behind her. He is naked as a symbol of his innocence, which he is affirming with his imploring folded hands. The servants of Calumny, Malice and Fraud, are busy arranging their mistress' hair and decorating it with rose flowers and

white ribbons. Her lies are to remain hypocritically concealed behind the pretty decorations in her hair and the blinding splendor of her sumptuous garments. Remorse, a bent old woman in a dark mourning cloak and torn garments, follows at a slight distance. She sorrowfully turns towards naked Truth, who is pointing towards heaven. The nakedness of the latter places her in a relationship with the innocent youth, whose folded hands are also an appeal to a higher power.

It is not certain why Botticelli created this painting. It is possible that he wanted to pit himself against the art of the great Apelles and prove that he was his equal, as the poet Ugolino Verino wrote in praise of Botticelli. There may also be a hidden political message in the painting. Many interpretations have been suggested for the painting, without any of them becoming entirely clear. What is not disputed is that the precious nature of the small painting, executed with the fineness of a miniature, is pleasing both to the eye and the mind; the various relief scenes on the architectural backdrop are an example. They depict mythological, literary and religious themes, including ones that Botticelli dealt with in his works; examples are the story of Nastagio degli Onesti in the left barrel vault or that of Judith at the top right. The sculptures in the pillar niches are classical and biblical heroes as well as saints, though the poet Boccaccio was also included as the second figure from the right.

Botticelli also set dramatic scenes amidst a lavishly decorated architecture in the paintings of *The Story of Virginia* (ill. 123) and *The Story of Lucretia* (ill. 125). It is thought that the two panels formed a pair. The ancient Roman writer Livy, who told the stories of the two Roman heroines, also connected Virginia and Lucretia with each other. The fate of each set important political changes in motion.

Above all it was Lucretia who was praised in contemporary Italian literature as a model of female virtue; in painting her story was frequently depicted on *cassoni*, Italian marriage chests. Due to their long horizontal format, it is likely that Botticelli's panel paintings were commissioned on the occasion of a wedding and were probably meant to be set into wall panelling.

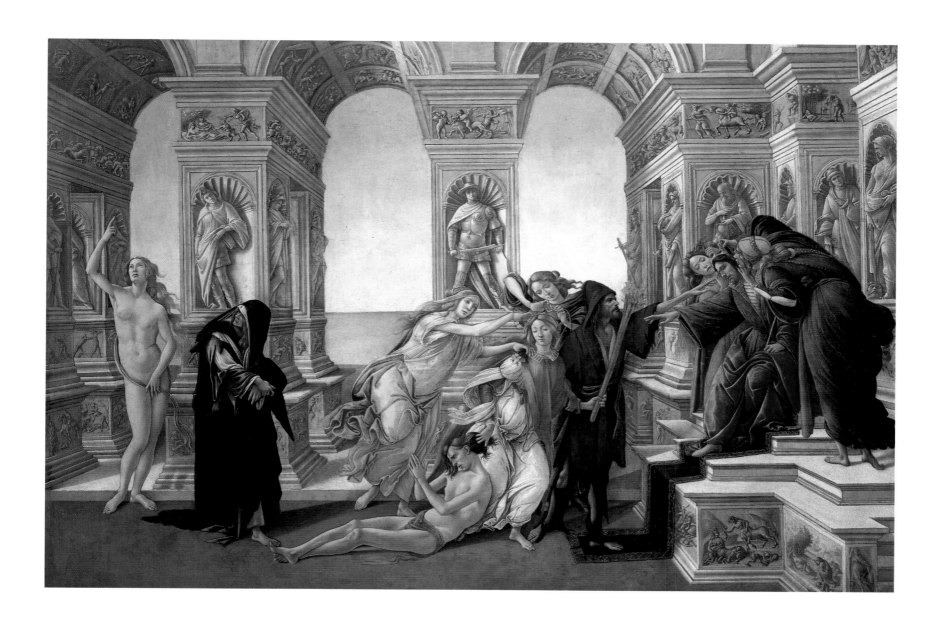

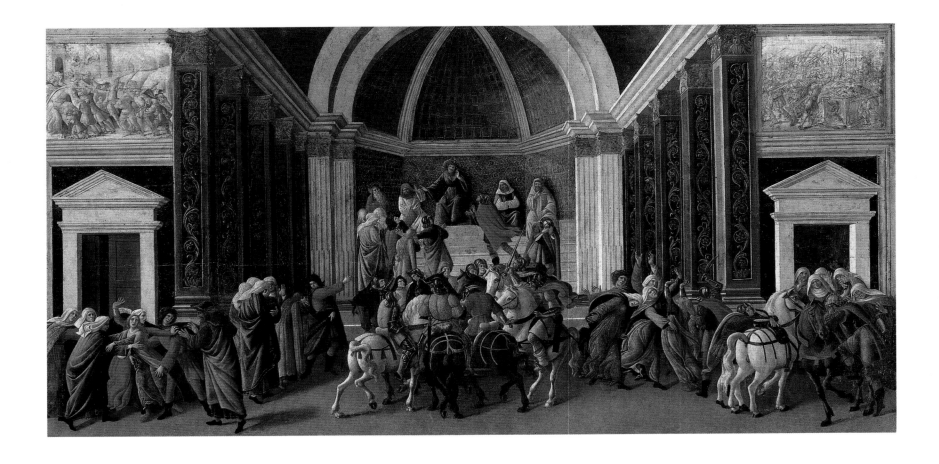

123 *The Story of Virginia*, ca. 1496–1504
Panel, 85 x 165 cm
Accademia Carrara, Bergamo

The panels on the subjects of Virginia and Lucretia (ills.
123, 125) were produced to be hung together. The
classical writer Livy wrote the stories of the two Roman
heroines. The beautiful, virtuous Virginia becomes the
victim of an intrigue of the dastardly decemvir Appius
Claudius, and despite her innocence is to be condemned
to a life of slavery. In order to avoid this disgrace, she is
stabbed to death by her father. The events lead to a revolt
against Rome's tyrannical decemvirs.

A large number of small figures populate the
generously conceived monumental pictorial spaces. The
strong, contrasting colors of their garments underline
their vehement, dramatic gestures. Botticelli also makes
effective use of the architecture, connecting the classical
and contemporary forms in the interior and exterior. It
defines a harmonious pictorial space within which the
various scenes of the story are taking place. On the panel
painting of Virginia, Botticelli starts on the left by
depicting the first scenes in a dramatically rising line.
The beauty of Virginia beguiles the dastardly Appius
Claudius, one of the power-obsessed decemvirs, or in
other words one of the ten men who laid down the laws
in the Roman republic. The virtuous young woman,
however, repulsed his advances, whereupon Appius
Claudius had her taken to court and condemned to
slavery. Botticelli makes the judge's decision the high
point of his painting. Virginia's father, in a red cloak, is
begging for mercy on behalf of his daughter, but then
turns away in despair; this movement takes us into the
next scene where, in order to save his daughter from
disgrace, he stabs her to death. On the far right he is
fleeing on horseback. In the center of the painting
Botticelli is highlighting the soldiers' revolt that was
caused by the unjust sentence.

The scenes in *The Story of Lucretia* (ill. 125) are
structured in a similar fashion. Once again, the soldiers'
revolt takes center stage, and the preceding episodes are
grouped around it. On the left Lucretia, the virtuous
wife, is pestered by the lustful Tarquinius, the king's son.
On the right her husband and father are returning from
battle with their comrades only to find that Lucretia,

having been raped by Tarquinius, has swooned out of
despair at the way in which she has been humiliated. In
order to regain her honor, she stabbed herself to death
immediately. In the center of the picture, her corpse is
on public display as if she was a heroine. Above the dead
woman, Brutus is calling on the army to take revenge.
The soldiers are rushing up in front of the triumphal
arch and the statue of David which is placed high on a
column.

As in the panel depicting the story of Virginia, the
center of the picture is taken up by the revolt against the
arbitrary misuse of power. By requesting this, the client
was clearly expressing his own republican views, which
had presumably made him an opponent of the Medicis
who were driven out of Florence in 1494.

One reference to this on the Lucretia panel is the
prominent location of the statue of David, who
vanquished the mighty Goliath. This may well be an
allusion on the part of Botticelli to a contemporary event
in Florence: in 1495 the famous bronze *David* by
Donatello was moved from the Medici palace courtyard
and erected in front of the Signoria, the seat of
government. Donatello's bronze group *Judith and
Holofernes*, which had also belonged to the Medicis, was
placed next to *David*. A tablet bearing the following
inscription was added to it: "Erected by the citizens as
an example of our public deliverance 1495". It is
therefore no coincidence that Botticelli also depicted a
scene from the story of Judith above the left palace
portal. The presence of David and Judith in the painting
is therefore symbolic of the people's uprising against the
Medicis. Even though, as is the case in many of

124 *The Story of Virginia* (detail ill. 123),
ca. 1496–1504

Botticelli structures the dramatic scene, in which Virginia
is stabbed to death by her father Virginius, by means of a
lively grouping of vehement gestures. The sorrowful faces
of the mourning women are typical of Botticelli's late
style. Virginius is turning his head to the right, creating a
link to the next scene, and this is a characteristic trick of
Botticelli's which he frequently used to connect various
episodes with one another.

125 *The Story of Lucretia*, ca. 1496–1504
Panel, 83.5 x 180 cm
Isabella Stewart Gardner Museum, Boston

While her husband is away, the virtuous Lucretia is raped by Tarquinius, the king's son. On the right we see how she is found unconscious by her husband and his companions. In order to save her honor she takes her own life. On the heroine's bier in the center of the picture, Brutus is calling on the army to take revenge. The revolt will lead to the fall of the kingdom of Rome.

126 (opposite) *The Story of Lucretia* (detail ill. 125), ca. 1496–1504

Above the scene in which Lucretia is pestered by her rapist, Botticelli shows a relief featuring Judith, the biblical heroine who freed her people from Holofernes' siege. Both women, Lucretia and Judith, were considered to be republican symbols of freedom.

Botticelli's later works, we do not know who commissioned the work, it is nonetheless safe to assume that he was an opponent of the Medicis.

Another figure who was particularly venerated in Florence was St. Zenobius, who was the city's first bishop. In the 15th century an active cult dedicated to this local saint, who died in 417, was revived. In 1439 his relics had been transferred to the main chapel in the cathedral choir. In 1491 work was started on decorating the vault in this chapel with mosaics, and Botticelli was involved in the project. But the work was never completed. Instead, Botticelli created a four part cycle of paintings (ills. 127–130) in which he depicted the deeds and miracles of St. Zenobius. A description of the life of the saint, published in 1487, may well have been one of the artist's sources.

In contrast to the paintings of Lucretia and Virginia, the individual scenes are not placed within a picture space that consistently obeys the laws of perspective. Instead, they are self-contained episodes arranged next to each other before an alternating architectural scenery, and in each painting the scenes can be taken from left to right. The architectural backdrop behind the figures is made up of Renaissance and mediaeval palaces or classical fantasy constructions. Botticelli solved the problem of having to depict scenes that take place indoors by opening the façade of the relevant building; an example of this is the third painting (ill. 129). Botticelli intensifies the lively movement of the figures, their effusive and dramatic gestures, to a new level of expressive intensity by means of restless, sharply drawn lines.

The St. Zenobius panels are probably the last works that Botticelli completed. In his later years he started an *Adoration of the Magi*, but never finished it; the painting was colored in the 18th century and is now in the Uffizi in Florence.

The few late works by Botticelli that still remain suggest that he worked little after 1500, the last years of his life. If Vasari is to be believed, the artist became increasingly frail and was forced to abandon his painting. However, we also know that in 1502 agents working for the Duchess of Mantua, Isabella d'Este, suggested that he would be "an excellent and available artist" to decorate her study. In 1504 he was a member of the commission which made the decision concerning the location of Michelangelo's *David*. The last years of Botticelli's life are shrouded in mystery. On 17 May 1510, he was buried in the Ognissanti cemetery.

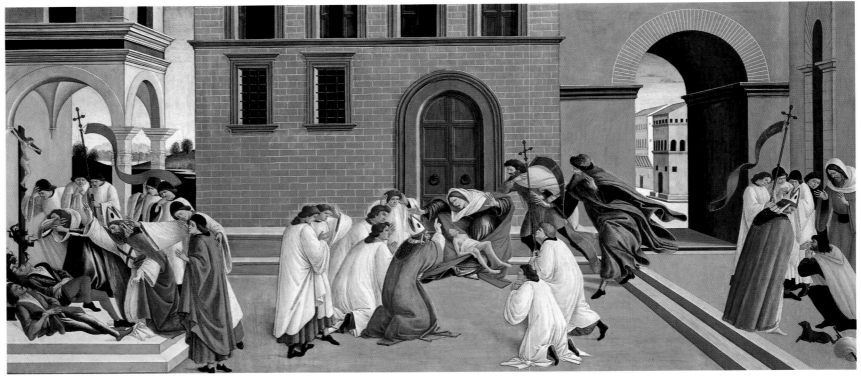

127 (above) *Baptism of St. Zenobius and his Appointment as Bishop,* ca. 1500–1505
Panel, 66.5 x 149.5 cm
The National Gallery, London

Botticelli depicted the life and work of St. Zenobius (337–417), the first bishop of Florence, on four paintings. In the first scene, St. Zenobius is shown twice: he rejects the bride that his parents intended him to take in marriage and walks thoughtfully away. The other episodes show the baptism of the young Zenobius and his mother, and on the right his ordination as bishop.

128 (below) *Three Miracles of St. Zenobius,* ca. 1500–1505
Panel, 65 x 139.5 cm
The National Gallery, London

St. Zenobius saves two men who are possessed by devils. After praying for them in front of the cross, he blesses them, and little devils disappear out of their mouths. According to legend, this occurred inside a church, and Botticelli depicts it as a chapel. Its walls are open, so that the observer can see what is happening. In front of a house entrance, he is restoring to life the child of a pilgrim to Rome. On the right he is healing a blind man who is kneeling before the bishop with his little dog.

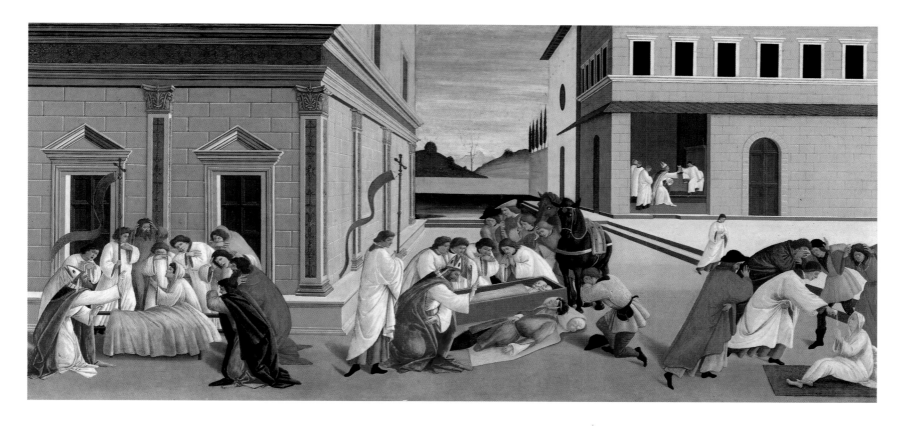

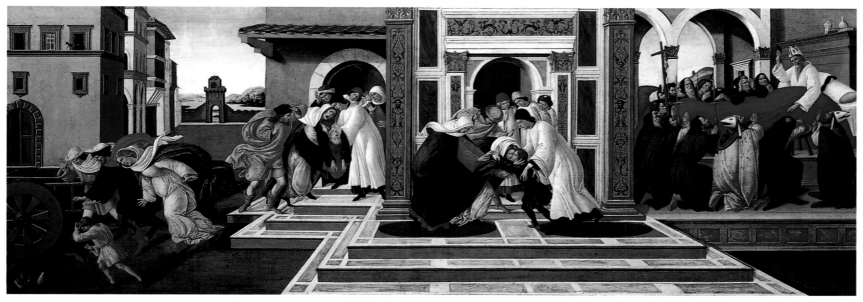

129 (above) *Three Miracles of St. Zenobius*, ca. 1500–1505
Panel, 67.3 x 150.5 cm
Metropolitan Museum of Art, J. S. Kennedy Collection, New York

In front of an astonished crowd, St. Zenobius raises a young man
already lying on his bier from the dead. He also saves a man who fell
from his horse while transporting the relics of saints. The scene in
the interior shows St. Zenobius healing his sick deacon. The latter
gets up immediately in order to use the water St. Zenobius has
blessed to bring a dead relative back to life.

130 (below) *Last Miracle and the Death of St. Zenobius*,
ca. 1500–1505
Panel, 66 x 182 cm
Staatliche Kunstsammlungen Dresden, Gemäldegalerie Alte Meister

A child is run over by a cart while playing. His mother, a widow,
wails as she brings the dead child to St. Zenobius' deacon. By means
of a prayer not depicted here, St. Zenobius is able to revive the child
and restore him to his mother. On the far right, the bishop, who has
meanwhile turned gray, blesses those praying by his deathbed.

CHRONOLOGY

1444/45 Alessandro is born in the Ognissanti quarter in Florence, the youngest son of Mariano di Vanni di Amedeo Filipepi and his wife Smeralda.

1447 Botticelli's family moves into a house in the Via della Vigna Nuova belonging to the Rucellai family.

1449 Lorenzo de' Medici is born.

ca. 1458 Botticelli is probably apprenticed to a goldsmith.

ca. 1460 Botticelli becomes an apprentice in the workshop of Fra Filippo Lippi. Lippi works on the fresco cycle on the *Life of St. John the Baptist* in the cathedral in Prato.

1464 Botticelli's father buys a house in the Ognissanti quarter, and the artist lives and works there from 1470 until his death.
Upon the death of Cosimo de' Medici, his son Piero the Gouty becomes Florence's new ruler.

1467 Lippi goes to Spoleto in order to paint frescoes in the cathedral there.

1469 Lippi dies in Spoleto. Botticelli works in his father's house.
Piero de' Medici dies. Lorenzo the Magnificent becomes the ruler of Florence.

1470 Botticelli is running his own workshop in Florence. He is commissioned to produce *Fortitude* for the Florentine Tribunale di Mercatanzia.

1471 Pope Sixtus IV succeeds Paul II.

1472 Botticelli joins the Guild of St. Luke and lists Filippino Lippi, the son of his teacher, as a member of his workshop.

1474 Botticelli's *St. Sebastian* is hung in the church of Santa Maria Maggiore in January.
The artist is invited to Pisa in order to work on the frescoes in the Camposanto. He paints a trial piece, an *Assumption of the Virgin*, which has since been destroyed.

1475 Botticelli paints a tournament standard, which no longer exists, for Giuliano de' Medici. Poliziano begins his poem "Stanze per la Giostra" in honour of Giuliano de' Medici. Botticelli is commissioned to produce a fresco, since destroyed, showing the *Adoration of the Magi* for the Palazzo della Signoria.

1477 The Roman branch of the Salutati Bank pays Botticelli for a *tondo* of the Madonna which is presented to Cardinal Francesco Gonzaga.

1478 The Pazzi conspiracy unfolds in Florence Cathedral: Giuliano de' Medici is murdered, Lorenzo de' Medici escapes, wounded. Botticelli is commissioned to paint the portraits, which no longer exist, of the hanged Pazzi conspirators on the façade of the Bargello. Pope Sixtus IV excommunicates Lorenzo and declares war on Florence.

1480 The Medicis make peace with Sixtus IV. For the Vespucci family, Botticelli paints the fresco of *St. Augustine* in the Ognissanti church. At the land registry, Botticelli names Raffaello di Lorenzo di Prosino Tosi, Giovanni di Benedetto Cianfanini, Jacopo di Domenico Papi and others as his assistants.

1481 In April and May, Botticelli paints a fresco of the Annunciation for the hospital of San Martino della Scala. He is called to Rome by Pope Sixtus IV in order to participate in the work on the frescoes in the Sistine Chapel.

1482 Botticelli's father dies on 20 January and is buried in the Ognissanti church. Botticelli returns from Rome to Florence. In August he is commissioned to paint frescoes in the Palazzo della Signoria, but he does not carry out the task.

1480s Botticelli, Filippino Lippi, Domenico Ghirlandaio and Pietro Perugino decorate the "Spedaletto" villa of Lorenzo de' Medici, near to Volterra, with mythological frescoes that have since been destroyed.

1482–1483 Botticelli paints the *Story of Nastagio degli Onesti* for the Pucci family.

1483 Lorenzo di Pierfrancesco de' Medici is authorized by the city of Florence to congratulate the French king Charles VIII upon his ascension to the throne. Botticelli asks his nephew Benincasa to collect money that he is owed by Sixtus IV for his work in the Sistine Chapel.

1484 Pope Innocent VIII succeeds Sixtus IV.

1485 In August, Giovanni de' Bardi pays Botticelli 78 florins for the altarpiece in Santo Spirito (*Bardi Altarpiece*, now in Berlin).

1487 Botticelli is commissioned to produce a circular painting by the Magistrato de' Massai della Camera (tax authority). The painting in question may be the *Madonna of the Pomegranate*.

1489 Botticelli paints the *Cestello Annunciation* for Ser Francesco Guardi and is paid 30 florins for it.

1490 Savonarola is brought to the Dominican monastery of San Marco by Lorenzo de' Medici. In 1491, he becomes its prior.

1491 Botticelli is a member of the commission of experts set up to decide on the design of the façade of Florence Cathedral.
He is commissioned to produce mosaics in the chapel of St. Zenobius in Florence Cathedral, but does not finish them.

1492 Botticelli receives a part payment of 53 florins for the *Coronation of the Virgin* from the guild of silk weavers, to which the goldsmiths also belong.
Lorenzo de' Medici dies of gout on 8 April. He is succeeded by his son Piero. Alexander VI is made pope.

1493 On 30 March, Botticelli's eldest brother Giovanni dies and is buried in the Ognissanti church. Botticelli is living in his parents' house with his younger brother Simone, who has returned from Naples, and his nephews Benincasa and Lorenzo.

1494 Botticelli buys a "manor house" in the country for himself and his brother Simone and pays 155 florins for it.
Charles VIII of France lays siege to Florence. The Medicis are driven out of the city.
Botticelli's frescoes showing the hanged Pazzi conspirators are destroyed.
The mathematician Luca Pacioli (ca. 1445–1510) publishes a book in which he praises Botticelli, Filippino Lippi and Domenico Ghirlandaio as masters of perspective.

1495 The Plague breaks out in Florence. Botticelli works for Lorenzo di Pierfrancesco de' Medici in his villa in Trebbio.

1496 Botticelli is paid 20 florins for a fresco of St. Francis, since destroyed, in the dormitory of the convent of Santa Maria de Monticelli.
Botticelli carries a letter from Michelangelo in Rome to Lorenzo di Pierfrancesco de' Medici.

1497 Botticelli receives a number of payments from Lorenzo di Pierfrancesco de' Medici for work which he and his assistants have carried out in his villa in Castello.
Savonarola instigates the "Bonfire of the Vanities"; the monk is excommunicated by Pope Alexander VI.

1498 Savonarola is hanged and burned to death on 23 May.
Charles VIII of France dies; he is succeeded by Louis XII.

1499 The French re-invade Italy under Louis XII.
Botticelli joins the "Arte dei Medici e degli Speziali" guild. He produces frescoes, which no longer exist, in the Ognissanti church for his neighbour Giorgio Antonio Vespucci.

1501 Botticelli completes his *Mystic Nativity*.

1502 Piero Soderini is made a lifetime gonfalonier of Florence.
The agent of the Duchess of Mantua, Isabella d'Este, suggests that Botticelli produce pieces for her *studiolo*.

1503 Ugolino Verino writes a poem in which he compares Botticelli with the famous Greek painters Zeuxis and Apelles.
Piero de' Medici dies in exile, Lorenzo di Pierfrancesco de' Medici dies in Florence.
Pope Alexander VI dies. He is followed by Pius III, and, three months later, by Julius II.

1504 Botticelli acts as an expert for the commission deciding on the location of Michelangelo's *David*.

1510 Botticelli dies. He is buried on 17 May in the cemetery of the Ognissanti church.

GLOSSARY

aerial perspective, a way of suggesting the far distance in a landscape by using paler colors (sometimes tinged with blue), less pronounced tones, and vaguer forms.

allegory (Gk. *allegorein*, "say differently"), a work of art which represents some abstract quality or idea, either by means of a single figure (personification) or by grouping objects and figures together. In addition to the Christian allegories of the Middle Ages, Renaissance allegories make frequent allusions to Greek and Roman legends and literature.

altarpiece, a picture or sculpture set up behind an altar. Many altarpieces were very simple (a single panel painting), though some were huge and complex works, a few combining painting and sculpture.

amoretti, sing. **amoretto** (It. "cupid"), cupids, small winged boys who attend Venus, the goddess of love.

a secco (It. "on dry"), a fresco which, unlike true fresco, is painted on plaster that has already dried. *A secco* painting is generally less durable than true fresco.

attribute (Lat. *attributum*, "added"), a symbolic object which is conventionally used to identify a particular person, usually a saint. In the case of martyrs, it is usually the nature of their martyrdom.

baldachin (It. "brocade"), originally a textile canopy supported on poles used for carrying dignitaries and relics. Later, an architectural canopy of stone or wood set over a high altar or bishop's throne.

baluster, one of the small posts that support a rail.

banderole (It. *banderuola*, "small flag"), a long flag or scroll (usually forked at the end) bearing an inscription. In Renaissance art they are usually held by angels.

bister (or **bistre**), a yellowish-brown pigment, made from soot. Soluble in water it was used as a wash in drawings from the 14th to the 19th century.

Book of Hours, a book of the prayers to be said at specific hours of the day. Books of Hours were usually for a lay person's private devotions, and many of them were richly illuminated.

cassone, pl. **cassoni** (It.), in Medieval and Renaissance Italy, a large chest, usually a marriage chest, for storing linen, documents or valuables. They were often elaborately carved and decorated and sometimes had painted panels set into them. Artists who are known to have painted *cassone* panels include Botticelli, Uccello, and del Sarto.

cherub, pl. **cherubim** (Hebrew "angel"), an angel. In the medieval hierarchy of celestial being, one of the second order of angels. They are usually depicted as a winged child.

coffering, a ornamental system of deep panels recessed into a vault, arch or ceiling. Coffered ceilings, occasionally made of wood, were frequently used in Renaissance palaces.

contrapposto (It. "placed opposite"), an asymmetrical pose in which the one part of the body is counterbalanced by another about the body's central axis. Ancient Greek sculptures developed contrapposto by creating figures who stood with their weight on one leg, the movement of the hips to one side being balanced by a counter movement of the torso. Contrapposto was revived during the Renaissance and frequently used by Mannerist artist, who developed a greater range of contrapposto poses.

copperplate engraving, a method of printing using a copper plate into which a design has been cut by a sharp instrument such as a burin; an engraving produced in this way. Invented in south west Germany about 1440, the process is the second oldest graphic art after woodcut.

cornice, in architecture, a projecting moulding that runs around the top of a building or the wall of room.

devotional image, a religious picture, usually smaller than an altarpiece, designed to be used by an individual or small group.

en face (Fr. "face on"), seen from the front, a frontal view.

frateschi (It. "brothers"), specifically, the followers of the religious leader Savonarola in Florence.

fresco (It. "fresh"), wall painting technique in which pigments are applied to wet (fresh) plaster (*intonaco*). The pigments bind with the drying plaster to form a very durable image. Only a small area can be painted in a day, and these areas, drying to a slightly different tint, can in time be seen. Small amounts of retouching and detail work could be carried out on the dry plaster, a technique known as *a secco* fresco.

glory, the supernatural radiance surrounding a holy person.

gonfalonier (It. "standard bearer"), a high office in the government of several Italian Renaissance republics, notably that of Florence.

Great Schism (Gk. "separation, split"), a split in the Roman Catholic Church, 1378 – 1417, when there were two lines of papal succession, one in Rome and one Avignon in France.

hatching, in a drawing, print or painting, a series of close parallel lines that create the effect of shadow, and therefore contour and three-dimensionality. In **cross-hatching** the lines overlap.

Hortus Conclusus (Lat. "enclosed garden"), a representation of the Virgin and Child in a walled garden, sometimes accompanied by female saints, angels and tame animals. The garden, set off from the rest of the world, symbolizes her purity.

humanism, an intellectual movement that began in Italy in the 14th century. Based on the rediscovery of the classical world, it replaced the medieval view of humanity as fundamentally sinful and weak with a new and confident emphasis on humanity's innate moral dignity and intellectual and creative potential. A new attitude to the world rather than a set of specific ideas, humanism was reflected in literature and the arts, in scholarship and philosophy, and in the birth of modern science.

iconography (Gk. "description of images"), the systematic study and identification of the subject-matter and symbolism of art works, as opposed to their style; the set of symbolic forms on which a given work is based. Originally, the study and identification of classical portraits. Renaissance art drew heavily on two **iconographical** traditions: Christianity, and ancient Greek and Roman art, thought and literature.

Legenda Aurea (Lat. "golden legend"), a collection of saints' legends, published in Latin in the 13th century by the Dominical Jacobus da Voragine, Archbishop of Genoa. These were particularly important as a source for Christian art from the Middle Ages onwards.

lunette (Fr. "little moon"), in architecture, a semicircular space, such as that over a door or window or in a vaulted roof, that may contain a window, painting or sculptural decoration.

Madonna lactans (Lat.) or **Madonna del Latte** (It.), a depiction of the Virgin breast feeding the infant Jesus.

mandorla (It. "almond"), an almond-shaped radiance surrounding a holy person, often seen in images of the Resurrection of Christ or the Assumption of the Virgin.

Man of Sorrows, a depiction of Christ during his Passion, bound, marked by flagellation, and crowned with thorns.

nimbus (Lat. "cloud, aureole"), the disco or halo, usually depicted as golden, placed behind the head of a hold person. It was used this way in Oriental and Classical, and Indian religious art, and was adopted by Christian artists in the 4th century. A **cruciform nimbus** contains a cross.

ornato (It. "ornateness"), in Renaissance art theory, a work's charm, richness, polish, elegance.

pala (It. *pala* [*d'altare*], "[altar] panel"), a large altarpiece. The term sometimes appears in titles, eg Pontormo's *Pala Pucci* (1518)

pendant (Fr. "hanging, dependent"), one of a pair of related art works, or elements within an art work.

piagnone (It. "someone crying or lamenting"), a derisory term for a supporter of the religious leader Savonarola.

predella (It. "altar step"), a painting or carving placed beneath the main scenes or panels of an altarpiece, forming a kind of plinth, and sometimes housing a chest used for storing relics. Long and narrow, painted predellas usually depicted several scenes from a narrative.

putti, sing. **putto** (It. "boys"), plump naked little boys, most commonly found in late Renaissance and Baroque works. They can be either sacred (angels) or secular (the attendants of Venus).

Quattrocento (It. "four hundred"), the 15th century in Italian art. The term is often used of the new style of art that was characteristic of the Early Renaissance, in particular works by Masaccio, Brunelleschi, Donatello, Botticelli, Fra Angelico and others. It was preceded by the **Trecento** and followed by the **Cinquecento.**

Sacra Conversazione (It. "holy conversation"), a representation of the Virgin and Child attended by saints. There is seldom a literal conversation depicted, though as the theme developed the interaction between the participants – expressed through gesture, glance and movement – greatly increased. The saints depicted are usually the saint the church or altar is dedicated to, local saints, or those chosen by the patron who commissioned the work.

sarcophagus, pl. **sarcophagi** (Gk. "flesh eating"), a coffin or tomb, usually made of stone, and sometimes (especially among the Greeks and Romans) carved with inscriptions and reliefs.

satyr, in Greek mythology, human-like woodland deities with the ears, legs and horns of a goat. Often depicted as the attendant of the Bacchus, the god of wine.

seraph, pl. **seraphim** (Hebrew "angel"), an angel. In the Medieval hierarchy of celestial beings, they are the first in importance. They are usually depicted with three pairs of wings.

studiolo (It.), a small room in a Renaissance palace to which the rich or powerful retired to study their rare books and contemplate their works of art. The *studiolo* became a symbol of a person's humanist learning and artistic refinement. Among the best known are those of Duke Federico da Montefeltro in Urbino, and Isabella D'Este in Mantua.

tiara (Lat. "triple crown"), dome-shaped triple crown worn by a pope.

tondo (It "round"), a circular painting or relief sculpture. The tondo derives from classical medallions and was used in the Renaissance as a compositional device for creating an ideal visual harmony. It was particularly popular in Florence and was often used for depictions of the Madonna and Child.

typology, a system of classification. In Christian thought, the drawing of parallels between the Old Testament and the New. **Typological** studies were based on the assumption that Old Testament figures and events prefigured those in the New, eg the story of Jonah and the whale prefigured Christ's death and resurrection. Such typological links were frequently used in both medieval and Renaissance art.

varietà (It. "variety"), in Renaissance art theory, a work's richness of subject matter.

vedutà, pl. **vedute** (It. "view"), a painting or drawing of a city, a "view".

Venus pudica (Lat. "modest Venus"), a depiction of the classical goddess Venus in which she holds one arm over her breasts and the other across her hips. The pose was popular with Renaissance artists.

votive image, a picture or panel donated because of a sacred promise, usually when a prayer for good fortune, protection from harm, or recovery from illness has been made.

Vulgate (Lat. "to make public"), the Latin version of the Bible translated by St Jerome, and in general use since the 8th century and made the official Latin version of the Catholic Church in the 16th century.

SELECTED BIBLIOGRAPHY

Alberti, Leon Battista: On Painting, translated by Cecil Grayson, London (Penguin) 1972

Baxandall, Michael: Painting and Experience in Fifteenth Century Italy, A Primer in the Social History of Pictorial Style, Oxford University Press 1972

Bode, Wilhelm von, Sandro Botticelli: Berlin 1921

Bredekamp, Horst: La Primavera. Florenz als Garten der Venus, Frankfurt/Main 1989

Broke, Peter: Tradition and Innovation in Renaissance Italy – A Sociological Approach, London 1974

Burke, Peter: Culture and Society in Renaissance Italy, London 1972

Chastel, André and Gabriele Mandel: Botticelli, Paris 1968

Dreyer, Peter: Dantes Divina Commedia mit den Illustrationen von Sandro Botticelli, Zurich, 1986 (volume of facsimiles and commentary)

Ettlinger, Leopold D. and Helen S. Botticelli: New York 1977

Hale, John R.: Florence and the Medici, London 1977

Horne, Herbert P.: Alessandro Filipepi Commonly Called Sandro Botticelli, Painter of Florence, London 1908

Lightbown, Ronald: Sandro Botticelli, Life and Work, London 1989

Mesnil, Jacques: Botticelli, Paris 1938

Panofsky, Erwin: Renaissance and Renascences in Western Art, Stockholm 1960

Piper, Ernst: Savonarola, Umtriebe eines Politikers und Puritaners im Florenz der Medici, Berlin 1979

Pons, Nicoletta: Botticelli, Milan 1989

Rubinstein, Nicolai: Florentine Government under the Medici, 1434–1494, Oxford 1966

Salvini, Roberto: Tutta la pittura del Botticelli, Milan, 1958, 2 vols.

Vasari, Giorgio: Lives of the Artists, translated by George Bull, London (Penguin) 1965

Warburg, Aby: Gesammelte Schriften, Leipzig/Berlin 1932

Weinstein, Donald: Savonarola and Florence: Prophecy and Patriotism in the Renaissance, Princeton 1970

PHOTOGRAPHIC CREDITS